WHO IS ANDY WARHOL?

WHO IS ANDY WARHOL?

Edited by Colin MacCabe with
Mark Francis and Peter Wollen

WHO IS ANDY WARHOL?

Edited by Colin MacCabe with Mark Francis and Peter Wollen

Papers from 'Warhol's Worlds', the inaugural conference of
The Andy Warhol Museum, 21–23 April, 1995

First published in 1997 by the
British Film Institute and The Andy Warhol Museum

The British Film Institute exists to promote appreciation, enjoyment,
protection and development of moving image culture in and throughout the
whole of the United Kingdom. Its activities include the National Film and
Television Archive; the National Film Theatre; the Museum of the Moving
Image; the London Film Festival; the production and distribution of film and
video; funding and support for regional activities; Library and Information
Services; Stills, Posters and Designs; Research; Publishing and Education;
and the monthly *Sight and Sound* magazine.
21 Stephen Street, London W1P 2LN

The Andy Warhol Museum is one of the Carnegie Museums of Pittsburgh
and is a collaborative project of Carnegie Institute, Dia Center for the Arts,
and The Andy Warhol Foundation for the Visual Arts, Inc.
117 Sandusky Street, Pittsburgh, PA 15212

Cover design: Angus Hyland/HG-M
Typography: Simon Piehl/HG-M
Cover image: *Invisible Sculpture* at the nightclub Area, 1985
(Patrick McMullan)

Set in Baskerville and Akzidenz Grotesk by Dorchester Typesetting

Printed in Great Britain by St Edmundsbury Press

British Library Cataloguing-in-Publication Data
A catalogue record for this book is available from the British Library
ISBN 0-85170-588-X hbk
 0-85170-589-8 pbk

Contents

Notes on Contributors

Victor Bockris is a writer. His books include *Warhol: The Biography*, *Keith Richards: The Biography*, *Lou Reed: The Biography*, *Uptight: The Velvet Underground Story*, *Making Tracks: The Rise of Blondie*, *With William Burroughs: A Report from the Bunker* and *The Passion of Muhammad Ali*.

Michael Eaton witnessed tantalising aspects of the radioactive half life of the Factory scene in the 70s. It terrified him so much that he went straight and is now a screen-writer. His films include *Fellow Traveller*, *Flowers of the Forest*, the ITV documentary drama *Shoot to Kill* and the BBC TV series *Signs and Wonders*. His latest work is a stage play, *Angels Rave On*. His play about Andy Warhol meeting Alfred Hitchcock, *Drella and the MacGuffin* has been published but still remains unproduced.

Hal Foster is Professor of Art History and Comparative Literature at Cornell University. He is the author of *Recodings*, *Compulsive Beauty* and *The Return of the Real*, and an editor of the journal *October*.

Mark Francis is Curator of The Andy Warhol Museum in Pittsburgh.

Christopher Hitchens is a cultural critic at large for *Vanity Fair* and the Washington correspondent of the *Nation*. He is the author of *The Missionary Position*.

Patrizia Lombardo is Professor of French at the University of Geneva.

Colin MacCabe is Assistant Director of the British Film Institute and Professor of English at the University of Pittsburgh.

Richard Martin is Curator of The Costume Institute of The Metropolitan Museum of Art, Adjunct Professor of Art History and Archaeology at Columbia University, and Adjunct Professor of Art at New York University. He has written many books, articles and exhibition catalogues.

Ralph Rugoff is a cultural critic and curator in Los Angeles. He is the author of *Circus Americanus* and has contributed to numerous exhibition catalogues.

Steven Shaviro teaches at the University of Washington. He is the author of *Passion and Excess*, *The Cinematic Body* and *Doom Patrols*.

Tony Rayns is a London-based critic and film-maker with a special interest in East Asian cinemas. He has a photo signed by Andy Warhol and Joe Dallesandro above his desk.

John Smith is Archivist of The Andy Warhol Museum.

Amy Taubin is a film critic at the *Village Voice* and a contributing editor of *Sight & Sound*.

Lynne Tillman is the author of the novels *Haunted Houses*, *Motion Sickness* and *Cast in Doubt* and of two collections of short fiction, *Absence Makes the Heart* and *The Madame Realism Complex*. She wrote the text for *The Velvet Years: Warhol and the Factory 1965–1967* and co-edited *Beyond Recognition: Representation, Power, Culture – Writings of Craig Owens*. She is a contributing editor of *Bomb* magazine and *New Observations*, and the co-director and writer of *Committed*.

Matthew Tinkcom is an assistant professor in the Department of English and Program in Communication, Culture and Technology at Georgetown University, Washington DC. His latest project is on gay camp and post-war film culture.

Peter Wollen is Chair of the Critical Studies program of the Department of Film at the University of California, Los Angeles. His books include *Signs and Meaning in the Cinema*, *Raiding the Icebox* (which has a chapter on Warhol) and *Visual Display*, co-edited with Lynne Cooke.

Mary Woronov is the author of *Swimming Underground: My Years in the Warhol Factory*.

Foreword and Acknowledgments
by Mark Francis

Despite his fame, an informed and serious recognition of Andy Warhol's achievements has had to wait until after his death. Even now it has tended to concentrate on his work as a painter, and to a lesser extent a film-maker, at the expense of his other crucial roles as a magazine publisher, producer of the Velvet Underground, author, photographer, illustrator, social and sexual provocateur, and so on.

It was therefore with great pleasure and enthusiasm that The Andy Warhol Museum responded to Colin MacCabe's suggestion (some years before the museum opened in 1994) of organising the inaugural conference at the museum as a forum for widely diverse viewpoints about Warhol's life and work. We called the conference 'Warhol's Worlds', and it took place April 21–23, 1995, presented as a collaboration between The Andy Warhol Museum and the University of Pittsburgh Programme for Cultural Studies and Film Studies Programme.

We are enormously grateful to all those who took part in the conference, and in particular Colin MacCabe, its progenitor and begetter, who held to the idea over a long drawn-out period. Peter Wollen was, as ever, a generous co-conspirator and source of ideas. Our thanks for making it all possible go to the Pinewood Foundation and to Armand and Celeste Bartos, whose faith in the project sustained us at a time when support for contemporary art and ideas is increasingly fragile and elusive.

At the University of Pittsburgh, plans for the conference were largely and ably coordinated by Sandy Russo of the Programme for Cultural Studies and Film Studies Programme. Elayne Tobin was also an invaluable resource.

At The Andy Warhol Museum, I am grateful for the unstinting efforts expended on behalf of the conference, and on this publication of its proceedings, by my colleagues Geralyn Huxley and Greg Pierce, John Smith and Matt Wrbican, and Margery King and Lisa Miriello. Kerry Spindler deserves our gratitude for the extraordinary job she did transcribing and ordering the papers. Lea Simonds' enthusiasm and warm hospitality ensured a convivial atmosphere during the weekend.

Preface
by Colin MacCabe

Warhol is one of the twentieth century's emblematic names. Like Picasso it immediately connotes the modernity of art. But unlike Picasso it is not clear that Warhol's prodigious output has ever been satisfactorily described, still less understood. It is for example very difficult to describe Warhol as a painter. It is not simply that the 'paintings' for which he is probably still most famous eschewed composition with brush and oils in favour of forms of mechanical reproduction, but that these works are only part of a range of cultural production that stretches from fashion to journalism via film and music.

It is a feature of academic inquiry that it attempts to separate out elements of the world in order to submit them to rigorous enquiry and analysis. A figure like Warhol is then inevitably badly served by an academy which is institutionally incapable of addressing the full range of his activities; is incapable of investigating the questions he posed about the relations between art and money, culture and commerce, because those questions escape the terms of academic debate. This weakness of academic discourse is not peculiar to the attempt to understand Warhol. Modern culture in its new technological forms inevitably confuses the division of aesthetics and economics that stretches back to Kant and before.

It is these problems of modern culture which have led to the development of new fields of study in the past twenty years, of which the most important are film studies and cultural studies. It was therefore a real conjunction of interests that led the University of Pittsburgh's Programmes in Film and Cultural Studies to suggest to The Andy Warhol Museum that the opening of this new museum, celebrating Pittsburgh's most famous son, was also the occasion for a conference that would attempt to assess Warhol across the entire range of his work and would explicitly raise the questions of art and money that are so central to his work. That conference was called 'Warhol's Worlds' and this volume collects many of the papers presented to it.

The organising of the conference and the editing of this resulting book have been one of my more pleasant experiences. Conversations with Mark Francis and Peter Wollen were constantly illuminating; Celeste Bartos and the Pinewood Foundation were the most pleasant and easy of sponsors and Sandy Russo and Elayne Tobin were a constant joy to work with as we toiled through the delights of conference organisation, Kerry Spindler at the beginning and Rob White at the end took most of the burdens of editing from me.

The importance of being Andy:
the 'Warhol's Worlds' Keynote Lecture, 1995

Christopher Hitchens

In Graham Greene's novel, *Travels with My Aunt*, which was written in 1969, the narrator is Henry Pulling, a grey, inoffensive and reclusive former bank manager. Thanks to an aunt who will brook no disagreement, perhaps because she is really his mother, he finds himself on the Orient Express between Venice and Belgrade. Through no fault of his own, he has become the confidante of a dangerously innocent young American girl named Tooley. Thrown together in a couchette, they improve the shining hour with an interlude of mutual incomprehension:

> 'Julian did a fabulous picture of a Coke bottle once,' Tooley said.
> 'Who's Julian?' I asked absent-mindedly.
> 'The boy-friend, of course. I told you. He painted the Coke bright yellow. *Fauve*,' she added in a defiant way.
> 'He paints, does he?'
> 'That's why he thinks the East's very important to him. You know, like Tahiti was for Gauguin. He wants to experience the East before he starts on his big project. Let me take the Coke.'
> There was less than an hour's wait at Venice, but the dark was falling when we pulled out and I saw nothing at all – I

might have been leaving Clapham for Victoria. Tooley sat with me and drank one of her Cokes. I asked her what her boy-friend's project was.

'He wants to do a series of *enormous* pictures of Heinz soups in fabulous colours, so a rich man could have a different soup in each room in his apartment – say fish soup in the bedroom, potato soup in the dining room, leek soup in the drawing room, like they used to have family portraits. There would be these fabulous colours, all *fauve*. And the cans would give a sort of unity – do you see what I mean? It would be kind of intimate – you wouldn't break the mood every time you changed rooms. Like you do now if you have de Staël in one room and a Rouault in another.'

The memory of something I had seen in a Sunday supplement came back to me. I said, 'Surely somebody once *did* paint a Heinz soup tin?'

'Not Heinz, Campbell's,' Tooley said. 'That was Andy Warhol. I said the same thing to Julian when he first told me of the project. "Of course," I said, "Heinz and Campbell are not a bit the same shape. Heinz is sort of squat and Campbell's are long like English pil-lar-boxes." I love your pillar-boxes. They are fabulous. But Julian said that wasn't the point. He said that there are certain subjects which belong to a certain period and cul-ture. Like the Annunciation did. Botticelli wasn't put off because Piero della Francesca had done the same thing. He wasn't an *imitator*. And think of all the Nativities. Well, Julian says, we sort of belong to the soup age – only he didn't call it that. He said it was the Art of the Techno-Structure. In a way, you see, the more people who paint soups the better. It *creates* a culture. One Nativity wouldn't have been any use at all. It wouldn't have been noticed.'[1]

Graham Greene was a passionate if unorthodox Roman Catholic. That is the only resemblance that I can unearth between him and Pittsburgh's most famous son. Yet this extended piece of aesthetic bafflement, with its brilliantly Warholian aperçu that, '*One* nativity wouldn't have been any use at all. It wouldn't have been noticed,' is testimony to the way in which Andy Warhol per-meates our culture. Writing of Thomas Carlyle in 1931, George Orwell described him as enjoy-ing a 'large, vague renown'.[2] I thought of annexing this phrase for my title, but I decided instead on 'The Importance of Being Andy' because, if dear Oscar's admirers will not find the comparison to be blasphemous, it can be argued that Warhol only put his talent into his works, while reserving his genius for his life.

There was a time when I would have laughed pityingly at anybody who attempted such a com-parison. I may have been jaundiced by the fact that I came to live in the United States at the beginning of the Reagan era; that period of what Robert Hughes scornfully termed 'supply-side aesthetics'.[3] Not only had Warhol been to dinner at Ron and Nancy's infamous table – at a ban-quet for Ferdinand and Imelda Marcos, which must have made it the most intense shoe-fetishist soirée in recorded history – but *Interview* magazine had published a conversation of excruciating falsity and embarrassment between Andy, Bob Colacello and the brittle first lady herself. Following as this did so hard on the heels of *Interview*'s Peacock period, when it was too breathlessly impressed by that supreme patron of the arts the Shah of Iran, this was too much for friends of mine like Robert Hughes and Alexander Cockburn. In fact, Alexander published a spoof *Interview* conversation, in which Andy and Bob took Adolf Hitler for a sustaining lunch at Mortimer's restaurant on the upper East Side. Since I used later on to write a book column for *Interview* myself, I know for a fact that this parody had the effect of seriously upsetting its tar-

gets. And you can see why from this extract:

Bob: Don't you wish you'd been able to spend Christmas in Berchtesgaden?

Hitler: Yes, it would have been fun to go along there and see them light up the tree and all that sort of thing. Do you spend a lot of time in Europe, Andy?

Andy: Gee. Maybe we should get a waiter and order.

Hitler: Just a salad for me, thanks. What about you?

Andy: I'd like a medium cheeseburger and french fries and a lot of ketchup. Tom Enders was saying the other day that the Polish thing shows what a lot of trouble the Russians are in.

Hitler: Here fate seems desirous of giving us a sign. By handing Russia to Bolshevism it robbed the Russian nation of that intelligentsia which previously brought about and guaranteed its existence as a state. It was replaced by the Jew. And the end of Jewish rule in Russia means also the end of Russia as a state.

Bob: Did you enjoy being Führer?

The conversation winds through swathes of *Mein Kampf* which neither interviewer recognizes, until the desultory finish:

Bob: Is there still pressure on you to think of your image and act a certain way?

Hitler: I don't think of image so much anymore. I really don't, Bob.

Bob: *Well.*

Hitler: Have I stopped you cold?

Andy: Well, no. It's just that it's interesting to be here, that's all. This is very exciting for us.[4]

That parody of atonal fascist chic summarised for many people the amoral, spaced-out, affect-less and cynical chill that seemed to emanate from the Warhol world and was caught so crisply by Warhol's self-description of his own 'blank, autistic stare'. In a recent conversation, Bob Colacello – Andy's Boswell in both senses of the term – made to me a point which may be help-ful in explaining my own reconsideration. Warhol, he stressed, was never verbal. Indeed, much of the time he was almost monosyllabic. Gee. Great. Really up there. These were his superla-tives. Really, really, really great might describe a transcendent experience, such as meeting Jackie Kennedy at Studio 54. Warhol's mother never broke out of the linguistic ghetto of her Ruthenian background. We may thank her for ensuring that Andy spent so many hours of his boyhood gazing at the vivid colours of the Catholic iconostasis, and we may thank her also for helping give him the idea of borrowing someone else's signature. But it is salutary to bear in mind that Warhol was semi-articulate and also partly dyslexic. Essentially non-verbal and quasi-literate, he had to realise from the first that he would communicate through images. This makes the durability of some of his cryptic sentences the more remarkable for their brevity and pith. Not just '. . . I want to be a machine'[5] or 'when I have to think about it, I know the picture is wrong',[6] or even the imperishable remark, usually misquoted, that 'In the future, everybody will be world famous for fifteen minutes.'[7] This appeared in the catalogue of his first retrospec-tive, which was shown at the Museum of Modern Art in Stockholm in February 1968. Just a few weeks later, Andy was pronounced clinically dead at Columbus-Cabrini Hospital in New York,

after taking three bullets from Valerie Solanas. Her list of non-negotiable demands, it may be recalled, ran as follows: she wanted an appearance on the Johnny Carson show, publication of the SCUM manifesto in the *Daily News*, $25,000 in cash and a promise that Andy would make her a star. She might have had better luck if she hadn't made her *démarche* on the day that Bobby Kennedy was blown away in Los Angeles. When Warhol came to and saw the Kennedy funeral on the TV, he thought he was watching his own obsequies. Robbed of that particular fifteen minutes by the coincidence, he nonetheless contrived another terse one-liner. When Ultra Violet asked him why he'd been the one to get shot, he observed that he'd been in the wrong place at the right time.[8] Today, Los Angeles, the city of which Andy said in that same Stockholm catalogue that 'I love Los Angeles. I love Hollywood. They're beautiful. Everybody's plastic, but I love plastic. I want to *be* plastic',[9] is the setting for a national Warholian Kabuki drama. Brigid Berlin, Andy's collaborator in early reel-to-reel tapings, evolved with him the post-modern pastime of watching TV on the telephone. The brilliant nullity of this was somewhat in advance of the nullity of either medium; soporific separately and narcotic together. Recently she was talking to Colacello about the old days and said that the O. J. Simpson affair had made her miss Andy more than ever. 'He would have thought it was just so really, really, really great.'[10] Pity the luckless network or Hollywood underling who draws the job of making a mini-series or a drama out of the black man in the white bronco. It has all, from the very night of the crime, been on screen already. And so, all unconscious, an ungrateful nation honours Andy Warhol in its daily devotions.

But this is to keep us in the area of the large, vague renown. In 1987, the American artists David McDermott and Peter McGough, who operate as a daubing duo, painted a tribute to Warhol in an atrium. In what might be termed a post-Raphaelite or neo-Victorian manner, they mimic the passing of a nineteenth-century polymath and omnivore. The muses are all represented, or almost all. Art. Music. Journalism. Theatre. Society. Photography. Philosophy. Literature. In strict conformity with their anti-anachronistic project, they omit Film.

Film

But the medium of film meant more than most to Warhol. Though his films never had the success he yearned for in America, being confined mainly to cult houses in New York and Los Angeles and San Francisco, in Europe they often did fantastically well and could also be said to have exerted a wide influence. In 1971, in Germany, *Trash* very nearly outgrossed *Easy Rider*, and we might not have heard as much from Rainer Werner Fassbinder in later years if this had not been so. Godard's practice of having people orate directly into the camera is a tribute of a kind and, if you ask me, one that could have been made more sparingly. Bernardo Bertolucci freely admitted that he took the idea for the climactic scene of *Last Tango in Paris* from Warhol's *Blue Movie*, where Viva and Louis Waldron divide their time between coupling and discussing the war in Vietnam. *Blue Movie*, of course, was banned in the United States. It also tempted Warhol out of his usual costive or cryptic syntax. Generally, when quoted on matters filmic he would be himself, saying for example that, 'The best atmosphere I can think of is film, because it's three-dimensional physically and two-dimensional emotionally',[11] or 'All my films are artificial, but then everything is sort of artificial. I don't know where the artificial stops and the real starts'[12] (as if anybody does, by the way). On *Blue Movie* he came dangerously close to actual enthusiasm. 'I think movies should appeal to prurient interests. I mean, the way things are going now – people are alienated from one another. Movies should – uh – arouse you. Hollywood films are just

planned-out commercials. *Blue Movie* was real. But it wasn't done as pornography – it was an exercise, an experiment. But I really do think movies *should* arouse you, should get you excited about people, should be prurient.' Wow. (That's me talking.) Gee. Warhol on engagement and authenticity can be infectious. How wise he was to make sure that such moments were rare, and collector's items. I especially like the bit where Warhol attacks Hollywood for its commercialism.

Art

To take the other muses in order, then. In January 1995 I went to the gala opening of the new San Francisco Museum of Modern Art. Mario Botta's edifice is so arranged that one can start at the top, at an atrium lit mostly by natural means, and work one's way down. On the top floor, in an airy wasteland of Koons and Kiefer, you are suddenly arrested by *National Velvet*, Warhol's 1963 homage to Elizabeth Taylor. The references are all filmic. For a start, the painting is a silver screen. The use of different pressures and consistencies gives the effect of different and partial exposures to the forty-two separate frames, which include some very worn ones and some blank ones too. As a sort of grace note at the end, the frames betray a slight but unmistakable flicker.

On a lower level, we find *Lavender Disaster 1964*, the *Electric Chair* and the red and black *Atomic Bomb*, where the bottom line of the multi-exposure chessboard is almost black. Foucault wrote of this period of Warhol's painting in the following terms: 'the oral and rich equality of these half-opened lips, these teeth, this tomato sauce, these hygienic cleaning products, equality of a death inside a ripped-open car, high up on a telephone pole, between the blue-sparking arms of an electric chair. If we study this unmitigated monotony more closely we are suddenly aware of the diversity that has no middle, no up, no beyond.' Though he does not cite it, this was the sort of encomium that irritated Robert Hughes in his batteries against Warhol in the famous *New York Review of Books* polemic in 1982. Read with care, this essay is actually an attack not on Warhol as a painter but on 'Warholism' as a cultural influence. 'To the extent that his work was subversive at all (and in the sixties it was, slightly) it became so through its harsh, cold parody of ad-mass appeal – the repetition of brand-images such as Campbell's soup or Brillo or Marilyn Monroe – a star being a human brand-image – to the point that a void is seen to yawn beneath the discourse of promotion.'[13] Yes, yes, I said to Hughes not so long ago, but what about the *pictures*? Not altogether grudgingly, he conceded that much of the work between 1961 and 1964 was very impressive. He specifically cited the *Electric Chair*. Let's build on this moment of consensus for a second. Look at the electric chair, or call it to mind. It sits untenanted, with the restraining straps dangling suggestively in an almost sado-masochistic fashion. But what remains on the retina the longest? To speak for myself, I would say that it is the word that appears on the wall of the cell. The word is SILENCE. That single injunction or admonition has a tremendous latent power. It expresses simultaneously the absolutism of the process, and also its futility and limitation. (Who cares about the noise?) It also anticipates the banalisation of capital punishment as we have come to know it. I have made a number of visits to Death Row, and on each of them have had Andy Warhol strongly in mind; another testimony to his potency. 'He was in our minds at all times,' says Ralph Ellison of a character in *Invisible Man*, 'and that was power of a kind.'[14]

Music

On music I am less qualified to pronounce than many who will come after me, but I know that Warhol's encouragement of Lou Reed and the Velvet Underground, apart from its well-known consequence of sponsoring a genre of later punk, had the effect of preserving the lyrical aspects of Delmore Schwarz for a generation that might not otherwise have bothered with him as a poet. And I agree with Mick Jagger that Warhol's album cover for *Sticky Fingers* is one of the best such things ever done. Blondie and The Cars perhaps owe more to Warhol, being ahead of the game on video, while Madonna the Material Girl is a Warhol kid in more ways than one.

Journalism

Journalism, in a way, speaks for itself. Some people believe that the resolution of contemporary journalism into celebrity coverage, gossip and ahistorical amnesiac media events is 'Warholian'. By this common attribution, they cannot presumably mean that the networks and the news magazines have actually modelled themselves on *Interview*. The question, rather, is whether Warhol had a finer instinct for the idea of celebrity narcissism than the omnivorous media do today. Bear in mind that when he decided to focus on Elvis Presley and Marilyn Monroe he had no way of knowing that they would have become iconographic figures a full generation later on. (It might, for all we knew, said one of his friends to me once, have been the Everly Brothers.) Bear in mind also, in an age when journalism is dominated by fact-checking and the literal mind so that the press conference and the interview are means whereby frauds and murderers may seize the megaphone, that the idea of the tape recorder anticipates the practice of the edited or unedited transcript, the gross raw material of today's coverage.

Today's coverage is only self-satirising by accident. Warhol's reporters occasionally knew what they were doing. When Warhol took Jackie Kennedy Onassis to the Brooklyn Museum with Lee Radziwill, the following exchange occurred, as narrated by Bob Colacello:

> After the usual greetings, Mrs. Onassis's first words were, 'So tell me, Andy, what was Liz Taylor like?' I couldn't believe it. Here was the only person in the world more famous that Elizabeth Taylor and she wanted to know what Elizabeth Taylor was like. Her first question was right out of an *Interview* interview. And what's more, it was asked in the voice of Marilyn Monroe![15]

Some like to sneer at Warhol's pathetic attachment to stardom and celebrity. Seeing Greta Garbo at a party when he was young, he drew a paper flower and wordlessly pressed it on her. When she left it behind, all crumpled up, he signed it and entitled it *Flower Crumpled by Greta Garbo*. Here we have the boy who wrote from the Ruthenian quarter of Pittsburgh to 30s screen goddesses. And of course he was much too thrilled to be included in a 1957 volume entitled *One Thousand New York Names and Where to Drop Them*. But remember that at this stage one of his body-and-soul jobs involved having just his hands made up so as to draw clouds on the weather map of a local TV station. After that, it might seem more justifiable for him to say, as he did to one of his amanuenses, 'You should write less, and tape record more. It's more modern.' And so, in a way, it is.

Theatre

Here one can be brief but perhaps, with luck, also pungent. In 1953, Warhol fell in with a read-

ing and writing experimental theatre group – Brechtian in its initial character – which paged through everything from Dylan Thomas to Kafka to the Elizabethans and Jacobeans. The chronicler of this period, a rather lugubrious German named Rainer Crone, records in a mirthless manner that 'some of the plays written by members of the group were actually performed'. Set designs and illustrations were supplied by Warhol, whose collages and Japanese screens embodied a consistent admiration for Bertolt Brecht. If this had been a strong motive, we would have known more about it.

Society

Here Warhol knew what he wanted. He wanted to be 'right up there' or 'way up there' in his favourite vernacular, and he also wanted to have a *nostalgie de la boue*. He got his way both ways because, as a close comrade once told me, he knew that everybody was secretly corrupt. The anomic space debris of the imploded 60s went on a whirl with the spoiled kids and rich Eurotrash of the catch-up generations. Any fool can become master of this subject in a few hours. Someone had to be responsible for the sub-Weimar impression given by that period, and Warhol was chosen by the media to be the exemplar. But we still postpone the question of who was laughing at whom. Suicide and drugs and despair played their part, but they had been cast in it already. This was not known as being non-judgmental.

Photography

Warhol restored the idea of portraiture, and this achievement ought not to be denied him. He grasped the idea of the Polaroid and the rehearsal shot, and encouraged newcomers like Robert Mapplethorpe. He knew that the cheapest and most instant techniques could set a pose or capture a moment of character. It didn't always work. Andy and Mapplethorpe together, both with Polaroids and one with a tape recorder, were almost defeated by Rudolf Nureyev. To quote the opening of the interview:

Andy: What colour are your eyes?
Nureyev: The interview is cancelled.

In the end, Nureyev executed major dance steps while Warhol and Mapplethorpe competed with Polaroid flashes to catch the scissoring of his limbs.[16]

Or you could say that every painter who has incorporated the negative into their own work – Jeff Koons, Keith Haring, Jean Michel Basquiat – is a linear descendant. The completion of Ed Ruscha's long-meditated project – a three-dimensional unspooling of the entire length of both sides of Sunset Boulevard at all times of day through video, photography and film – will, in fact, mark the culmination of a Warholian venture.

Was Warhol just lucky? His earlier remark about being in the wrong place at the right time was actually a satire on his ability to know which people would be said to matter, whose fame was going to last, and when to show up or be seen where. For example, in *Couch* there exists the only known image depicting Jack Kerouac, Gregory Corso, Peter Orlovsky and Allen Ginsberg within the same frame. I don't think that this really is just luck.

Philosophy

I think we've done philosophy, if not from A to B and back again. The philosophy is connected on the surface to the idea that nothing strenuous or arduous is worth the anxiety or the excitement or the naiveté. It is so laid back that it almost falls out of the shot. It is, in an inverted and perverse way, also connected to a religion of abjection and fatalism and surrender. John Richardson says mistakenly that only when Andy died did people understand what an intense and devout Catholic he had been.[17] I *dis*agree. Twenty years ago, I was mentally scanning the title POPism and inwardly translating it as Pope-ism. A friend of mine was hired on to *Interview* because he had reviewed *Trash* as a Catholic reworking of Jean Genet's version of *Our Lady of the Flowers*. Cultish Catholicism, with its hints of camp and guilt, were of the essence. Walter Benjamin once defined surrealist art as a series of 'profane illuminations'. 'Profane Illuminations' was another title that I considered, until I realised that the subliminal trope was the sacred and not the profane.

Literature

The above makes it the more interesting that William Burroughs never guessed the truth about Andy's religiosity. But in his own 'cut-up' style of composition, he clearly acknowledged a prosaic debt, not to mention an attitudinal one. Perhaps they both owed it to Jean Genet; at all events one can trace a lineage of obligation here. Here we also find Warhol's greatest disappointment. He admired Truman Capote with an almost adoring consistency. He designed a shoe for him, in gold. He tried to catch his attention. He understood at once the idea of the non-fiction novel, because it comprised one of his own definitions of film. But he was repeatedly snubbed by Capote, who once said that Andy was 'a sphinx without a riddle'. Warhol's own later comment, that Capote said he could have anybody he wanted while Andy didn't want anybody he could get,[18] is one of the best definitions of thwarted homosexuality that has ever been compressed into a phrase.

Uneven as this all is, it manifests an amazing touching of bases. If it is undervalued – at least aesthetically if not commercially – it may be because Warhol always spoke with a flat, defiant economism about the subject:

> Business Art is a much better thing to be making than Art Art, because Art Art doesn't support the space it takes up, whereas Business Art does. (If Business Art doesn't support its own space, it goes out-of-business.)[19]

He made the same unhypocritical and down-to-earth point in a different tone of voice when he said, 'Rich people can't see a sillier version of *Truth or Consequences* or a scarier version of *The Exorcist*. The idea of America is so wonderful because the more equal something is, the more American it is.'[20] I think he must have thought about this paean to conformity and sameness a lot, because it appears several times in interviews throughout his life, often with tiny variations (such as the President having to relish the same cheeseburger as the rest of us) but always making the same celebratory point.

Here is a style that is often held against him, like his obsessive parsimony and his preoccupation with accountancy and his anal-retentive attitude towards savings and collections and even time capsules and souvenirs. But of what does it remind you? The answer should not, in a city of

industrialism and abundance like Pittsburgh, seem very surprising. The voice that is speaking is the voice of that great artist and innovator Henry Ford. The Henry Ford who said that history was bunk. The same Henry Ford who announced, this time really anticipating Andy, that any colour was fine as long as it was black. Warhol's achievement was to define the aesthetics of mass production, not to be a business artist. Business artists are more common than we want to think or like to believe. Michael Fitzgerald's new book on Pablo Picasso, *Making Modernism: Picasso and the Creation of the Market for Twentieth Century Art*, has more tales of painterly stock manipulation and artistic insider trading than Warhol had cans of soup. The thing is that Warhol cheerfully and in a way challengingly affirmed what the 'community' of painters and dealers was at some pains to muffle.

Don't knock business art unless you are very sure of yourself. Anthony Powell once wrote (in *A Dance to the Music of Time*) that he never did his insurance policy without imagining it landing on the desk of Aubrey Beardsley before being passed to that of Wallace Stevens and eventually landing up in the in-tray of Franz Kafka. And if you think these insurance men are scary, think of the ad-business. Public relations as an American science was pioneered by Edward Bernays, the nephew of Sigmund Freud. Salman Rushdie began his career as a writer of enticing ads and jingles. Jasper Johns and Robert Rauschenberg also worked in what was politely termed 'commercial art', but (of course) only to support themselves while they did the real stuff. Only Andy Warhol proclaimed that there was no difference between the two things, except in the way you did them, and thus opened the question of whether there was or is an artistic way of making or finding art. Partly, this was his settling of accounts with Picasso, of whom he said, 'When Picasso died I read in a magazine that he had made four thousand masterpieces in his lifetime and I thought, "Gee, I could do that in a day." You see, the way I do them, with my technique, I really thought I could do four thousand in a day. And they'd all be masterpieces because they'd all be the same painting.'[21] More insulting still, Warhol used to say that the same faculty would have made him into an ideal Abstract Expressionist. More is involved here than being a fool for God.

Having been pronounced clinically dead twenty years too soon, Warhol was pronounced actually dead several years too early. He survives in our references, in our imagination and in the relationship of his own sense of timing to ours. Just because he knew the price of everything doesn't mean he didn't know the value of some things.

Notes

1. Graham Greene, *Travels with My Aunt* (New York: Viking Press, 1969), pp. 99–100.
2. George Orwell, *The Collected Essays, Journalism and Letters of George Orwell: An Age Like This*, ed. Sonia Orwell and Ian Angus (New York: Harcourt, Brace & World, 1968), p. 33.
3. Robert Hughes, 'The Rise of Andy Warhol', in *The First Anthology: 30 Years of 'The New York Review of* (New York: The New York Review of Books, 1993), p. 216. (First published in 1982.)
4. Alexander Cockburn, *Corruptions of Empire* (New York: Verso, 1987), pp. 278–81.
5. G. R. Swenson, 'What is Pop Art?: Answers from 8 Painters, Part I', *Art News* 62 (November 1963)
6. Andy Warhol, *The Philosophy of Andy Warhol: From A to B and Back Again* (New York: Harcourt Brace Jovanovich, 1975), p. 149.
7. Andy Warhol, Kasper König, Pontus Hultén and Olle Granath (eds), *Andy Warhol* (Stockholm: I Museet, 1968), n.p.
8. Ultra Violet, *Famous for 15 Minutes: My Years with Andy Warhol* (Orlando: Harcourt Brace Jovanovich, 1988), p. 178.
9. Warhol, König, et al., *Andy Warhol*, n.p.
10. Conversation with Bob Colacello.
11. Warhol, *The Philosophy of Andy Warhol*, p. 160.
12. Read by Nicholas Love at Warhol's memorial service (1 April 1987).
13. Hughes, 'The Rise of Andy Warhol', p. 216.
14. Ralph Ellison, *Invisible Man* (New York: Random House, 1952).
15. Bob Colacello, *Holy Terror: Andy Warhol Close Up* (New York: HarperCollins, 1990), p. 160.
16. Ibid., pp. 107–8.
17. John Richardson, 'Eulogy for Andy Warhol', in *Andy Warhol: A Retrospective* (New York: The Museum of Modern Art, 1989), p. 454.
18. *Andy Warhol's Exposures,* ed. Bob Colacello (New York: Andy Warhol Books/Grosset & Dunlap, 1979), p. 176.
19. Warhol, *The Philosophy of Andy Warhol*, p. 144.
20. Ibid., p. 101.
21. Ibid., p. 148.

Andy Warhol: Renaissance man

Peter Wollen

Warhol became famous as a Pop artist. But as this museum
reminds us, it is clear that Pop Art was only one phase in his artis-
tic career and that not only was it preceded and followed by differ-
ent kinds of art production, but that he was by no means limited
to fine art. He was also a film-maker, a writer, a photographer, a
band-leader (if that's the word to characterise his involvement
with the Velvet Underground), a TV soap opera producer, a win-
dow designer, a celebrity actor and model, an installation artist, a
commercial illustrator, an artist's book creator, a magazine editor
and publisher, a businessman of sorts, a stand-up comedian of
sorts, an exhibition curator, a collector and archivist, the creator
of his own carefully honed celebrity image, and so on. His art-
related activities were extremely multifarious and all of them are
worth examining both in their own right and as aspects of the
Warhol phenomenon in general. Warhol, in short, was what we
might loosely call a 'Renaissance man', albeit a Pop or perhaps
post-modern Renaissance man.

It was the Swiss art historian Jakob Burckhardt who coined the
term 'many-sided man' or 'all-sided man' in the mid-19th century,
in his great book, *The Civilization of the Renaissance in Italy*, and thus
popularised the idea of what became known as the 'Renaissance

man'. He had in mind artists such as Alberti, Leonardo and Michelangelo who did not simply paint but also excelled in other fields – as musician, scientist or poet. He saw the Renaissance as a time when the ideal of humanist learning was one of 'generalism' rather than 'specialism', a voracious interest in the whole field of human culture. This image of the Renaissance was, in a certain sense, a rehabilitation. It was developed in antithesis to the cult of medievalism which had thrived under the influence of the Romantic Movement. Liberal scholars like Burckhardt celebrated the Renaissance precisely because it broke with the crabbed and constraining asceticism of the Middle Ages, its dogmatic religion and its feudal structures, when art and culture were enslaved by obscurantism, and free enquiry and creativity were stifled and repressed.

It may, of course, be sheer coincidence that Clement Greenberg referred to Jackson Pollock both as 'Gothic' and as 'Baroque', never as a 'Renaissance' artist, but it is certainly true that Greenberg saw painting as an activity which existed within the limits of its own world, self-validated and self-contained. Warhol, more than anyone else, broke open this enclosed world of 'ambitious art', a world in which art had become a kind of substitute religion with its substitute theology and clerisy. The Warholian Renaissance indeed repeated, in miniature, many of the features that Burckhardt saw in the Florentine Renaissance – a breaking-down of cultural barriers, an exuberant neo-paganism, the rise of the artist as celebrity, a fascination with a certain kind of court culture. I should add that the idea of the Renaissance man was also crucial to John Addington Symonds, whose massive *Renaissance in Italy*, published in seven volumes between 1875 and 1886, drew on Burckhardt and popularised his outlook in the English-speaking world. Symonds was also the first scholar to connect the Renaissance interest in Greek culture and paganism with the homosexuality of so many Renaissance men, including, most notably, Leonardo and Michelangelo.

In my view, this change in the concept of art was more important historically than the specific character of Pop Art as a movement. In this sense, Warhol was absolutely correct to see Pop as an -ism, rather than a style or a movement. It involved a cultural re-evaluation. In the 60s, the discovery of popular culture and the mass media within the art world played the same sort of role that the discovery of Classical literature did for the Renaissance. In many ways, this 'new learning' had many of the same antiquarian and philological aspects that the Renaissance did. Warhol's incunabula were film fan magazines, pulp newspaper front pages, comic books and wallpaper patterns. His gods and goddesses were Hollywood stars, Elvis Presley and Marilyn Monroe. As I have suggested elsewhere he may well have read (or leafed through) Edgar Morin's scholarly (yet popular) book on *The Stars*, an Evergreen Profile Book first published in 1960, whose chapter headings read: 'I Genesis and Metamorphosis of the Stars; II Gods and Goddesses; III The Stellar Liturgy; IV The Chaplin Mystery; V The Case of James Dean; VI Star-Merchandise; VII The Star and the Actor [a celebration of "being" rather than "impersonating"]; VIII The Star and Us [a study of fan-dom].' Like Leonardo, Warhol was fascinated by new technologies – the tape recorder, the Polaroid, the video camera. Like Michelangelo, he was deeply marked by a religion whose interdictions he publicly pushed to the limits, and like Raphael he became a courtier with his own court.

I think that, as we look at Warhol, it is important to realise the centrality of fashion to his career and to his view of the world. Warhol's art career, his historic role as the most publicly prominent instigator of Pop Art, took off at a time when the fashion world itself was changing

in crucial ways. As has often been argued, most forcibly by Gilles Lipovetsky, the 60s was a period during which the century-old social and economic organisation of the modern fashion world, first established in the mid-19th century by Worth, finally entered into crisis and began to mutate. In a nutshell, the balance of power between *haute couture* and ready-to-wear began to change. Ready-to-wear designers began to aspire to the same status as creators, innovators and artists that Paris couturiers, with their custom clientele, had long enjoyed. This trend began in France, where Pierre Cardin held the first ready-to-wear show at Printemps in 1959, and in England, where Mary Quant opened Bazaar in 1955. Warhol followed English fashion from 1963 when he first met Nicky Haslam, who had come to New York as an art director for *Vogue*, at around the same time that Warhol hired Gerard Malanga to do silk-screening for him. It is worth noting, in this context, that at that time, magazine art directors were the key figures in Warhol's career, essentially acting as patrons. Gallery owners and directors played a similar role for Warhol in the art world proper. Later, when Warhol became a society portraitist, he finally developed a fleeting although direct social relationship with each individual sitter.

Beginning as a fashion illustrator, Warhol moved into multiples, or ready-to-hang, so to speak (rather as Beaton moved into costuming) and then, at a later stage, tried to develop a line of old-fashioned *haute peinture*, flattering the narcissism of the rich and famous, while maintaining his brand-name ready-to-hang niche. In the first phase of his career, Warhol was an adjunct in the marketing of accessories – shoes mainly. In the second phase, he developed his own art-world counterpart to the new fashion launched in London by Quant, Foale & Tuffin and Biba and in Paris by Courrèges and Rabanne, and developed in its New York version by Paraphernalia, Tiger Morse and Andy's own superstars – Baby Jane Holzer wearing Foale & Tuffin, Edie Sedgwick wearing Gernreich, and so on. In the third phase, he tried to return to the classic *haute couture* set-up, catering to aristocratic and *nouveaux riches* patrons. Couture, in its modern sense, began when Worth was able to detach himself from the role of court dress-maker and establish his own business in his own house, so that princesses and duchesses had to come to him rather than the other way round. Warhol never quite achieved this degree of success or eminence. He always remained a courtier, angling for work, relying on charm, manipulating the situation. These were the very same skills that he had honed as a young illustrator, cultivating his coyly reticent-but-memorable image, using intermediaries, playing for the sympathy vote, slyly leaving charming little home-made gifts and remembering to send cards.

The fashion milieu provided the model of a world which, in many respects, was like that of a feudal court, but which was also, like that of the Medici, a commercial enterprise. It was a world which, like a Renaissance court, put a high value on eye-catching display, original talent and pleasing those in power, a world full of favouritism in which the personal relationship between A and B was of primordial importance, and consequently a world full of intrigue and gossip. When Warhol made the transition from illustrator to artist he was able to reverse the roles, to become the duke of his own small duchy (with his own 'duchess', in fantasy at least) surrounded by his own retinue of courtiers. Warhol had already created an incipient putting-out structure for himself, as he became more successful as an illustrator, delegating work to assistants, who thus became dependent on him in the same way that he was dependent on his art directors. At the Factory, this system became something like a full-scale court in its dynamics, with all the traditional pathology of a court – struggles to reach the monarch's ear, plots and intrigues, a turnover of favourites, a ritualised pecking-order, a ceaseless round of entertainments to keep

the courtiers happy and busy. Valerie Solanas was a product of just this pathology, a disappoint-ed courtier who attempted to kill her patron, as though she were in a Jacobean revenge play.

This reduplication of the structure of a court within the studio itself followed Renaissance precedent. As James Saslow points out in his extremely interesting book titled *Ganymede in the Renaissance*, 'Leonardo was commonly thought to choose his assistants more for their looks than their talent' and 'in a letter probably dating from 1518, Michelangelo recounts an incident in which this assumption was made of him. A man had come to him asking that the artist take on his son as an apprentice, adding as an enticement, "if I [Michelangelo] wished, I could have him not only in my house but in my bed."'[1] Michelangelo, despite his homosexual inclinations, always defended himself against charges of lasciviousness, as Warhol did too, in his own way, but, of course, it was widely believed and publicly claimed that Michelangelo did, in reality, act on his inclinations.

Ganymede, many of you will remember, was the cup-bearer of the Gods – the contemporary equivalent might be the drug-pusher – who was desired by Zeus, king of the Olympian court. The story of Ganymede was frequently represented after mythological subjects became com-mon during the Renaissance, reaching an apogee in the mid-1500s, then beginning to decline with the Council of Trent and becoming rare by the 17th century. Ganymede was represented by Michelangelo, Correggio, Parmigianino, Giulio Romano and Cellini. Leonardo, a major influence on Correggio, never painted Ganymede, although his androgynous subjects are well known. By no means all of the painters drawn to the Ganymede theme were themselves homo-sexual, although the court cultures of Florence and Mantua, in which they worked, were steeped in the pagan permissiveness derived from Ovid and, specifically, the homoerotic inter-pretation that could be given to the Platonic doctrine of love, introduced to the Medici court by Ficino. Ficino explicitly argued the superiority of homo-eroticism to hetero-eroticism, as taught, under his interpretation, by Plato himself.

I am not suggesting that Warhol was steeped in neo-platonism or Renaissance thought (in the same way that Derek Jarman was) or even that his court intellectuals (Henry Geldzahler and Ivan Karp) were reliving the Renaissance. However, it is not hard to see elements of the Ganymede aesthetic in Warhol's work, especially his films. Moreover, even his painting is sur-prisingly classical and antiquarian in its iconography, following the classic genres of portrait, still life, Dutch genre painting (flowers, cows) and the Passion, and martyrdom motifs of execu-tion, death and grief (the First Lady Dolorosa). Warhol also, of course, repainted two of Leonardo's own masterpieces – the *Mona Lisa* and *The Last Supper*, both of which have been given androgynous and/or homoerotic readings. Doubtless, these works also appealed to Warhol because of their celebrity. Warhol's portraits are disproportionately skewed towards subjects richer, more famous or more socially acceptable than himself (thus placing himself in the courtier position) and both the *Mona Lisa* and Christ and the Apostles fall into this category.

I also think that Warhol's fascination with technology relates both to the innovative Renais-sance mentality and to the breadth of Warhol's own cultural production. The Renaissance was a period in which new technologies reshaped human perception and, in particular, artistic representation of the world. As is well known, Renaissance artists developed and used optical devices for ensuring correct perspective and for mastering complex schemes of representation.

These technical aids were not seen as substitutes for or limitations on human creativity. Quite the contrary. As in any other field of endeavour, the Renaissance artist believed technology should be used when available. Technology also permitted difficult things to be done more easily, with *facilita* or *prestezza*. I believe Warhol's proliferation of interests was closely linked to his fascination with technology, particularly the technology of reproduction – the Polaroid, the tape recorder, the video camera. Each permitted instant execution. (Perhaps it might be noted that the 60s was also a period in which fashion embraced technology – Courrèges and Paco Rabanne used plastics and metal, Tiger Morse used vinyl and mylar; Morse, Deanna Littell of Paraphernalia, and, in 1966, Yves Saint-Laurent, all used electric lights.)

There is another important biographical precondition of Warhol's protean capacities. In the first phase of his career, he worked primarily for magazines: *Glamour*, *Harper's Bazaar*, *Vogue* and others, all of which carried print, photography and illustration, as well as dealing with an endless variety of subjects. Warhol retained this magazine mentality. Indeed, he ended up publishing a magazine (*Interview*), itself a remake of *Park East*, a magazine devoted to Upper East Side celebrities which Warhol read avidly, while an illustrator, and eventually broke into. Moreover, besides magazine illustration, Warhol worked in a number of other related fields – he did album covers (the music industry), book covers (the book industry), store windows (installation works), and so on. This, too, clearly predisposed Warhol towards working in a variety of different media. During the 60s, film, which became his major preoccupation, was a natural development of his personal interests, his taste for technology and the Renaissance-style studio system he favoured. A Hollywood studio, the site of his fantasy, was itself the closest thing to a Renaissance court which the contemporary United States had to offer.

At the very end of his career, in phase three, Warhol finally encountered real courts – most notoriously, the Pahlavi court of Iran. The intermediary here was Fereydoun Hoveyda, ex-contributor to *Cahiers du Cinéma*, whose brother was Court Minister in Teheran. Paraphernalia gave way to Halston, speed-freaks gave way to young Republicans, Whistler gave way to Winterhalter, Edith Scull's photo-booth portrait gave way to the blown-up Polaroid with added brush-strokes from the master's hand. At the same time, Warhol's field of interests also seems to have narrowed as he assumed the role of supplicant and flatterer. Perhaps, looked at charitably, it can be seen as a form of camouflage. Underneath, Andy was still playing with his paper dolls and hoarding his fan magazines and wishing he was more attractive. Or, looked at another way, the oil shock of the 70s, the end of the long post-war boom and the swing to the right that followed was Andy's Council of Trent. The *cache-sexes* went up in the Sistine Chapel and, like Cellini, he cleaned up his act, perhaps even considered family life. At the very least, he reined in the public display of 60s homosexuality, certainly its less socially acceptable aspects. At the same time, he narrowed the scope of his work. The two retreats were not unconnected. They took Warhol away from the role of Renaissance man, in the humanist sense, towards Post-Renaissance man, in the Tridentine sense, the chastened Catholic, the man who served dinners to the homeless at the Church of Heavenly Rest. With Stephen Sprouse.

Notes

1. James M. Saslow, *Ganymede in the Renaissance: Homosexuality in Art and Society* (New Haven: Yale University Press, 1986).

Andy Warhol the writer

Victor Bockris

I was first introduced to Andy Warhol through his voice in 1973. I was working with a writer named Andrew Wylie in New York City. Wylie had interviewed Warhol and was trying to convince me that Andy was not only the most important artist of the 20th century but also the greatest person in the United States. I was *not* convinced of this and argued with him about it. Wylie then played for me, on a cheap tape recorder, a cassette of the interview he had done with Warhol a couple of weeks prior. I listened to that voice for approximately one minute and was *immediately* convinced of both of these assertions.

In his writing, Warhol was most interested in depicting what I call 'voice portraits'. I discovered this when I went to work for Warhol at *Interview* magazine in 1976. He told me that the best way to do an interview was to visit the subject, ideally in their own home, with no questions and no preconceptions – with as empty a mind as possible. This way, the interviewer will get the most accurate and revealing image of the subject via the topics he or she chooses to discuss, as well as the grammar, syntax and vocabulary used. If a tape is transcribed very accurately, with each 'uhm', 'err' and 'but' included, what is redacted is a voice portrait. Warhol demonstrated this in the distinct interviews he did for *Interview* magazine between 1974 and 1982.

The first book Andy wrote, and probably the most obscure in his catalogue of fourteen books, is called *a (a novel)*. One day, in August of 1965, through the kind of serendipity that decorated Warhol's career, Andy received a package in the mail from Philips Recording Company containing the first cassette tape recorder. Warhol was told that he could keep the machine on the condition he do something to publicise it. Andy instantly decided that he would write a book with it. Everyone at the Factory laughed and thought how stupid he was, because that's not writing, that's tape recording – or as Truman Capote said about Jack Kerouac, 'That's not writing, that's typing'. Apparently, 'language' is not writing, words have to be written in some kind of preconditioned manner to be considered true writing. Andy didn't agree and approached his favourite superstar, Ondine. Ondine was not only Warhol's court jester but he was also the most articulate, funniest, fastest-talking person at the Factory. Warhol proposed that he would record '24 Hours in the Life of Ondine' (the reference to *Ulysses* is inescapable, and Andy knew the implications of writing a novel which would cover twenty-four hours in the life of a man), and he told Ondine that the book would make him famous. Ondine, who was a great person and wanted to be as famous as he was fabulous and loved Andy, was happy to do it so they agreed to meet a few days later on a Saturday morning. When they met, both ingested some Disoxyin pills – Ondine took ten (a superstar-strong dose), Andy took two – and off they went, living what in those days was a normal day in the life of Andy and Ondine. They went to the Factory, they went to visit people in their apartments, to restaurants, they rode in the back of cabs to clubs . . . and Andy recorded it all on his brand new toy. After twelve hours, however, Andy tired and went home. The book was not completed until two years later during a second marathon session in August of 1967. *a* is, by the way, undoubtedly the most accurate written portrait of the silver factory. It is typical of the blindness of the publishing industry that while facile books on Warhol tumble into print yearly this echt document remains almost entirely neglected although available (through Grove/Atlantic who own the rights). What makes it so puzzling that the book is out of print in the celebrity soaked USA is that it contains an all star cast. Ondine dominates the text but Edie Sedgwick makes some fascinating appearances twittering a series of the trippiest titters in the book like 'gone down from divinity to star to somehow the mockery walks get in.'[1] And Lou Reed makes a guest appearance. Since a book about Edie was a bestseller and there are several books in print about Reed it is inexplicable that a book *by* Warhol about these people remains out of print (and don't give me that 'it's hard to read' routine; it's easier to read than *The Naked Lunch*). It looks like another part of the denial of Warhol's genius. Although he was, in my humble opinion, as creative with words in 1965–7 as William Burroughs, Richard Brautigan, Thomas Pynchon or Susan Sontag, to name but a few of the stars of the day, nobody takes him seriously as a writer. And he was an industrious one.

Once the recording had been finished, Andy had to get the 24-hour tape transcribed. And it was in this step that the book was transformed from a good idea into literature. Rather than asking one person to transcribe, Warhol chose a bevy of (mostly) women to do the vital work. He gave the tapes to various people including Maureen Tucker, the drummer for the Velvet Underground who happened to be a super typist, and Gerard Malanga's secretary, Susan Pile. Warhol also hired a couple of high school girls to come to the Factory each afternoon after school to type.

A number of inconsistencies occurred in the process of transcribing the tapes. Maureen Tucker refused to type up any swear words, so every time there was a swear word, Maureen left that

blank (there were a lot of blanks). One of the little high school girls had a tape confiscated and thrown into the trash when her mother overheard the language used – so one entire section of the book was lost. Susan Pile and Paul Katz, who were privy to the inner workings of the Factory and knew everyone there, felt strongly about some of the nasty things that were said about certain people on the tape, so they changed them to nice things. They also felt strongly about some of the nice things said and changed those to nasty things. Throughout the transcription words are misspelt, including 'and' and 'but', and grammar is confused; sometimes there are sixteen colons in a row or paragraphs with six brackets that open but never close. In this sense it is the 'worst' book ever written, just as Warhol's films are the 'worst' films ever made. However, the films have, albeit grudgingly, at least been recognised for changing the form and content of American cinema, and The Velvet Underground's first record produced by Warhol has been recognised as among the greatest rock records ever recorded. *a* is just as important a book as *The Chelsea Girls* is a film or *The Velvet Underground and Nico* is a record and should be recognised as among the most accurate, creative, influential novels of the 60s. It is a useful, revealing, funny, educative book. To ignore it is a cultural crime, is to rewrite history incorrectly. It should be included on college reading lists in anthropology courses and history courses as well as English 101.

In August of 1967, Andy was handed the six hundred page manuscript to read in preparation for publishing the book. He was astounded by what he received, but contrary to what was expected, rather than take the pages to someone and have them properly retyped, Warhol embraced the transcription exactly as it was. This is fantastic, he said, this is great. He read it six times from beginning to end.

In preserving the manuscript's shattered state Warhol was actually presenting the precise aura of the conversations. Because as we know, people don't actually speak in sentences, and there aren't always periods of complete silence when one person speaks and others are supposed to be listening. Instead, there is always some sort of babble going on during a conversation. Language is broken, people literally don't 'spell' words right when they speak them, words are spoken incorrectly. In *a* Andy created an accurate picture of a day in the life of the Factory in the 60s.

Although the book was completed in 1967, it was not published until after Warhol was shot, in the fall of 1968 by Grove Press, which also published Warhol's *Blue Movie* (the script illustrated by stills of its stars Viva and Louis Waldron making love in the shower and in bed). Thus, although *a* was the first book Warhol wrote which was published, another book written in 1966, *Andy Warhol's Index (Book)*, was published first by Random House in December 1967.

Andy Warhol's Index (Book), which is an expensive rarity today, was another portrait of the mysterious silver factory as a schizoid funhouse. It consists primarily of photographs, blank pages, joke pages and a pop-up cut-out of a medieval castle inhabited by Warhol's superstars above the logo 'We are constantly under attack'. The text is a rambling, seemingly random, classically monosyllabic interview with Warhol. Although it stands today as an essential report on the Warhol factory, the *Index* book operates on a different level entirely than *a* inasmuch as it does not rely primarily on language.

In fact 1967–8 saw the first stream of Warhol books: apart from *Andy Warhol's Index (Book)* and *a*, there was *Screen Tests: A Diary* (in collaboration with Gerard Malanga); *Intransit: The Andy*

Warhol–Gerard Malanga Monster Issue, as well as the famous catalogue of the Svenska Moderna Museet in Stockholm with the flower paintings on the cover, popularly known as the telephone book because of its thickness, that contained some three hundred photographs by Billy Name and Stephen Shore as well as ten pages of Warhol's most famous aphorisms: 'I don't believe in love.' 'I want to be a machine.' 'I don't like to think.' All these books had a single purpose – to popularise Warhol just as the Bible popularises God. Only *a*, however, succeeded as a work of art on a par with his films, music and painting. As I see it, *a* is part of a trilogy that is married to, and is very similar to, the film *The Chelsea Girls* and the record *The Velvet Underground and Nico*. It was made at the same time and based on the same people. The stars of *The Chelsea Girls* and the stars of the Velvet Underground are in *a*; and *a* follows the same themes and subjects as do *The Chelsea Girls* and *The Velvet Underground and Nico*.

a stands, I suggest, among the ten greatest books of the 60s, along with *The Naked Lunch* and *A Clockwork Orange*. As is all great literature, *a* is a record of contemporary human speech. (Go back and read *The Goncourt Journals*[2] or *The Diaries of Samuel Pepys*[3] – the authors are reporting patterns and kinds of human speech.) *a* is a complete insight into the workings of the Factory and of the Warhol world and, as such, is tremendously successful. When published in the aftermath of Warhol's shooting, it was well reviewed in (the highly intellectual) *The New York Review of Books* – at length and seriously for exactly what it was. But inevitably, *a* was treated as were *The Chelsea Girls* and *The Velvet Underground and Nico* – recognised as an underground masterpiece it was largely ignored, and was probably read by as few people as have seen *Sleep*.

Andy believed the tape recorder could change writing as much as the camera had changed painting. In the mid-70s, Warhol turned the machine on himself in another attempt to create literature. Hence, we get his second string of books: *The Philosophy of Andy Warhol: From A to B and Back Again*,[4] *POPism: The Warhol '60s*[5] and *Andy Warhol's Exposures*[6] (of which I wrote the first draft).

In the 80s Warhol wrote three more books – I like to think he saw his books in the 60s, 70s and 80s as trilogies mirroring each decade, but that is perhaps overwarholising Warhol – *America*, *The Party Book* and the posthumously published *Andy Warhol Diaries*,[7] which was his only bestseller (what he had hoped *a* would be). The diaries were edited by one of the most talented, least known 'lifers' at the Factory, Pat Hackett, who had revealed a flash of brilliance in writing the scripts for Andy Warhol's *Dracula* (1974) and *Bad* (1977), with George Abagnolo, which is one of the reasons they captured Warhol's voice so well artistically and commercially. *America* and *The Party Book* were primarily photo books with a text dictated by Warhol on tape mixed with interviews with a number of the photo subjects. Compared to their peers in the 60s and 70s they indicated a dire falling off of Andy's interest in publishing books. Books were too much work for too little money. In fact, in 1985 when Andrew Wylie, by now a powerful literary agent who owed a good deal of his success to what he had learned from Warhol, approached Andy with a proposal to get him a one million dollar advance for five books that were for the most part already written – *The Diaries*, his *Pork* (1971), the text of *The Chelsea Girls* and other factory documents – Warhol refused, somewhat bitterly, on those grounds. One could not help getting the impression, however, that the real reason behind Warhol's rejection of Wylie's super offer was the treatment Andy had received over thirty years from the publishing industry – from the editors to the reviewers – which had been, in a word, 'stupid'.

a, The Philosophy of Andy Warhol and *The Andy Warhol Diaries* are in my opinion the three great books that Andy Warhol wrote. (*The Diaries* successfully take you back to the 80s, as *The Philosophy* takes you to the 70s, and *a* takes you to the 60s.) They are 'the essential Warhol'. And we hope that in time some enterprising publisher like Penguin or Vintage will put out a portable Andy Warhol, doing what they have done for so many dead writers: by presenting a well-edited selection of his work with an instructive, informative, entertaining introduction, to make available to the reading public around the world a book that could place Warhol in an appropriate, well-earned context as among the most influential reporters of his times. Such a book would of course include extracts from a number of his 'voice portraits' in *Interview* magazine as well as from interviews he gave throughout his life. For more than any other writer of the period, Warhol made out of human prose a poetry as vital as Allen Ginsberg's, as tough as William Burroughs's and as delicate and passionate as the writings of Malcolm X. When I read the histories of the 60s and note with astonishment that the attempted assassination of 1968 (coming right between Martin Luther King and Robert Kennedy's assassinations) is ignored and his influence on film is ignored and his influence on journalism and literature is never mentioned (despite the fact that back in 1974 *Newsweek* noted that *Interview* magazine had given birth to *People*, among others, and Warhol has inspired at least one hundred books in the last thirty years), I begin to grasp what it means to say that Andy Warhol died of neglect.

Notes

1. Andy Warhol, *a (a novel)* (New York: Grove Press, 1968).
2. Edmond de Goncourt, *The Goncourt Journals, 1851–1870* (New York: Greenwood Press, 1968).
3. Samuel Pepys, *The Diary of Samuel Pepys* (New York: Crosup & Sterling, 1892). This citation describes the first publication fully transcribed from the shorthand manuscript in the Pepysian library. However, numerous other volumes of Pepys's diaries have been published at later dates.
4. Andy Warhol, *The Philosophy of Andy Warhol: From A to B and Back Again* (New York: Harcourt Brace Jovanovich, 1975).
5. Andy Warhol and Pat Hackett, *POPism: The Warhol '60s* (New York: Harper & Row, 1980).
6. *Andy Warhol's Exposures*, ed. Bob Colacello (New York: Andy Warhol Books/Grosset & Dunlap, 1979).
7. *The Andy Warhol Diaries*, ed. Pat Hackett (New York: Warner Books, 1989).

★★★★

Amy Taubin

To begin: a few paragraphs about the title of this piece.

The film whose spoken title is 'Four Stars' is designated on the page, or movie marquee, by a sequence of four identical graphic signs, either four stars or four asterisks. In 1967, when the film received its first and only screening, printing methods were less sophisticated than they are today. In those days, an asterisk was accepted as a substitute sign for a star. Thus, in a 1968 *Village Voice* column by Jonas Mekas, the film was referred to as ****. Two and a half decades later, in *The Andy Warhol Museum* catalogue, the title is printed as ★★★★ (*Four Stars*).

What's been lost in the transition to more flexible methods of printing is the ambiguity Warhol built into the title. On a movie marquee ★★★★ is a sign of excellence, but **** appearing within a printed text indicates 'expletive deleted'.

**** was shown publicly on 17–18 December 1967 at the Film-makers' Cinematheque on 42nd Street, a dank basement theatre devoted to avant-garde films in the Wurlitzer Building (as in Wurlitzer pianos and organs), one of the last remnants of class amid the sleaze that was Times Square (the pre-Disney Times

Square). In its 42nd Street incarnation, the nomadic Film-makers' Cinematheque was a perfect analogue to Warhol's Factory and may have inspired certain presentational aspects of the films Warhol showed there.

**** is 25 hours long, consisting of ninety-four uncut 33-minute reels shown two at a time, one image superimposed inside the other. This strategy of superimposing projections of unequal size so that one image appeared to be nestled inside another (or, perhaps, to be eating away at the guts of another) did not originate with Warhol but with Barbara Rubin, who projected her great film *Christmas on Earth* (1963) that way. Rubin continued to use the technique when she was 'image consultant' to Warhol's multimedia carnival 'The Exploding Plastic Inevitable'.

**** encompasses many of the exploitation films that Warhol made in 1967 (*Bike Boy*; *I, a Man*) as well as the eight-hour *Imitation of Christ* and a number of films that were never shown except as part of ****. Callie Angell, who is writing the *catalogue raisonné* of Warhol's films for the Andy Warhol Project, has located almost all the reels (each of which has its own title) as well as some of the detailed instructions Warhol wrote for the screening. Angell sees **** as both a summation of the films Warhol made during his sound period and a synthesis of Warhol's aesthetic (involving impossible durations and non-linearity) with Paul Morrissey's commercial drive (Morrissey being the force behind the exploitation films). In any event, it's unlikely that **** will be shown much before the millennium – it's been designated for the Andy Warhol Film Project's second round of preservation which is not scheduled to begin until 1997.

**** should not be confused with *Fuck*, made in 1968 and released briefly in 1969 as *Blue Movie*. *Blue Movie* is, in the language of 60s minimalism, a single-task film and is reported to have been partly inspired by Viva's insistence that Warhol witness the beauty of heterosexual intercourse. In fact, the sex act occupies only a few of *Blue Movie*'s 133 minutes, the rest being divided into foreplay (mostly a matter of verbal evasions in the face of the inevitable, including one conversation, shades of Godard, about the Vietnam War) and post-coital relaxation, which takes the form of cooking and eating dinner.

Blue Movie was the last film Warhol directed. In its single-mindedness, it harks back to the early silent films – *Kiss*, *Sleep*, *Eat*, *Haircut*. And its title, or at least its original title, *Fuck*, is precisely the expletive deleted and replaced by the asterisks of ****. But it's the polarity of **** that makes it so graphically satisfying as a title – it's at once a sign of the unspeakable and a stamp of approval (not to mention how it reiterates Warhol's preoccupation with the mystery of stardom). Under that sign, anything goes.

> I really do think movies should arouse you, should get you excited about people, should be prurient. Andy Warhol, 1970

In 1963, several years after I'd become a devotee of underground cinema, I saw a film that let me know what my late-adolescent obsession was all about. Unannounced and untitled, Andy Warhol's *Kiss* (then dubbed *The Andy Warhol Serial* because it was shown in weekly four-minute instalments) flickered on to the screen of the Grammercy Arts Theater on West 27th Street. Its black and white was as deep and impenetrable as archival nitrate, its motion slower than life. Framed in tight close-up, two faces lunged at each other, mouth on mouth, sucking, nuzzling,

merging, devouring. Some kisses were erotic, some comic, some verged on abstraction – less the oscillation of orifices than a play of light and shadow. Never in the history of the movies had the invitation to look but don't touch seemed quite so paradoxical.

During the months that followed, *Kiss* was succeeded by the meditative *Eat*, the tortuous *Sleep*, the cock-teasing *Blowjob*, the vaguely threatening, flagrantly gay *Haircut*, and the monumental *Empire*. Nothing if not the measure of their own time, they needed to be seen to be believed. Like the best of his painting (the *Disaster, Marilyn* and *Elvis* series), Warhol's silent films and some of the sound films that followed in 1965 and 1966 existed in the tension between presence and absence, assertion and denial. Fetishistic in the extreme, they allowed the receptive viewer access to the fundamentals of cinematic pleasure. Their surfaces opened onto the depths of your psyche.

Warhol's films were hardly *sui generis*. Their sources were both in Hollywood and the avant-garde. In the early 60s, Warhol had trolled the underground from 'pasty' drag shows to mini-malist dance/performances at the Judson Church. He had spent weeks at the Film-makers' Cooperative looking at films by Jack Smith, Ron Rice, Kenneth Anger, Stan Brakhage, Gregory Markopoulos, Willard Maas and Marie Menken. Sometime in there, although it's never been mentioned in the reams of diaries and reminiscences of the period, he must have seen *Rose Hobart*, Joseph Cornell's collage film which had been discovered and was being presented (with significant alterations) by Ken Jacobs and Jack Smith. It's almost all there in *Rose Hobart*: the paring down of a mass-culture object to its fantasy essence (Cornell extracted from a print of the 30s B-picture *East of Borneo* all the shots in which the actress Rose Hobart appears and edit-ed them together); the fetishisation of the female star; the single-minded title; the phantasmal effect that results when film shot at sound speed (24 frames per second) is projected at the slightly slower speed of silence (16 fps).

More generally, Warhol learned from the avant-garde how to produce a (per)version of Hollywood in his own studio for little more than the cost of a roll of 16mm film and developing. In 1964 I was introduced to Warhol's Factory (then on East 47th Street) by the rapidly fading early superstar Naomi Levine. Like all newcomers to the factory, I was screen-tested: I was escorted into a makeshift cubicle and positioned on a stool; Warhol looked through the lens, adjusted the framing, instructed me to sit still and try not to blink, turned on the camera and walked away. My screen-test was included in one or another version of *The Thirteen Most Beautiful Women*. Later that day I was drafted into the ongoing 'Banana' series, which was at some point incorporated into *Couch*. (Contrary to early published descriptions, *Couch* is not totally porno-graphic. I sat on a couch with superstars Levine, Baby Jane Holzer and Gerard Malanga, and for $2\frac{1}{2}$ minutes each of us masticated her/his own banana.) I was fascinated by Warhol's work process but otherwise found the scene as unpleasant as high school – people with outlandish expectations all competing for a piece of the master. Although I only made one or two more vis-its to the Factory, I followed the films religiously through *The Chelsea Girls* and was a regular at 'The Exploding Plastic Inevitable' when it took up residence in the Dom on St Marks Place.

In 1972 Warhol withdrew his films from distribution, leaving available only the Paul Morrissey-directed 'Andy Warhol Productions'. The reasons (directly and obliquely stated at various times by various people, including Warhol himself) reveal the typical, perhaps irreconcilable

Warholian oppositions between aesthetic and economic value, high and mass culture. There was the art market notion that the films would gain in value from their unavailability. There was the Hollywood industry notion that the films depressed Warhol's potential value as a commercial film director. Hollywood types, it seemed, were incapable of the kind of selective vision practised by the art world, which managed to ignore the films entirely, although during the period of his greatest work (1961 to 1968) Warhol devoted as much time to film as he did to painting. Left to moulder in the Factory and various laboratories, the films became merely an absence, a campy con-job, until, in 1982, John Hanhardt, film and video curator of the Whitney Museum, convinced Warhol to turn all the existing materials over to the Whitney and the Museum of Modern Art so they could be catalogued, preserved, and re-released.

To date, twenty-five films have been reissued; most of them are now available for non-theatrical distribution through the Museum of Modern Art. (Theatrical exhibition and electronic media licensing is handled by the Andy Warhol Foundation, which owns the films.) In the past six years, there have been four major exhibitions of Warhol films in New York: two at the Whitney Museum (in 1988 and 1994), one at the Museum of Modern Art (in 1989 as part of a major Warhol retrospective) and one at the Film Forum in the winter of 1995. The confusion, defensiveness and outright hostility exhibited by most museum-goers toward the films are no less marked today than when they first appeared three decades ago. At the 1994 Whitney screenings, reverential silences quickly gave way to outraged heckling and noisy walkouts. Who knows what these viewers expected – the ones who expressly came to see a film by the notorious Andy Warhol, or the casual drop-ins making a brief stop on their way down from the main attraction, the Richard Avedon retrospective which, coincidentally, included Avedon's 1969 photo of Warhol's scarred torso and a huge mural of Factory superstars, among them the transvestite Candy Darling with cascading platinum hair and penis in full view. Whatever it was they were looking for, it certainly wasn't this: a pudgy-faced man in a rumpled, buttoned-to-the-neck white shirt, self-consciously facing down the camera for 99 minutes (*Henry Geldzahler*); superstar Edie Sedgwick filmed for 33 minutes with a lens so severely out-of-focus that one could barely distinguish the outlines of her lace bikini panties and bra (*Poor Little Rich Girl*); eight hours of the Empire State Building framed from a single camera position (*Empire*).

When asked in 1987, during the last interview of his life, if he was excited about his upcoming film exhibition at the Whitney, Warhol responded in the negative. 'They're better talked about than seen,' he said. It's terribly sad to think that Warhol had lost faith in the films as films, that he was unaware that the intervention he had made, specifically through the films, in the society of the spectacle was as profound as what Godard had done in roughly the same extended 60s moment. But if Godard framed his psychosexual obsessions within a political analysis of global economic power, Warhol, the American anti-intellectual, transformed his psychosexual identity into a world view.

What Warhol threw up on the screen was basically a single shot removed from the editing language that facilitates narrative in the movies. It's the absence of narrative that's so off-putting to viewers conditioned by Hollywood cinema. Warhol's cinema frames time as it passes. (The films, thus, invert the strategy of the silkscreen *Disaster* series, in which time, stopped dead, is framed over and over again.) Warhol described his early 60s silent films in terms of their extraordinary duration: *Sleep*, an eight-hour film of a man sleeping (which actually turned out to be

only 5 hours and 21 minutes at 16 fps); *Empire*, an eight-hour film of the Empire State Building. The minimalists were making very large paintings and sculptures; Warhol made very long films.

It would be a mistake to think, however, that Warhol was interested in real time. 'My time is not your time' is the message of the silent films, which basically begin with *Sleep* (1963) and end with *Henry Geldzahler* (1964). Shot at sound speed and projected at silent speed (slowed by a third), the films unwind at a pace that's out of sync with the rhythms of the viewer. This disjunction – between the body clock of the person *as image* and the body clock of person watching – heightens the viewer's sense of alienation from the image. It makes one aware of the image as 'other' and therefore unknowable. Hollywood codes of realism elide the gap between seeing and knowing. Warhol's films reinforce it.

'My time is not your time' is also the message of the double-screen talkies, of which the best known is *The Chelsea Girls* (1966). Prior to making *The Chelsea Girls*, however, Warhol had begun to show most of the talkies from 1964 and 1965 (the Ronald Tavel-scripted films, the Edie Sedgwick films) as double-screen projections. Thirty-three minute reels that had been filmed sequentially (using a single-system sync-sound Auricon camera) and, indeed, in 'real time' were shown simultaneously. By splitting the attention of the viewer between two shots, real time is effectively cancelled. Warhol's double projection experiments culminated in the aforementioned ****.

Most Warhol films open in stillness. Initially, one feels as disoriented by the image as when unexpectedly catching sight of one's reflection in a mirror on the street. The image seems both incomprehensible and strangely familiar, distanced and confrontational. Certain areas are too dark to be read (notably in *Haircut*, *Vinyl* or *Beauty #2*); when a part of the body is framed in close-up, it's difficult to make out exactly what we're looking at (as in *Sleep* or *Lupe*). What's most disconcerting, however, is the marked frontality of the image, our sense that the performers, though operating in some radically different time zone, are directing their attention not at us, but at least towards us, or rather towards something that once occupied a place isomorphic with the place in which we are seated. In other words, the camera.

All Warhol films celebrate the presence of the camera. The great Warhol 'superstars' – Mario Montez, Fred Herko, Edie Sedgwick, Nico, Viva – never concealed their awareness of the camera and often played directly to it, thus undermining a fundamental rule of Hollywood realism. The intensity of their relation to the camera – their unmistakable libidinal investment in the image they project for it – mirrors the viewer's libidinal investment in the image on the screen. In *Stargazer* (published in 1973 and still the most illuminating book on Warhol's films), Stephen Koch analyses the profoundly narcissistic dynamics of Warhol's art:

> So narcissism means dividing the self to obviate the threat of needing others. All its energy, all its eros, all its sweetness, all its rage are directed toward this repressive end, which is almost never recognized as repression, because it is a repression that takes the form of desire. ... It is desire as frustration.

> The narcissist yearns for wholeness because he feels himself divided, and his self-division finds its very image as he stands before the mirror. His divided autonomy is preferred to

a wholeness of self. Yet that wholeness – obscurely intuited, loved as another is loved, mysteriously immanent in the mirror – is also his most dire image of self-obliteration. That is his dilemma.[1]

'I'll be your mirror', sang the Velvet Underground and Nico in 1965, a decade before the Lacanian take-over of film theory. Warhol's camera was the mirror of the Warhol scene, but the scene also reflected on him. The scene was as much Warhol's product as were the films it inspired. 'Knock and announce yourself' read the sign on the door of the 47th Street Factory. People came to score sex, drugs, fame. There was a core group of assistants, art world power brokers, collectors, current and aspiring superstars. And then there were all these others coming and going – Pop and underground celebrities, socialites, poets, photographers, models, drug dealers, hustlers, transvestites, beautiful girls and boys. The primary sexual orientation was gay: the drug of choice was speed. Some came to see the freaks, others to freak out. But primarily they came because the camera was always running. The camera inspired 'acting out'.

Warhol presided over this alternative family like an inaccessible, inverse father figure; a father who in gesture and voice, as Victor Bockris notes in *The Life and Death of Andy Warhol*,[2] was the incarnation of his childhood idol, the eight-year-old Shirley Temple; a father who licensed behaviours that were taboo, even to the imagination, in the conservative, working-class, Catholic immigrant family of his 'real' childhood; a father, who, despite his seeming passivity, was all-powerful. Warhol was the sole arbiter of whose concepts or scenarios were made into movies, of who became a star and who languished in the shadows. He almost never said no, but, given the numbers of people clamouring for attention, he seldom said yes. For those vying for his favour, the scene was a perpetual audition. Most took out their frustration on one another, until Valerie Solanas, who couldn't get Warhol to commit to her screenplay, pumped the master himself full of lead. Warhol didn't die but the scene did. He had exhausted it anyway. What came next was by invitation only.

In Koch's terms, Warhol became a star by being a 'stargazer', which is not precisely the same as being an auteur, although the 60s infatuation with auteurism contributed to Warhol's conflating of the artist with the film director. (It wasn't until the 70s that he replaced both models with that of the producer. 'After I did the thing called "art" or whatever it's called, I went into business art.')

It's an oft-remarked upon paradox that the most recognisable image Warhol produced was his own, that the star power of the shy voyeur eclipsed that of the under- and above-ground celebrities who were the ostensible subjects of his work. Appropriately, the first image one sees upon entering The Andy Warhol Museum in Pittsburgh is of Warhol himself. It's one of the death's head-like 1986 self-portraits: hair standing on end in petrified spikes, skull bones outlined through thin skin that glows as if radioactive, gaze frozen in bewildered horror before what it sees – which is nothing more or less than its own reflection in the lens of the camera. One thinks, of course, of Cocteau: 'The camera shows death at work.' But one is also struck by the historic specificity of the image; it's the face of someone trapped between Hiroshima and the age of AIDS, someone for whom death has the luminescence of the television screen.

Awesome in their emptiness, the late self-portraits are less evocative than occasional snapshots

taken of, but not by, Warhol during the Factory film years. Peering though the view finder of his 16mm camera or sitting next to the projector during a screening, Warhol's face has the absorbed, disassociated look of a child sitting in front of a television set or a hacker contemplating the computer screen. 'The charm of the child lies to a great extent in his narcissism, his self-content and inaccessibility,' wrote Freud. 'Indeed, even the great criminals and humorists, as they are represented in literature, compel our interest by the narcissistic consistency with which they manage to keep away from their ego anything that would diminish it.' How better to contain the danger imminent in the Factory scene than to make it into an image – a virtual world, exciting but never threatening. Once the camera rolled, Warhol never intervened in the action taking place before it. He merely watched through the view finder, responding with an occasional zoom, tilt or pan. One imagines that if Warhol, for whom the telephone was a lifeline, were alive today, he'd be trolling the Internet, enthralled with other people having virtual sex, absorbing on-line conferences about global horrors.

'In Warhol's view,' writes Callie Angell in her authoritative essay for The Andy Warhol Museum catalogue, 'television and his movies were "just one big thing – a lot of pictures of cigarettes, cops, cowboys, kids, war, all cutting in and out of each other without stopping." Eventually, once the preservation of the Warhol film and video collection has been completed, it will be possible to consider Warhol's films and videotapes together as a single prodigious body of work, the result of three decades of non-stop effort in which the artist seemed to be laboring to create his own version of the omnipresent media culture.'

Unquestionably, the films *are* part of a project that's bigger – and longer – than any of them but, viewed individually, they prove singularly resistant to such assimilation. There's something archaic about films such as *Haircut*, or *Beauty #2*, or *Henry Geldzahler*. They reference a world before television when the body, fetishised in celluloid, was projected larger than life. They're a response to Hollywood films Warhol grew up on, the films that were available to every American, just like Campbell Soup. They're a campy send-up and furious attack on the Hollywood myth of sexual normality – that men are men and women are women, that sexual identity is naturally determined by genitalia, that men desire women (and act on their desires) and that women desire only to be desired by men (and therefore are allowed certain artifices to make their femininity more alluring and thus give men more pleasure).

Warhol's films, from *Sleep* through *The Chelsea Girls* (excluding the sexploitation films that begin with *My Hustler* and continue in collaboration with Paul Morrissey), are made from a deeply transvestite position, from the position of the boy who identified with Shirley Temple. Warhol understood that the distinction between identification and desire is not as clean-cut as Hollywood tried to pretend. He took Hollywood's great subject – sexual identity – and destabilised it, turning it inside out and every which way. In Warhol's films, sexual identity is never naturalised. Constructed as masquerade, it's an imperfect shield for a terrible anxiety about sexual difference. The Warhol superstars are either drag queens (Mario Montez, Fred Herko, Candy Darling) or women who exaggerate their femininity out of the fear of being mistaken for boys (Edie Sedgwick, Viva) or studs (Gerard Malanga, Joe Dalessandro) whose obsessive focus on their own groins suggests some secret suspicion that things might not be in order.

For all its seeming passivity, Warhol's camera is a weapon. Before its impassive gaze, the sexual

masquerade eventually crumbled, revealing raw narcissistic wounds and pathological insecurities as great as Warhol's own (and that seemed even greater when magnified by the projector). No one – not the most beautiful women nor the most beautiful boys, not the rich nor the famous – was immune to the fear that the camera would find something wrong. The would-be superstars flocked to the factory to have their narcissistic investment in their own sexuality confirmed; the camera left them in shreds. One can remember no more than a dozen moments in all those hours of film in which the performers are *not* in an agony of self-consciousness though desperately pretending otherwise: John Giorno cat-napping while the camera rolled in *Sleep*; Billy Linich and Fred Herko, co-conspirators in the castration metaphor implicit in *Haircut #1*, turning to the camera and laughing at the audience for being taken in; Viva cooking dinner in *Blue Movie*, totally relaxed once her ordeal of actually fucking on camera is over.

The only subject to remain totally impervious to Warhol's camera was the Empire State Building. The most infamously conceptual of the films, *Empire* is actually one of the most visually subtle and richly reflexive. The longer one watches the stronger one's desire to witness some structural collapse, some disturbance of that phallic monumentally. 'The Empire State Building is a star', said Warhol, mocking the model to which no man can measure up.

Certainly not Henry Geldzahler. The morning after he shot *Empire*, Warhol used the rented camera and two left-over 1200-foot magazines to shoot a silent, 99-minute portrait of the then-curator of contemporary art at the Metropolitan Museum who was also his personal friend and a power broker for his art world career. Like *Empire*, *Henry Geldzahler* is a silent, single-shot film. Geldzahler is positioned in medium shot at one end of a curving velvet couch facing the camera. Warhol turned on the camera and left the room, returning once to reload the camera and then departing again.

Left to his own devices, Geldzahler begins by nonchalantly staring down the camera. He's armed himself with sunglasses and large cigar which on this occasion is not 'just a cigar'. Geldzahler is one of the few intellectuals to appear before Warhol's camera and he makes sure we know that he means to out-smart it. For the first twenty minutes or so, it seems as if he is pondering the entire history of modernist portraiture and the place of the motion picture within it. But no sooner does one impose this narrative on the film than one begins to question the basis for one's assumption. Is it something in the way he flicks his cigar or tilts his head? Or is this imagined narrative suggested by what one knows about Geldzahler in the real world rather than what one perceives in the image. It's possible that modernist aesthetics are nowhere in his mind. And yet ...

Geldzahler passes his hand across his brow. Unlike his earlier magisterial gestures, this one is involuntary. It takes him by surprise. It upsets him. He carefully rearranges himself, takes off his glasses, puts them back on, as if to show that he's in control of the image he's presenting. But the involuntary gestures keep coming. There's something swish about them. And Spanish as well. Has Geldzahler been inhabited by Mario Montez, the Factory's reigning drag queen?

In any event, he's beginning to look unnerved. He sinks into the couch, he feigns sleep, he twitches, he sweats, and then, he just seems to give up. He disengages from the power struggle with the camera and sits slumped over, an expression of total boredom on his face. The boredom

is contagious. But how can that be? How can one feel empathy with an image that's so distant, so locked within its own time – 1964, flickering on the screen eight frames slower than life?

Geldzahler starts moving around on the couch, more anxious than ever. He stubs out the last of the cigar. His hands go to his face, they reach down below the frame. And then suddenly his arms fly up, he clasps his hands behind his head, he straightens his neck – and finds himself as Goya's *Nude Maya*. How improbable that this balding, pale-faced, slack-bodied man could fantasise himself as an odalisque. But whether the *Nude Maya* is in Geldzahler's head, or merely in the mind of his beholder, the brief moment of triumph fades. Geldzahler scrunches down into the couch, curled in a foetal position, his hand over his face. A few minutes later, the film is over.

The antithesis of cinéma vérité, *Henry Geldzahler* demonstrates the power of the camera to transform its subject, to instigate a narcissistic splitting in which the self becomes totally invested in its own image, an image which is both excessive and never enough. Warhol pursued this line of attack in the sound portraits of Edie Sedgwick (*Poor Little Rich Girl* and *Beauty #2*) and in *Paul Swan*, a portrait of an eighty-year-old former Isadora Duncan dancer who continued to perform the 'aesthetic' dances he'd choreographed at the turn of the century, long after his limbs turned arthritic and his flesh spread through every gap in his costumes. Warhol filmed Swan's performance on a tiny stage draped with torn tapestry and illuminated by four hardware-store floodlights. As Swan plods through his atrophied routines, one imagines Warhol, peering through the lens at his possible future, especially when Swan reveals a shoe fetish that Drella (Warhol's nickname at the factory, a combo of Dracula and Cinderella) could relate to. At one point Swan leaves the stage to poke about for twenty minutes in the wings, looking for a missing shoe without which he can't continue.

If Swan seems painfully (or perhaps blissfully) unaware that the film unfolding in his head has nothing to do with the film Warhol is shooting ('You'll cut all this out anyway, won't you?' he queries, when an on-stage costume change proves awkward), Sedgwick, in *Beauty #2*, drunk and stoned though she is, realises she's being set up and fights back. Seated on her bed, clad in a black lace bra and bikini pants, she's being pulled in three directions at once. To her left on the bed is Gino, a dumb hustler type who she's ostensibly brought home for a quick fuck. Facing her, but off-screen, is an intimate friend, Chuck Wein, who keeps needling her about her looks, her voice, her mannerisms, her self-involvement, and the little problem that she can't bear to face – that she might be pregnant (in 1965 abortion was illegal). And to her right is Warhol's envious camera, waiting for her to break. The camera is placed so that the tiny strip of Sedgwick's bikini is dead centre in the frame. Twisting nervously on the bed, Sedgwick keeps thighs pressed together as she shifts her legs from left to right and back again. As the film wears on, one realises that its objective is to destroy the upper-class social poise which is her only source of power and the only protection for her fragile sexual identity. Only if she loses herself completely will she spread her legs. It's this sign of defeat that the camera waits to capture. It never comes.

These extended portraits are among the most extraordinary films in the history of cinema. Warhol discovered that the camera could tear people apart (and the destruction could be accelerated by tongues applied like knives). Not a pretty picture, but then, none of Warhol's portraits, no matter what their medium, could be called pretty. Unspeakable and highly acclaimed

– in other words, **** – is more to the point.

Notes

1. Stephen Koch, *Stargazer* (New York: Marion Boyars, 1973).
2. Victor Bockris, *The Life and Death of Andy Warhol* (New York: Bantam Books, 1989).

Warhol as dandy and flâneur

Patrizia Lombardo

A long time after the explosion of Pop Art, beyond the question if Warhol was or was not a Pop artist, more than twenty-five years after Stephen Koch's definition of Warhol as 'the last dandy', in his April 1969 article in *The New Republic*, my title suggests that the modern becomes classic, in the same way that the most avant-garde work can become part of a museum's permanent exhibition: Pop Art goes classic. This irredeemable ambivalence inhabits the new at least since Baudelaire's attempt to define the endeavour of modern art. The immediate reference of the words 'dandy' and 'flâneur' is in fact Baudelairean, and my own Warhol-Baudelaire flânerie is justified because of some persistent aesthetical concerns since the second half of the 19th century – and because of some French allusion in Warhol, who, playing on the title of Proust's novel, humorously called one of his early books: *A la Recherche du Shoe Perdu* (1955). The themes that link Baudelaire and Warhol are the classical themes of modernism and mass-media production, which critics (Paul Valéry, Bertolt Brecht, Walter Benjamin, etc.) have explored in order to read the art of modernity.

Any theory of modern art must stress the importance of technique; the role of fashion; the necessity for the artist to be part of

society, of the masses – to be like all the others – together with the parallel necessity to be different from the others; the need to capture the rhythm of the world in order to produce the art capable of responding to present life. But, within those obsessive modernist themes, my association of Warhol and Baudelaire also implies a critical construction which adopts Warhol's silk-screen technique. Discussing Warhol as dandy and flâneur, I want to make a 'silk-screen article' which chemically precipitates the network of theoretical and aesthetical affiliations between Baudelaire and Warhol, juxtaposing, crystallising and repeating quotations or motives from both artists. I am therefore trying to find the critical equivalent of Warhol's method in painting.

Repetition is obviously central in Warhol's work. My article aims to be visual, leaving aside a linear historical narrative, even if it will deal with questions of time: for isn't listening to a talk or reading an article some sort of stroll among various pieces, in the way in which we stroll in a museum where our gaze meets paintings and written pieces, walls and windows open onto the city, as in Pittsburgh, in The Andy Warhol Museum? There, my eyes, your eyes, go from Warhol's silk screens, to the pictures of him with his friends, to the buildings and streets of Pittsburgh's North Side: Manhattan, Andy, the Factory on 47th Street, the Museum, Iron City, Baudelaire, Paris, LA, Pop Art, the 60s, the 19th century, the American dream.

The Flâneur

The flâneur and the dandy, who are crucial figures in Baudelaire's poetics, are not exactly the same thing, although they both belong to modernity. The flâneur is insatiable and passionate, capable, like a child, of having a devouring desire for the world, an infinite taste for observation, an endless curiosity. In his famous 1863 essay *Le Peintre de la vie moderne* (*The Painter of Modern Life*), Baudelaire identified as the perfect flâneur the painter Constantin Guys, whose passion for the external world knew no limits: 'The crowd is his world, as air the bird's, and water the fish's. His passion and profession is to *marry the crowd*.'[1] In *The Philosophy of Andy Warhol: From A to B and Back Again* this city fever returns: 'I have a social disease. I have to go out every night, it's so exciting.' This excitement Warhol talks about seems to be the twentieth-century prolongation of the intoxication with the metropolis that characterises Baudelaire's poetic work as well as his art criticism, each entirely haunted by the idea of modernity. In *The Painter of Modern Life*, Constantin Guys' sketches are described as capturing the modern, the Parisian streets' hustle and bustle, the enticement of night-life, of horse-races at Longchamp, of theatres and public ceremonies. Constantin Guys is, according to Baudelaire, not an artist in the narrow sense of the word, which is to say somebody withdrawn in his own vocation, but a *homme du monde* (a man of the world), open to any type of experience, any form of life. For such an individual, nothing could be more thrilling than the urban night:

> But here comes the evening. It is the odd and disquieting hour when the sky's curtains shut, when cities light up. Gas lighting spots the sunset with purple. All human beings – honest or dishonest, wise or foolish – are telling themselves: 'This days is ended, at last!' The good and the evil think of pleasure, and they all hasten their steps to what they have chosen as the place where to drink the cup of forgetfulness. M. G. will be the last one everywhere, everywhere the light is still bright, and everything sounds poetic, in every place swarming with life, vibrating with music. M. G. is everywhere, passion can become a model for his eye, and the natural as well as the conventional human kind appear with an odd beauty, everywhere the sun shines on the quick joy of the depraved animal![2]

Those who want to capture modernity know the attraction of 'gay' city-life – from Paris, capital of the 19th century to the glamour of New York in the 60s, to the visual orgies of Los Angeles, future capital of the 21st century. The silk-screen technique repeating Baudelaire and Warhol relies on repeated flâneries in big cities.

We learned from Victor Bockris that Warhol's book *America* was involved in what he called 'a problematic editorial adventure'. But it is about America and being American; it is a book that in some way fulfils the most surrealist dream, the one of André Breton who wrote a novel in the first person, *Nadja*, where the written text is interrupted by several photographs. The juxtaposition of pictures and text in *America* gives us the pleasure of being a flâneur in New York: 'I don't think that there is any place in the world like New York City as far as city life goes. Here you can see every class, every race, every sex and every kind of fashion bumping up against each other. Everyone gets to mix and mingle and you can never guess what combinations you are going to see next.'[3] This quote describes the flâneur's metropolitan obsession: the big city is the domain of the gaze. It is also an immense happening, a non-stop happening, an uncontrolled series of events in which different images come together, jam together, break up, vanish from sight.

The city is a continuous artificial vitality, continuously offered to the eyes, and yet intangible. 'I do not want to touch things', Andy said in *The Philosophy of Andy Warhol*. The eyes devour, ingest images, are overwhelmed by images, while trying to keep track of all of them: the nineteenth-century metropolis of Constantin Guys continues in the contemporary media world. Warhol suggested: 'I'm the type who'd be happy not doing anything as long as I was sure I knew exactly what was happening at the places I wasn't going to. I'm the type who'd like to sit home and watch every party I'm invited to on a monitor in my bedroom.'[4]

In the metropolis of the 20th or 21st century, even people or celebrities do not exist in the flesh. They are just optical effects. Los Angeles shines with the brightest colours of artifice: 'The last time I was in Los Angeles, when I walked down the street it was like I was invisible, nobody recognized me. But in the car, people would honk, and wave, and blow kisses and even pull over and ask for autographs, because they were only used to seeing celebrities on the road and never in the flesh.'[5] The almost bodiless aspect of the images is what ties modernist and post-modernist themes. The conditions of human perception and their effects in relationships among people, perfectly identified by Baudelaire around 1860, and elaborated by Benjamin's reading of Baudelaire, are accelerated and intensified by contemporary media. It is a question of degree, not of quality: the possibility of what is taking place in our society was anticipated by the nineteenth-century flâneur who is the artist confronted by consumer society on its first spectacular appearance in Second Empire Paris's apparatus of urban leisure.

The Dandy

When the insatiable curiosity for external life surrenders to the abstract power of images, the unexpected character of what Warhol called 'the combinations you are going to see next' is congealed, and a blasé attitude seems to overtake the flâneur's excitement. The dandy is, according to Baudelaire, somebody whose profession is that of being, or pretending to be, *insensitive*, without passion. A true aristocrat of the mind – the dandy is cool, and his coolness is a religion.[6]

The crucial point is that, notwithstanding Baudelaire's temperamental distinction between flâneur and dandy, the theory of modern art and modern life needs both figures at the same time, however different they might initially appear. Together, they conceptualise the constitutive tension of modernity, the interplay between love and scorn for the crowd, or, in other words, between mass and élite culture, between a movement of revolt and its framing within the very system it wants to denounce. The dandy and the flâneur are two halves of the modern artist – and what probably makes Andy Warhol exemplary is that his artistic behaviour is equally made up by both attitudes.

The Baudelairean dandy is extremely careful about his clothing, pushed by 'a burning need to construct his own originality', by 'the pleasure of surprising the others and the proud satisfaction of never being surprised'.[7] Obviously Warhol continues that dandy tradition. David Bourdon remembered: 'I knew Andy had to be somebody special. He was spiffily dressed in a close-fitting suit with a loud red paisley lining. . . . His metamorphosis into a pop persona was calculated and deliberate. The foppery was left behind as he gradually evolved from a sophisticate, who held subscription tickets to the Metropolitan Opera, into a sort of gum-chewing, seemingly naive teeny-bopper, addicted to the lowest forms of pop-culture.'[8]

Being or pretending to be insensitive or cynical is certainly a large part of Warhol's game in many things he has written or said in interviews. In a famous 1964 radio discussion between Lichtenstein, Oldenburg and Warhol, Andy performed like a perfect dandy. His interventions came seldom and were extremely short, while Oldenburg and Lichtenstein talked a lot: they saw impersonality as the sign of Pop Art's rejection of the previous generation's artists who were highly subjective. Oldenburg commented on Warhol's Brillo boxes as a new form of still life that had been passed through the media. Those commercial objects were examples of 'an urban art which does not sentimentalize the urban image but uses it as it's found'. This strong focus on the object seemed to them characteristic of Pop. As a passionate artist driven to capture the secret of Pop, Lichtenstein was eager to find definitions: 'Pop differs from Cubism and Abstract Expressionism because it does not symbolize what the subject matter is about. It does not symbolize its concern with form but rather leaves the subject matter raw.'[9] The discussion got more and more animated about the problem of the audience and the possibility of an art that would appeal to everybody, and at the end Oldenburg directly asked Warhol about his paintings with the police dogs or the electric chairs. Oldenburg was emphatic and insistent about the lack of any political dimension to Warhol's coolness: 'When you repeat a race riot, I am not sure you have done a race riot. I do not see it as a political statement but rather as an expression of indifference to your subject.' Warhol's answer is cool: 'It is indifference.'

Andy's dandyism irritated critics: in an article commenting on Marcel Duchamp's and Pop artists' exhibitions at Pasadena Art Museum, Ferus Gallery and Dwan Gallery in Los Angeles, Gerald Nordland found Warhol's *Elvis Presley* series completely uncommitted and without emotion, 'stripped of Duchamp's scandalous flair'.[10] Nordland perceived the same lack of emotion in the spectator's unfeeling reaction: 'Mass media have so dulled our sensibilities that we can accept two rooms filled with 8 foot repeated portraits of Elvis as Cowpoke without blinking.'[11]

An American Artist
In 1987, Thomas Crow problematised the stereotype of Warhol's lack of emotion. He wrote that

the public Warhol consisted of three persons, the first one being the self-created one; the second all the 'passions that are actually figured in paint on canvas'; the third 'the persona that has sanctioned a wide range of experiments in non-élite culture far beyond the world of art'.[12] I would argue that the separation Thomas Crow saw within Warhol is the result of the interplay between the dandy and the flâneur, between the impersonal and the emotional. The man who in 1963 launched the famous programme of impassivity, saying that he wanted to be like a machine, is also the artist whose *Gold Marilyn Monroe* (1962) or *Saturday Disaster* (1964) emotionally respond to death and violence in American life in a way which is incompatible with Warhol's construction of an image of his art and person as passive and blasé towards commodities, and towards the image and the person themselves as commodity. Thomas Crow stressed the vision of Warhol's early production as a 'complex of interests, sentiments, skills, ambitions and passions' exactly against the most common readings of it as representing the utter impersonality of commercial culture.

Critics, as much as artists, are taken into what I call the complicity and tension between the dandy and the flâneur: they either confuse them or try to solve the contradiction in favour of one attitude or the other. Nevertheless the difference between the flâneur and the dandy is not a problem of character, even if the temperament of artists and their formal-ideological choices are important (that's why, in nineteenth-century terms, Constantin Guys is different from Delacroix, or, in twentieth-century terms, Warhol is different from de Kooning and also from Lichtenstein).

The fundamental difference between the attitudes of the dandy and the flâneur concerns time. We cannot avoid thinking of time since when we are in The Andy Warhol Museum, we are presented with dates. How could we forget time? We see in the pictures of Warhol's New York life the fashion of the 60s and 70s, and we know how much he worked for fashion. We can have a whole period of time running quickly in front of our eyes, just by going through the fashion magazines held in Warhol's library. It is time past, two or three decades concentrated in photographs and, according to our age, we recognise and do not recognise ourselves or pieces of our history in the images; we see how we looked in those years, how we dressed and felt, we identify people, we know that pieces of history and of our lives have gone by.

The flâneur attitude corresponds to the emotion and the surprise of anything that happens in life, in modern life, in the quick, ephemeral moment, in that little bit of distance that inevitably arises whenever a blink of reflection sanctions the existence of an event, however minor it is. One the other hand, the dandy is the one who has already stocked in his brain the quantity of events that could take place in the variety of modern life. Nothing is surprising for the dandy because everything has already happened before it happens: the kernel of repetition orients perception.

The point is not to decide if Warhol's work is subversive of commodity culture either actively, thanks to the violence of a critical apprehension of it, or passively, through the endless reflection of its infinite repetitiveness. Nor is the point to establish if Warhol is fully, consciously and cynically exploiting the very culture he both embraces and opposes. The tension between the dandy and the flâneur shows that the condition of modern art is schizophrenic, constitutionally divided so that no individual talent can counteract the discrepancies that inhabit it. The critic

re-enacts the division inherent in art by focusing on the gap between what Warhol painted and what he wrote. The critic emerges in the gap between art criticism that develops at the very moment a certain type of work is produced and art criticism that looks back to both the art and the art criticism of at least two decades ago. The effect of time does not spare our thoughts, our life, our critical reflection.

An inevitable archaeology of knowledge is at work whenever we examine the past, and Thomas Crow is right in trying to recapture what has obviously disappeared today, the feeling in those early paintings that Warhol was still moved by Marilyn Monroe's suicide and by the presence of death in everyday American life, as well as the feelings of those who saw those paintings in the years they were produced. I would say that those polymer and silk-screen canvases, still glimmering with the inventiveness of a new technique, echoed the surprise of an event seized almost in the very moment it happens. That emotion was there before Warhol's attempt to disclaim emotion when he was interviewed in the 60s, and before the academic debate on modern art in which we write the history of Warhol in the 60s. In the same way, the short history of photography written by Walter Benjamin in 1931 distinguishes between the first scandalous impact of photography and the subsequent indifference toward a technique that became a habit. The blasé attitude cannot but grow on the foundation of a deep emotion. Warhol's early silk screens are the work of a passionate American Constantin Guys, whatever the dandy Warhol could say about himself. But in order to capture the rhythm of repetition, the heart of the dandy must beat within the flâneur's.

In other words, through the interplay of the dandy and the flâneur, I mean that the opposition between high culture and popular culture is not as clear as one might like to believe in the mass media society that started in the metropolitan life of the 19th century, to continue in today's commodity world. If Warhol's work is so interesting, beyond the 60s explosion of Pop Art and Duchamp's ready-made objects, it is because both his created persona and his painting bear witness to the divided history of modern art.

Clouds

An important theme in *The Painter of Modern Life* is that beauty is composed by two elements: the ephemeral and the eternal. Baudelaire insisted, against his contemporaries, on the quality of the ephemeral, even if one can never really know how to distinguish the ephemeral from the eternal. But it is sure that they both belong to a reflection on time.

Baudelaire ended his poem 'Le Voyage' with the haunting search for the new, the spell charming the traveller to death. In Warhol's terms a passion for what is ephemeral takes the form of an incessant attraction to the Now:

> There is no country in the world that loves 'right now' like America does. I guess so many things are happening today that we are too busy to do anything but look, talk and think about all of it. We do not have time to remember the past, and we do not have the energy to imagine the future; we are so busy, we can only think: Now! . . . The real news, the big thing, whether it's in the magazines or in the newspapers or on TV, is the Now.[13]

In her paper, Amy Taubin mentions with sorrow that the *Mao* painting is decontextualised and

has lost its political energy now that it is housed in a museum. But in some way, all artistic objects are condemned to the double temporality of the context in which they were produced and the more or less strong decontextualisation of their existence through time. But, although decontextualised, they still harbour a continual need to retain the effort addressed at the time the artwork was created: the imperative of art criticism is to recapture that spark of the now.

The tension between context and decontextualisation, between the ephemeral and the eternal, is the double bind tearing apart the artist, the artistic object and the reception of art. Warhol's show of indifference contradicts the awareness that many of his works are filled with the emotion Thomas Crow talked about. But how can we look at the *Electric Chair* without being overwhelmed by emotion? How can we have the distance of the dandy? Dandy and flâneur fuse in the artist, dandy and flâneur fuse in the spectator. The timing of the event is double; double that of the artistic object; double that of the artistic perception. We realise that we are confronted simultaneously with a piercing image, the aesthetic of mass consumer production, and also with some inevitable nostalgia for the past. When I look at the Brillo boxes, or the Coke bottles, or the Campbell's Soup cans repeated over and over again, I cannot help but think this is somehow the prehistory of mass-production. This was almost thirty years ago, in the 50s and in the 60s, the dream of grasping the Now, the novelty that was going on at a very specific moment.

Who was Andy Warhol? Was he indifferent, passionate, an artist, a business man? I would like to go back to Victor Bockris's beautiful paper. He gave us the usual quotations showing Andy's obsession with money; but he added that, if Andy cared to, he could have made much more money. Money was not the problem, Andy was looking for something else. He was vulnerable as well as strong, cool as well as shy, dandy and flâneur.

The most Baudelairean note to be found in Warhol is a poetic one. I think of his silver clouds – those beautiful clouds we can play with, like children. We walk among those clouds and touch them. They are unbearably light, so light, and glossy silver. Silver: the colour of surface, the colour of the foil in the Factory, the colour of a dream.

A dream glimmers through the very beginning of Baudelaire's prose poem *Paris Spleen*, in the initial conversation between two voices, one of which always answers: 'I do not know.'

– But what do you know?
– I know that I love the clouds up there.

Notes

1. Charles Baudelaire, *Le Peintre de la vie moderne, Oeuvres Complètes II* (Paris: Gallimard, Pléiade, 1976), p. 691.
2. Ibid., p. 693.
3. Andy Warhol, *America* (New York: Harper & Row, 1985), p. 132.
4. Ibid., p. 11.
5. Ibid., p. 181.
6. One could mention several articles in the 60s insisting on Warhol as dandy: Philip Leider, 'Saint Andy', *Artforum*, February 1965; Calvin Tomkins wrote: 'No one in the history of cool has been cooler than Andy,' 'Ragged Andy', in the exhibition catalogue of Pasadena Art Museum, 1970, p. 14.

7. Baudelaire, *Le Peintre*, p. 710.

8. David Bourdon, 'Andy Warhol 1928–1987', *Art in America*, May 1988, p. 139.

9. Bruce Glaser, 'Lichtenstein, Oldenburg, Warhol: A discussion', *Artforum*, October 1966, p. 20.

10. Gerald Nordland, 'Marcel Duchamp and Common Object Art', *Art International*, February 1964, p. 31.

11. Ibid.

12. Thomas Crow, 'Saturday Disasters: Trace and Reference in Early Warhol', *Art in America*, May 1987, p. 129.

13. Warhol, *America*, p. 27.

Pre-Pop and post-Pop:
Andy Warhol's fashion magazines

Richard Martin

Fashion was alpha and omega to Andy Warhol's visual world.
From a boy's imagination of glamour, chiefly embodied in
Hollywood but principally palpable in clothing, to an artist's start
as a professional in New York, and finally to the transformation of
a journal initiated in film culture into a fanzine of fashion, Warhol
touched and affected fashion again and again. The matrix of his
thinking was fashion-related; the artist who sought the distinct,
crystalline form within a fragile and evanescent culture took fash-
ion as his paradigm from childhood through the 50s and again in
the 70s and 80s. There is much to be said for Warhol's sensitivity
to democracy, his populist yearnings, but there is also an argu-
ment to be made for Warhol's sensibility for the stylish, chic and *à
la mode*. We look to Warhol to help us realise the yield of the extra-
ordinary from the ordinary. He would become for a time a fashion
model, becoming machine, mask and mannequin of artifice in
ways that are adumbrated throughout his work, before Pop, possi-
bly through Pop, and after, even to his continuing influence on our
time.

Thus, are we looking at a Maybelline image or are we looking at
the burst mirror of Hollywood when we see a Warhol glam-
portrait of Hedy Lamarr? It is important to recognise that Warhol

is still looking through the advertising and editorial pages as guide and perfect model when he creates such an image. One could say that glamour is a kind of intermediary here, but more importantly, one must argue that fashion is the leavening, the excitement, the charisma that attaches to the work and makes it transcendent, not only in Warhol's selection of the image, but in his fulfilment of the image as well. In this thought, I am not posing fashion as having a wardrobe or possessor status for some select garments; I am offering instead a concept of fashion as a system that, especially for Warhol, configures excitement around appearances and confers charismatic appeal on dressed beings. In fact, there are many ways to consider fashion and Warhol, but the image-making faculty of fashion in relation to contemporary art must perhaps be paramount.

The 19 March 1965 issue of *Life* magazine devotes a feature story to 'Bizarre styles to match avant-garde movies: Underground Clothes'. Earnestly, *Life* reports, 'The wild and way-out clothes shown on these pages are in the tradition – if you'll pardon the paradox – of the wild and way-out new cinema form known as the underground movie. These movies, usually plotless and soundless amateur efforts by experiment-minded artists, are much in vogue with the avant-garde set, who flock to see them at private showings and in beatnik-type bars and coffeehouses – hence the word underground.' Warhol's films *Batman Dracula* and *The Thirteen Most Beautiful Women* are shown projected into an interaction with models wearing clothing from Teal-Traina and Geoffrey Beene, among others. *Life* archly accounts, 'With the same attitude toward conformist fashions that the underground movie-makers show toward Hollywood films, designers on New York's Seventh Avenue have come up with the extreme shapes and bizarre colorings for the young and bold shown on these pages. They are displayed against scenes from several underground movies made by Pop artist Andy Warhol.'

The imagery employed by *Life* is definitely of a tradition, even if tradition is invoked here in paradoxical ways. While other kin might be registered, the most illustrious parent to the Howell Conant photographs in *Life* is the Cecil Beaton photographic campaign at the Betty Parsons Gallery published in the 1 March 1951 issue of *Vogue*, employing Jackson Pollock's 1950 exhibition of his action-painting at its mid-century apogee. Beaton poses what *Vogue* proudly trumpeted as the 'new soft look' in dress in front of Pollock's paintings. T. J. Clark has, of course, devoted prodigious effort to examining these Beaton/Pollock images in the context of the bourgeois assimilation of the radicalism of Pollock's art.[1] In fact, the art historian may find vexing such a work that brings the powerful components of high art's insurrection against culture and against itself into the realm of the fashion magazine and Beaton's all-too-apparent opportunism and commercialism. Such issues reverberate in the *Life* magazine presentation of Warhol and its claim of the 'way-out' status of this work, set to service for dresses it is now hard to see as utterly outrageous.

For Clark, the exercise is about the nihilism or the audacity of Pollock's art, its self-conscious detachment from the bourgeoisie but also its almost immediate return as an object for the bourgeois gaze directed at the pages of *Vogue*. Clark's statement that 'the negative can very well be one arm of aristocracy, whether the aristocracy is real or ersatz' operates in the case of Pollock's recruitment to the magazine's purposes in 1951.[2] Clark acknowledges that the magazine's motives were not wholly incompatible with the artist's interests, as visibility, financial gain, a forthcoming expiry of contract with the Betty Parsons Gallery, and other more or less tangible

factors might have enticed Pollock into participation in the culture of the popular magazine. In any case, the magazine page is a point of presentation for the contemporary artist. In the light of this, we must examine Warhol on the fashion pages of *Life* in 1965. The presentation is, it must be remembered, *ex post facto*, without the determination of the artist himself, but its implications, I believe, go to the heart of Warhol's aesthetic and his proximity to fashion.

Warhol's fashion was still, the unmoving world of the illustration, the store-window display, and the fashion photograph, not the fashion of a wearer's mobility or a runway's volatility in time. Thus, the contrived white cube with film projections used in the feature is compatible with Warhol's illusion of fashion as the fixed entity of the glamour still, the fashion photograph and the display technique. To move from the white cube of the Betty Parsons Gallery to the white box of the underground movie theatre is hardly to travel at all. Despite the fact that we are ostensibly seeing movies, the technique chosen by *Life* gives us the visual equivalent of slides, a fixed image that is consonant with Warhol's film imagery of the period. Static models can then touch their hair or impose themselves on lips that we know to be eating a mushroom. Inevitably, especially perhaps for art historians, the imagery seems almost more that of the pedagogy of art history, not the vivacious world of film, even film rendered as stationary as possible.

'All nature is but art,' wrote Diana Vreeland, quoting Alexander Pope, when she brought images of Woodstock to the pages of *Vogue* immediately in the wake of the music festival (December 1969). Subsequent to the *Life* appropriation of Warhol for the fashion milieu, Vreeland mingled image and art-works in the pages of a fashion magazine, as she always did in the trenchant pages of *Vogue* while she was editor. In this instance, images of Woodstock that would be little more than banal photojournalism are transformed by their direct association with art. Thus, a relaxed crowd scene of 60s youth is juxtaposed with Seurat's *Sunday Afternoon on the Grand Jatte*. Vreeland's editorial manner was one that matched Warhol's fondness for the disjunctive juxtaposition, that is, the startling affiliation of disparate elements, each of which renders the other tangier in a sweet-and-sour sense, more provocative in an intellectual sense, more loquacious in an affective sense. In this, Vreeland excelled at what fashion representation and codes customarily perform. Each image is, in its way, jejune, but the combination of the two images on the page give an eloquent reason – far beyond that of text – to the event of Woodstock and to the time-implicated ceremonies of the Seurat painting. Implicitly, Vreeland argues for the acceptance of the radical 60s ethos, rendering it as wholly assimilated and even bourgeois as Seurat's still world of Parisians at leisure. Subsequently, in the same article, Vreeland employs Manet's *Le Déjeuner sur l'herbe* to similar effect, so that scenes from Woodstock resonate with the formal arrangement of nude, semi-nude and dressed figures in this painting. Woodstock becomes related to the history of art. In another spread from the same article, the Woodstock skinny-dippers are presented alongside Cézanne's *Wilstach Great Bathers*. In this instance of the use of art history added as corner-notes to the images of Woodstock, Vreeland completely transforms the common perception of the event, for the reader of *Vogue* at least.

This later fashion editorial is germane to Warhol's absorption into fashion as represented by *Life* and, in fact, to Warhol's personal interest in fashion. Vreeland's editorial technique is about taking the still images and conveying the story through those images. Even if cinematic in a way, Vreeland's technique is at the heart of the magazine experience of fashion, a visual reading of the images of living, but conveyed through their secondary life as images. Fashion from

the Vreeland or Warhol point of view and professional practice is more about a quintessence than continuance. It is about the isolation of an icon within a consecutive and ceaseless evolution. Thus, as we see models in fashion for 1965 in interplay with the Warhol film images, we are witness to fashion's arrested image just as clearly as that of inert architecture, premeditated mushroom eater and fashion model as most beautiful girl. These are, of course, the generative elements for creating a visual symbol whether the field is fashion or art or both, especially Pop Art and especially popular fashion. The image depends upon the creation of the crystal-clear, even hyperbolic symbolic impact and sign that stands for its idea and that stands out visually. Even when models Imo and Ivy Nicholson appear with their own images from *The Thirteen Most Beautiful Women* projected as their faces on to their bodies, we are aware of the two complementary planes of representation. If these models pose now in a manner we would more recently have called 'voguing', they only resemble the icons to which they are palimpsest and screen. Baby Jane Holzer simulates movement, but possesses none. The magazine seems to emulate Warhol's emphasis on stillness. Warhol, who used fashion's traits to distinguish the iconic in contemporary life's ceaseless commercial picturesque, became *Life*'s vehicle for doing the same in this fashion article, though it must be granted that *Life* had its own canny and uncanny ability to extract the iconic from a photojournalistic continuum.

Iconic status is a principle of Warhol's fashion. Donna de Salvo has written compellingly in *Hand-Painted Pop* of the personalisation, the self-projection in Warhol's appearance-related painting, in *Before and After* (1962). In this argument, de Salvo sees the newspaper advertising for nose jobs as metaphor for Warhol's personal and class strivings, especially his own surgical alteration to his nose. De Salvo concludes, 'It is through an understanding of Warhol as a person, therefore, that *Before and After* gains its greatest power as a metaphor for assimilation.'[3] Here, Warhol has taken from a vernacular vehicle and plays in the 'real world' of media. What is most notable is the absence of glamour: Warhol makes the vernacular image more than clinical, bereft of the possibilities of glamour that he so systematically attributes to fashion. There is something earthbound and deadly serious here, as opposed to fancies and frills for I. Miller, Condé Nast or Bonwit Teller. His selection may be subjective, a personal history, for he is not seeking the objectified, reified glamour and high-style gloss that he seeks in fashion, only the appearance change promised by the newspaper ad.

Thus, *Life*'s interpolation of Warhol into fashion and into fashion's iconic message-giving is no mere caprice, but an indication of Warhol's own projection of fashion on to his work and his work on to fashion. Fashion is indisputably an abiding theme for Warhol. Consider, for instance, the late photograph taken from mannequin imagery of two women surrounding a sailor-like smiling male. Long after the childhood collection of Hollywood glamour and the eking out of glamour in shoes and fragrance display, Warhol is still using a medium related to fashion. Of this body of work, Stephen Koch has written suggestively that 'he likes to move in the space between meaning and meaningless. ... This area, after all, is where the visual artist can make an arrangement of things seem to "speak", make "meaningless" objects articulate with the vocabulary of the eye'.[4] Koch adumbrates fashion's potential as he describes Warhol's proclivity.

Thus, what Warhol is seeing is a kind of hyperbolic glamour to which there is a real-life index, not only in the mannequin he may see in front of him, but also in the mannequin's relationship to reality. Yet we know that the figures have been transformed by the fashion mannequin into

the archetypes of female beauty and, here, especially the character of a perfect, unchanging male beauty. What fashion extracts, Warhol exploits – or perhaps the other way around. But significantly, we again see Warhol using the fashion mechanism of stilling and distilling as the basis for his art. As Warhol told Gene Swenson in 1963, 'I'd do anything they told me to do, correct it and do it right. I'd have to invent and now I don't; after all that "correction", those commercial drawings would – have feelings, they would have style. The attitude of those who hired me had feeling or something to it; they knew what they wanted, they insisted; sometimes they got very emotional. The process of doing work in commercial art was machine-like, but the attitude had feeling to it.'[5]

Crucial to this legerdemain of feeling and machine, two chief antipodes of Warhol's art and thought, is the role of the client. Even as the client is obviated in Warhol's photograph of mannequins, it nonetheless seems to speak to the circumstances of his ideals and his constraints, using the fabricated forms of fashion to restrain imagination, but also shaping his art around these display surrogates for animated human beings. Fashion manifests the abilities that Warhol artfully polished. Thus, confronted in his epigrammatic drawings with the need to represent the process of apparel-making in an article on the Fashion Institute of Technology, 'Fashion Fosters a New Kind of College', for the October 1951 issue of *Glamour*, Warhol makes no tough new invention, but depends upon a simple set of drafting-table work, pattern-making, and even the pin-cushion and thimble. Picking out these telling signs, Warhol creates with facility the effect of a fashion education, even apparent to those who would not recognise fashion production and for whom a tall urban building is hardly the sign of traditional college architecture.

Fashion's commerce in identifiable and stylish symbols became Warhol's means and *métier*. Democracy might become the political agency of the art, but a reverie and aura of glamour was its hallmark. Still and symbolic, fashion allowed Warhol to exert glamorous magnetism. Moreover, it seems likely that even by the mid- and late 50s, there was a sense that the aura and allure of traditional fashion and Hollywood were waning. Warhol resurrects glamour even as early as the 50s, as if it were as outdated as the telephone that he depicts in memory of a lost America and as homage to Charles Sheeler and Dorothy Norman. The pre-Pop work in 50s window displays at Tiffany and Bonwit Teller indicates how Warhol works to discover the sign in fashion and products of glamour. The escutcheon on which a fragrance is evoked is, of course, fanciful and populated with the Warholian angels of the 50s as well as his period-style dancers, though these two may betoken the fascination with the glamorous dancing movies of the 40s and 50s. Revillon's Carnet de Bal fragrance is given a dance narrative, implicating, in the lower centre, Matisse's *The Dance*, but placing that work with its reductive spaces and figures into a fuller, more complicated narrative, one that gives picaresque romance and dancecard fascination and particularity to the dance. Thus, the four figures at top centre of the field are a kind of representational garden-variety form of Matisse's elegance. Here, too, some symbols are painfully obvious, such as hearts, but the imagery of fragrance has long depended on the ineffability of the product being sold and the absolute need to make a palpable magic from something that is inherently invisible. As de Salvo points out, this image is also one that fuses personal desire – in fact, homosexual desire – quite discreetly with the commercial message suitable for a store window.[6] Both personally and publicly, Warhol has announced a visual equivalent for the fragrance, a way of seeing aroma.

Philosopher Gilles Lipovetsky has argued that today 'consumption as a whole operates under the sign of fashion'.[7] If so, fashion's diffuse propagations must seem to be societal, and the aesthetic direction for every form. Whether one can speak in quite so grand tones, I am sceptical. But I am convinced that Warhol's work and its effectiveness in culture and as art is permeated by a sensibility akin to and derived from fashion. We need not a catalogue of the fashion and style work, but at least a survey and review, a chance to see Warhol operating in the world that he loved before and after and during his art. We must see Warhol in a kind of comfort zone *vis-à-vis* fashion, dreaming, being indulgently gay, imagining a world of perfect smiles and innate grace. We must also see an impulse in Warhol's art towards fashion diction, its insistent way of selling us through symbol, its charming way of burnishing with charismatic appeal an indifferent world.

One perceives fashion as a way of seeing and thinking in the transformation of Warhol's publication *Interview* from its initial conception as a journal of film, for which there would be any number of so-called underground models of the time, to a journal of fashion and glamour whose oppositional, yet manifestly engaged, stance was without significant precedent. The bare-chested and blatant sexuality of the films is not wholly betrayed by the more superficial sensuality of the fashion magazine. Warhol knew that fashion could be sexy as well as chic, especially vicariously sexy, the best kind. Once Mrs Vreeland is displaced from the editorship of *Vogue* in 1972, Warhol's *Interview* takes on the role that her advanced thinking had projected in the fashion magazine of the Establishment. Warhol in some ways fills the vacuum, yet still preserves his own imprint on the fashion publication in its emphasis upon individuals of style, personal beauty and cosmopolitan tastes.

A mode of imagining fashion that was strictly of the world of fashion for Vreeland becomes a more expansive mode of imagining art, life and glamour for Warhol in this transposition of roles in which there is a distinct psychic transference, confirmed in the personal relationship of Vreeland and Warhol. Not only does Vreeland herself continue as a frequent point of reference for *Interview*, but the qualities of her magazine work are continued, including the coterie of figures serving the magazine, while André Leon Talley emerges from *Interview* as a kind of privileged god-child or love-child to Vreeland *mère* and Warhol *père*. Could two of the great masks of the century give birth to style progeny? The Vreeland–Warhol doppelganger deserves further study, including Warhol's commissioned work for *Vogue*. These two voyeuristic connoisseurs, unquenchable kindred spirits of art's vicarious animation and fashion's intelligent passions, are mirrors of each other: Vreeland's *Allure* album is a Warholian enterprise and Warhol's unabashed view of, and absorption into, fashion in the 70s is a continuation of Vreeland's career after she retreated to a museum position.

The significance of concepts of fashion for developing a view of Warhol can be suggested again in two final references, the first to Warhol's camouflage works in which he reimagined apparel as art. Warhol's camouflage, itself seminal for Stephen Sprouse and others in fashion, assumes his pre-Pop mode of toying with consumerist devices and achieving visual and commercial satisfaction. Although these works evoke Magritte and sophisticated Surrealism in their imputation of a plane beyond appearance, especially in the portraits and self-portraits, Warhol keeps the mood light by involving fashion in a time sufficiently removed from the war in Vietnam to let military clothing seem serene. Yet camouflage is still manifestly the conundrum of deception

and reception, being visible and being invisible, the context of the chameleon.

No art's significance ought to be judged by its influence, but one cannot ignore the way in which Warhol remains a compelling force in fashion. Gianni Versace's fashion makes reference to Warhol, but Versace's aesthetic interests are so canny, encyclopedic and broad that one could affiliate Versace with more than a dozen major twentieth-century artists and designers.

Ultimately, one is not attempting to think only of tawdry paper dresses with Campbell's Soup cans on them nor to remember innumerable late nights at Studio 54. One is attempting to describe an ethos that has shaped our world, allowing for feminist discourse to introduce fashion as object and metaphor in the body-consciousness of art in our time, for example, and, at an opposite extreme, allowing a 90s journal such as the *New Yorker* to become deeply engrossed in the dimensions of fashion and its allure. In such regard, we look at a Warhol portrait of Halston and what do we see? Of course, we see Halston, the fashion designer who wanted to dress every woman in the world and who concomitantly wanted to play with and among the glamour of the select few who might possess style leadership. But we also see an image so close to Warhol's mask that we might wonder if those affinities, now so painfully poignant and obvious to us, are not more profound than they seem.

The second example is to be found in *The Philosophy of Andy Warhol: From A to B and Back Again*, where the author notes, 'Some company was recently interested in buying my "aura". They didn't want my product. They kept saying, "We want your aura." I never figured out what they wanted. But they were willing to pay a lot for it. So then I thought that if somebody was willing to pay that much for my it, I should try to figure out what it is.'[8] Fashion was genuinely a Warhol world, and it accounts, I would propose, for something of that aura we all want to figure out.

Notes

1. Timothy J. Clark, 'Jackson Pollock's Abstraction', in Serge Guilbaut (ed.), *Reconstructing Modernism: Art in New York, Paris, and Montreal, 1945–1964* (Cambridge, MA: The MIT Press, 1990).
2. Ibid., p. 173.
3. Donna de Salvo, *Hand-Painted Pop: American Art in Transition, 1955–1962*, ed. Russell Ferguson (Los Angeles: Museum of Contemporary Art; New York: Rizzoli International Publications, 1992), p. 89.
4. Stephen Koch, *Andy Warhol Photographs* (New York: Robert Miller Gallery, 1986), unpaginated.
5. G. R. Swenson, 'What is Pop Art? Answers from 8 Painters, Part I', *Art News* 62 (November 1963), pp. 24–7, 60–3, also frequently reprinted.
6. De Salvo, *Hand-Painted Pop*, pp. 86–8.
7. Gilles Lipovetsky, *The Empire of Fashion: Dressing Modern Democracy* (Princeton: Princeton University Press, 1994), p. 168.
8. Andy Warhol, *The Philosophy of Andy Warhol: From A to B and Back Again* (New York: Harcourt Brace Jovanovich, 1975), p. 77.

Introduction to visual essay

John Smith

The following illustrations, selected from the several thousand images housed in the Archives of The Andy Warhol Museum, have been chosen in an attempt to represent as fully as possible all of the various facets of Andy Warhol's life. Fortunately, Warhol's life has been so assiduously documented, by both himself and others, that we are able to watch his life unfold. The narrative is, of course, quite familiar: the humble Pittsburgh origins, the early commercial success in New York, the 60s King of Pop, Studio 54, the Zoli model of the 80s. However, included in the Archive's photograph collection are numerous images that capture a more private aspect of Warhol, particularly those taken before the great public recognition of the 60s.

At nearly every stage of Warhol's life, he was closely involved with photography and photographers. The Archives contain a wealth of photographs documenting Warhol's youth, many taken by his brother John, who briefly ran a photo studio in Pittsburgh after World War II. Warhol's later association with photographers such as Edward Wallowitch, Billy Name, Nat Finkelstein, Stephen Shore and Christopher Makos ensured that a complete record of both Warhol's private and public life has been created.

The small group of images reproduced here, while far from definitive, is yet another attempt to address the question posed by this book's title, *Who is Andy Warhol?*

(Parenthetical credits refer to the source of the photographic reproduction.)

Certificate of Baptism

and Confirmation

Greek. Cath. Church of

St. John Chrysostom
at Pittsburgh. Pa.

This is to certify, that

Andrew Varchola

Child of Andrew Varchola

and Julia Zavacky

born on the 6. day of August 1928

was **Baptized and Confirmed**

on the 28. day of August 1928

According to the Rite of the Greek Catholic Church

by the Rev. Stephen Kozak

the Sponsers being Steve Kalinack
Maria Shock

as appears from Baptismal Register of this Church

Dated May 22. 1942

Rev. Stephen Kozak
Pastor

left Warhol in the studio he and Carnegie Tech classmates rented for the summer, 1947

centre Autographed photograph of Mae West inscribed to Andrew Warhola (Susan Wrbican)

right Warhol's drawing of a boy picking his nose, 1949 (Richard Stoner)

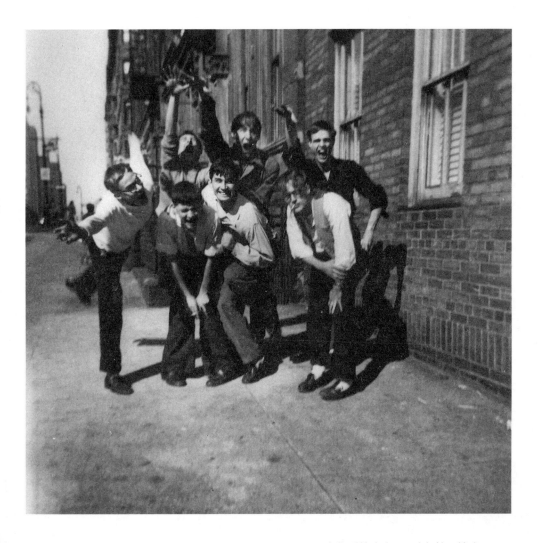

left Warhol at work in New York
(Edward Wallowitch)

centre Warhol, portfolio in hand, on the
way to see potential clients, 1950
(Leila Davies Singelis)

right Warhol (far left) with Victor Reilly
(front row, far right) and friends,
1950 (Leila Davies Singelis)

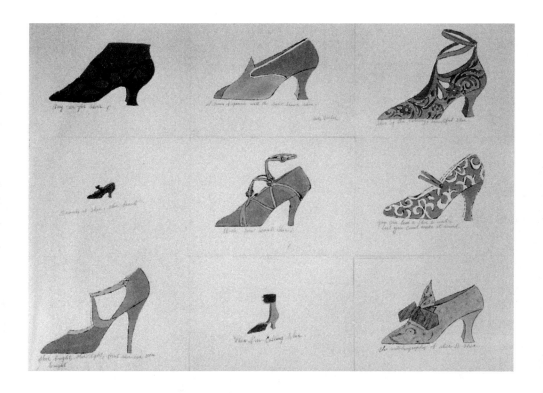

left A Warhol portrait of Truman Capote, 1950s (Richard Stoner)

centre Invitation, designed by Warhol, to an exhibition of his work at the café Serendipity, 1954 (Matt Wrbican)

right Page from Warhol's book *A la Recherche du Shoe Perdu*

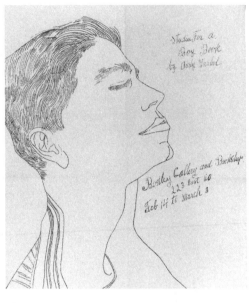

left Photograph of Warhol with pencilled-in alterations to his nose, 1957 (Melton Pippin)

centre Invitation, designed by Warhol, to his 'Studies for a Boy Book' exhibition at the Bodley Gallery, 1956 (Bruce White)

right Warhol's paste-up of advertisements used in the creation of paintings, 1960 (Richard Stoner)

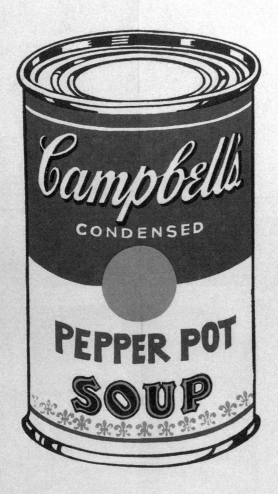

ANDY WARHOL
FROM MONDAY, JULY 9TH, 1962
FERUS GALLERY
LOS ANGELES, CALIFORNIA

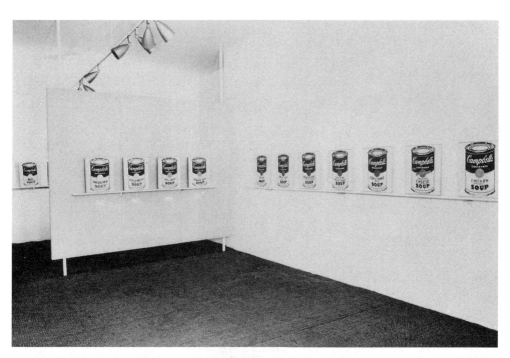

left Announcement of Warhol's exhibition of *Campbell's Soup Can* paintings at the Ferus Gallery, 1962 (Matt Wrbican)

right Installation of Warhol's exhibition of *Campbell's Soup Can* paintings at the Ferus Gallery, 1962

bottom Warhol's paste-up of newspaper and magazine images of Jackie Kennedy used in the creation of his *Jackie* paintings, 1963

Bar Roa For

MURAL TO COME DOWN AT THE FAIR
Most Wanted Criminals' Photos to Leave N. Y. Pavilion Wall

Fair's 'Most Wanted' Mural Becomes 'Least Desirable'

By MEL JUFFE

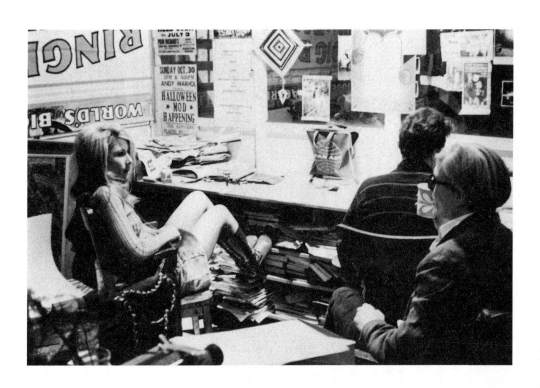

left John Giorno in Warhol's film *Sleep*, 1963 (Courtesy The Andy Warhol Film Project, Whitney Museum of American Art, New York)

centre Feature in the *New York Journal American*, April 18, 1964, on the removal of Warhol's *Most Wanted Men* from the facade of the New York Pavilion at the World's Fair (Matt Wrbican)

right Baby Jane Holzer (left) and Warhol (far right) at the Factory (Matt Wrbican)

Andy Warhol's
MY HUSTLER

*from 42nd Street
to Fire Island...*

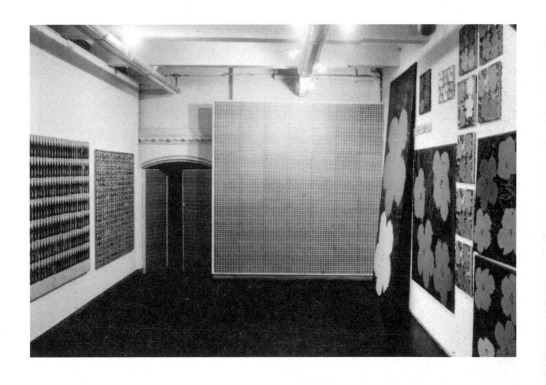

left Installation of Warhol's box sculptures

 Poster for Warhol's film
centre *My Hustler,* 1965 (Patty Wallace)

right Installation of Warhol's retrospective at the Institute of Contemporary Art, University of Pennsylvania, 1965 (Courtesy Institute of Contemporary Art, University of Pennsylvania, Philadelphia)

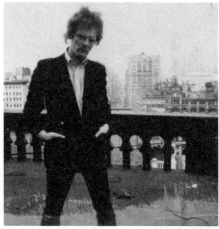

left Edie Sedgwick (Billy Name)

centre Paul Morrissey

right The Exploding Plastic Inevitable, 1966 (Billy Name)

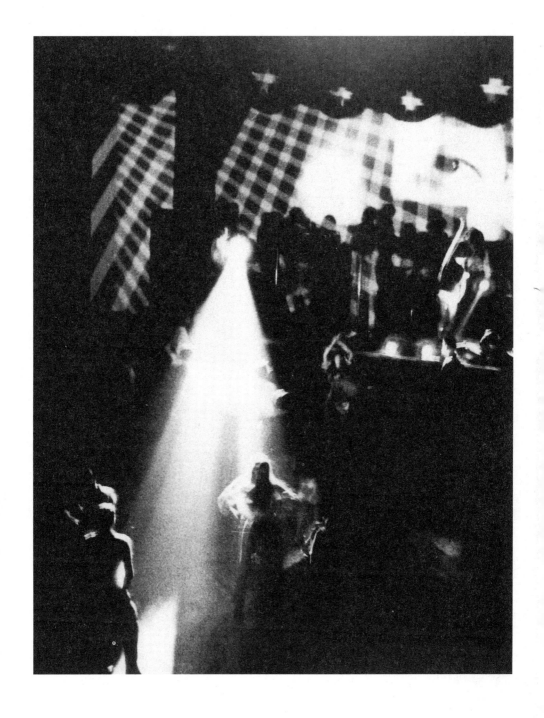

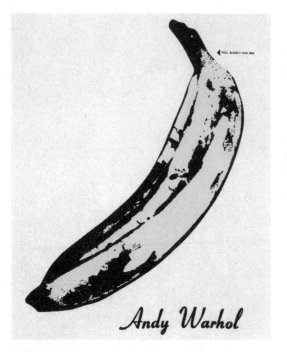

top left Cover designed by Warhol for the
first album by the Velvet
Underground and Nico, 1966

centre Gerard Malanga screening Nico's
paper dress, with Warhol oversee-
ing the process, from a profile of
the artist in *Réalités* magazine, c
1968 (Matt Wrbican)

right Viva, Warhol and Ondine
(left to right) at Max's Kansas City
(Billy Name)

left Promotional photograph of the
Velvet Underground and Nico,
1966

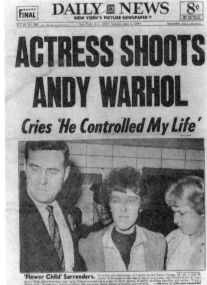

left Candy Darling

centre Installation view of the exhibition 'Raid the Icebox I with Andy Warhol' at the Museum of Art, Rhode Island School of Design, 1969 (Courtesy Museum of Art, Rhode Island School of Design, Providence)

right Warhol's shooting featured on the front page of the *Daily News*, June 4, 1968 (Bruce White)

inter/VIEW

A MONTHLY FILM JOURNAL

VOLUME 1, NUMBER 9 (out of n.y.c. 50¢) 35¢

this issue:

inter/VIEWS with:

BRUCE DAVISON,
star of THE STRAWBERRY STATEMENT

BRUCE BAILLIE

TOM COURTENAY

JOHN KORTY

RICHARD RUSH
director of GETTING STRAIGHT

left Early issues of Warhol's *Interview* magazine, founded in 1969 (Bruce White)

right Warhol's dining room in his townhouse at 57 East 66th Street (Evelyn Hofer)

FRED SOUZA
6' 40R 15½/34 10

DAVID SPIEWACK
6' 40R 16/34 11
SAG

PETER STANLEY
6' 40R 15½/34 11
SAG-AFTRA

TONY STEPHANO
6' 40R 15½/34 10D
SAG

JEFF

TERRY VAN DERENT
5'11 40R 15½/32 10½
SAG

RICHARD VILLELLA
6' 40R 15½/34 10

ANDY WARHOL
SPECIAL BOOKINGS ONLY

GEORGE WEEKS
6'1 40R 15½/34 10D
SAG-AFTRA

DAVID WHITE
5'11 38 90R 15½/33 10
SAG

REN

zoli ®

146 East 56th Street, New York, N.Y. 10022

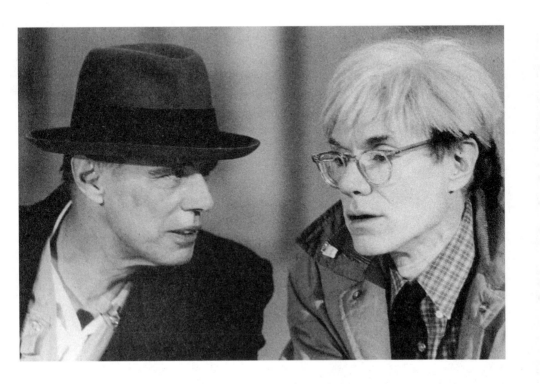

left Warhol in a Zoli modelling agency brochure (Susan Wrbican)

bottom Installation of Warhol's exhibition of *Dollar Sign* paintings at the Castelli Gallery, 1982 (Courtesy Leo Castelli Gallery, New York)

right Warhol and Joseph Beuys (Horst Luedeking)

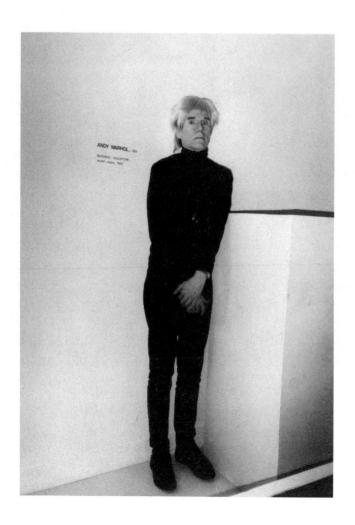

left Warhol's *Invisible Sculpture* at the
nightclub Area,
1985 (Patrick McMullan)

right Warhol in an advertisement for the
financial services company Drexel
Burnham Lambert,
1986 (Bruce White)

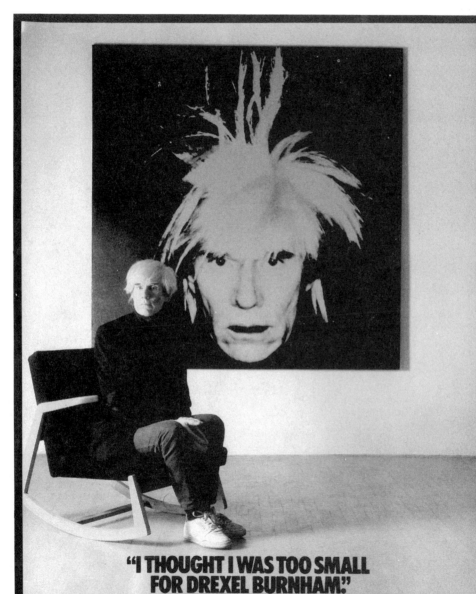

M R golden 3½screens
plese make Contrast
very Black & white Andy karly

Andy's hand-jobs

Tony Rayns

Twelve years ago I wrote an essay on Derek Jarman for the maga-
zine *Afterimage*. It was called 'Submitting to Sodomy' and it
explored the interface between Jarman's film aesthetic and his
resolution to train himself to enjoy the passive role in sex. Colin
MacCabe asked if I could come up with an equivalent analysis of
Andy Warhol for this book. I've written about Warhol elsewhere
(at greatest length in Michael O'Pray's anthology *Andy Warhol:
Film Factory*), mostly looking at the implications of his reinvention
of film language from scratch and puzzling over his decision to
surrender control of the marketing – and, ultimately, the making
– of the films to Paul Morrissey. The sexual dimension of Warhol's
cinema has already been analysed to death by Stephen Koch, and
nobody needed Victor Bockris to tell them that Andy himself
never had much of a sex-life. Is there anything left to say about
the films in the light of Warhol's own sexuality? Let's see.

In the Realm of the Hand-Job
If all film-makers are fundamentally voyeuristic-going-on-
scopophiliac, then Andy was first among equals. It's said that he
watched Vitascope films of the 1890s (including *The Kiss of May
Irvin and John C. Rice*) before beginning his own *Kiss* series; if that's
true, then he certainly learned as much about the distance

between film-maker/viewer and subject as he did about 'primitive' film form. Andy's early films of singles (*Blow Job*), couples (*Kiss*) and groups (*Couch*) are all founded on a sense of the film-maker's own exclusion from the action. This exclusion is in itself erotic, of course, partly because it's the non-participation which enables the committed voyeur to reach a climax and partly because the ever-present danger of being discovered or drawn into the action heightens the intensity of the pleasure. If Andy did look at the early Edison films, did he also see the shot of two men 'innocently' dancing together in 1895, recently brought to light in *The Celluloid Closet*?

Andy's erotics of detachment, strongly erethistic in 1963–5, waned in impact as Paul Morrissey muscled in on the making and exploitation of Factory films. The decline in masturbatory excitement was in inverse proportion to the rise of 'performance' in the films, itself closely related to the addition of sound recording to the Factory's technical repertoire. (Wasn't it Georges Bataille who noted that eroticism is profoundly silent?) More on this later.

Despite all those great Billy Name photos, the most iconic and suggestive of all the many mid-60s portraits of Andy was his uncredited appearance as 'Poseidon' in the late Gregory Markopoulos's *The Illiac Passion* (shot in 1964–6, completed in 1968). This was the film in which the director sought to reconcile his long-term quests for 'old world' money and 'new world' status with his growing sense that overtly homosexual art was suddenly permissible by superimposing his fantasy of Prometheus as a fallen angel on to the New York gallery crowd. Andy appears in one sequence, wearing a tracksuit and pumping furiously at an exercycle in front of his own giant silk screens of flowers; on the floor, blindly reaching out to him while thrashing around in a 'sea' of crumpled cellophane, is the naked muscle-queen who represents 'the conscience of Prometheus'. This was one occasion when Markopoulos got everything right: the tackiness of the setting, the absurdity of the action, and the vision of Andy as a rocking-horse winner stimulated by the beyond-reach sight of a sex object.

The Terence Davies Experience

The posthumous revelations that his Upper East Side townhouse was full of religious paintings and statuary and that he served as a volunteer with a local church mission for the homeless confirmed what was suggested when he brought his mother from Pittsburgh's Ruska Dolina immigrant community to live with him in New York: Andy was a pious Catholic all his life. The child being father to the man, he also never quite outgrew his origins as a small-town faggot who used Hollywood-bred fantasies to escape from poverty, homophobia, loneliness and disgust with his own body and face. Insofar as he grew up in a working-class family with a relatively strict Catholic father, he could be said to have had the full Terence Davies experience.

Like all gay viewers, though, Andy had deeply ambivalent attitudes to Hollywood glamour. Small-town faggots are (were?) all at some level junior-league Myron Breckinridges, exulting in vintage Hollywood fantasies of class, wealth and emotional fulfilment; all but the most ditzy are simultaneously aware that there is a man behind the curtain, pulling the strings. The resulting ambivalence tends to produce a particularly acute form of the syndrome common to all film viewers everywhere: the tendency to mentally edit or re-direct movies, to take from them what's interesting, exciting or sexy and to repress or ignore the rest. Gay viewers, constantly on the lookout for everything from style tips to snappy pick-up lines, tend to 'edit' their film-viewing more than

most. They also tend to feel more free than most to talk back at the screen, a phenomenon with intriguing implications for Andy's developing sense of film form. More on that in a moment.

When Andy actually began to make films, he never had the least aspiration to meet Hollywood on its own terms. Billy Name, Gerard Malanga and some other Factory insiders still maintain that he always had one eye set on Hollywood, but nothing bears them out. Andy's one-man reinvention of film form was a deliberate affront to Hollywood style and technical know-how; his plucked-from-the-streets star system was a parody of Hollywood image-engineering and glamour. He identified with New York's underground film-makers and screened his work at the Filmmakers' Cinematheque; he picked up on Jack Smith's devotion to B-movie schlock and to street-level drag queens as stars capable of *literally* embodying contradictory feelings about beauty, desire and screen presence.

Even in the early 70s, when Andy Warhol Enterprises began producing 35mm features for theatrical release, the movies ridiculed Hollywood values and pretensions. Paul Morrissey's wretched *Heat* focused on Hollywood has-beens, no-hopers and riff-raff, and wanly invoked memories of *Sunset Boulevard* in the apparent hope that some of Wilder's sophistication would rub off. And the Carlo Ponti-financed horror diptych and the self-financed *Andy Warhol's Bad* are sick-joke movies in bad-taste genres, explicitly designed to go beyond Hollywood parameters. *Bad* even has a joke about setting fire to a cinema because the movie is boring, a sequence cut from the film by its justifiably nervous UK distributor.

I, a Voice-Off

If Paul Morrissey hadn't got in the way, *My Hustler* would have opened with a reel-long stare at 'Paul America' on the Fire Island beach rather than the lurching pans between the beach and the beach-house patio (and the two in-camera edits) of the released version. Andy's idea was that the strenuously bitchy chat between Ed Hood, Joe 'Sugar Plum Fairy' Campbell and Geneviève Charbon on the patio would have served as an off-screen commentary on the charms of the sex-object on display, a corn-fed, dyed-blond tyro sent along by the 'Dial-a-Hustler' service. Andy's own version of that first reel is supposedly extant; maybe the Whitney Museum curators will be able eventually to screen the film as he originally wanted it.

Left to his own devices, the Andy Warhol of 1963–5 was never that hot for orthodox sync-sound film-making. As soon as he acquired the camera and equipment to record direct sound, he used it as much to record off-screen sound as to record his non-actors. It's said that he even recorded the chatter between those around the camera while he shot *Empire* (the first film made with his new Auricon camera) on the evening of 25 June 1964; the film has always been screened silent, though, probably because the calibre of the back-chat didn't measure up to the 'star quality' of the Empire State Building itself. (Since Jonas Mekas was behind the camera, it's safe to assume that the repartee wasn't scintillating.) Andy's interest in voices-off remained constant throughout his collaborations with Ronald Tavel and Chuck Wein during the following two years: *Harlot*, *Screen Test #2* and *Beauty #2* are among the known titles which are founded on the play between image and off-screen voices, most of them gay and/or bitchy.

The clear resemblance between this formal trait in Andy's early movies and the gay fondness for 'talking back' at the movie screen noted above *might* be coincidental, but ...

Flesh for Andy

Just as committed masturbators tire of fixating on a single image and constantly require new stimuli, so Andy had an unending desire for 'new blood'. Some Factory 'stars' got little more than their statutory fifteen minutes: the unidentified male seen in *Blowjob*, for example, evidently rented for his passing resemblance to Gerard Malanga (very possibly by the ultra-narcissistic Malanga himself), was never seen again. Others were granted a year of 'celebrity' before being dropped. Paul Morrissey's long-term fascination with Joe Dallesandro was the exception rather than the rule.

Clearly the pious Catholic who wanted to be a tap-dancer, not a painter, had more than one consideration in mind when he selected people to be in his films. He was drawn to some of them by their speedy loquacity, to some by their exhibitionism, to some by their social connections, and to some by their visible drive to auto-destruct. And some were in the movies because Andy fancied them, at least for a moment. As portraits of lust-objects, however, the early films add a new dimension to the concept of minimalism. The framing of *Blowjob* to show reaction rather than the action itself is at two levels a joke: it parodies the reaction shots of allegedly orgasmic women in the soft-core porno films of the day and at the same time implicitly ridicules the idea of censorship. (*Pace* Stephen Koch, this does *not* make the film a comedy.) But the framing also implies a sexual reticence to match the film's formal restraint. To watch a face rather than the theatre of fellatio two feet below is to primly avert one's gaze.

In 1963, of course, to produce images of blowjobs was to invite legal action. Andy knew from his visits to the Film-makers' Cinematheque that other underground film-makers (notably Jack Smith, Kenneth Anger and Ron Rice) were testing all the limits, but he did so himself only in the austere but intermittently pornographic *Couch*, a film evidently intended only for private screenings at the Factory. (The print of *Couch* seen in Europe in the 70s was a terrible optical dupe, illicitly copied from the original by one of the people seen in the film; he was one of many Factory hangers-on who claimed that Warhol had 'exploited' him.) Even in the late 60s, when the First Amendment battles had been won and Times Square had turned hard-core, Andy made only one film featuring penetrative sex: the resolutely heterosexual *Blue Movie*, a four-reel film whose second reel is an uninterrupted take of Viva and Louis Waldron making love one sunny afternoon.

Virtually all of the countless reels Andy shot in the mid-60s were louche in atmosphere and to some degree homoerotic. But very few were specifically gay in theme or situation, and even fewer featured full nudity, let alone sex. Consider the momentary exposure of Patrick Fleming's penis in Reel 4 (the second reel on the left-hand screen) of *The Chelsea Girls* – a useful example, since we know that Andy himself operated the camera. Fleming is in his underpants, lying on a bed in George Plimpton's apartment with Ed Hood. Two women are also present. After a desultory attempt to tie Fleming's hands behind his back Hood pulls down his friend's underpants, exposing his arse and then rolling him over to expose his genitals. Andy excitedly zooms in (but only for split seconds) on the attempted bondage and the exposure of the arse, but when the limp penis comes into view he zooms in on the face of the woman (is she International Velvet?) sitting on the bed beside the men. Aware that the camera is on her and evidently embarrassed by the turn of events, she doesn't know where to look or how to react. Andy's camera, naturally, stays fixed on her face. His own reticence about observing the sex-play between the boys on the bed finds its expression *and its mirror* in his decision to reframe on the woman's embarrassment.

Pass the Kleenex

To mop up, we need to turn to the 1967 shift from underground 'art' films to sexploitation fea-
tures for the burgeoning 'counter-culture' market. In other words, to Andy's ceding of most of
the creative control of the films to Paul Morrissey. The Morrissey features of 1967–72 are all
set up as heterosexual narratives – usually, boy-meets-a-series-of-neurotic girls, the girls occa-
sionally played by drag queens – in such a way as to focus attention on the male sex-object. The
last film *not* to centre on a male sex-object was 1967's *The Loves of Ondine*; Morrissey compensat-
ed for the absence by inserting a reel of a food-fight between naked and near-naked Hispanic
men in the middle of the film. Morrissey in fact became expert in arbitrary compensation
strategies: when none of the women in *Bike Boy* succeeded in getting Joe Spencer undressed, he
added the opening study of Spencer in the shower so that the film would contain a modicum of
male nudity.

But Morrissey's studies of naked men rarely stack up as gay masturbation fantasies. Even his
extended celebrations of Joe Dallesandro's lithe Italian-Norwegian torso have less sex-appeal in
total than the 20-minute reel of Dallesandro performing nude exercises shot by Robert Mizer
for the Athletic Model Guild in 1968. (After shooting his scenes for *Lonesome Cowboys* at the end
of 1967, the nineteen-year-old Dallesandro stopped off in Los Angeles; Mizer, a veteran connois-
seur of working-class male physiques who had founded the AMG in 1945, rented him to pose for
both stills and the solo film reel.) Mizer's film, made specifically for the realm of the hand-job,
shows off the boy's torso and genitals to best advantage but crucially – like the great majority of
his portrait photos – insists on the model's consciousness of the camera. The sexiness springs
less from the viewer's imaginary relationship with the sex-object than from the viewer's aware-
ness of the rapport between the sex-object and the cameraman. By encouraging Dallesandro
and the others to 'act', Morrissey set himself the challenge of devising scenarios or situations
which would *themselves* generate erotic frissons. He rarely succeeded.

Andy could never have shot a film as relaxed and intimate as Mizer's reel of Dallesandro, but
he understood the erotic element in portraiture in a way that Morrissey never did. He knew
that sexuality was sparked in the vacuum between model and artist, and that the sexual charge
of the finished work depended on the evidence of that spark found in the work itself. But Andy
spent his life disavowing the role of artist, and he took refuge in the idea of substituting record-
ing machines for himself. The introduction of an unoperated cine-camera shooting a portrait,
whether the subject is receiving an off-screen blowjob or an on-screen haircut, adds an extra
twist to the sexual conundrum. Hence Andy's erotics of detachment. For him, the *avoidance* of
personal involvement and the *embrace* of neutral, non-judgmental recording technology generat-
ed exactly the kick that a shy and repressed Catholic boy needed. Masturbation was no party-
game for Andy. For him, hand-jobs were as lonesome as he imagined cowboys to be.

In preparing these notes, I re-read Gretchen Berg's superb interview with Andy (originally published in
Cahiers du Cinéma in English *no. 10, 1967), Stephen Koch's book* Stargazer *and Debra Miller's invalu-
able* Billy Name – Stills from the Warhol Films. *I also took another look at the TV documentary*
Warhol's Cinema 1963–1968 *by Keith Griffiths and Simon Field. Grateful thanks to Noel Purdon for
showing me the Robert Mizer reel of Joe Dallesandro. – T. R.*

Warhol before the mirror

Steven Shaviro

To be obsessed with images, with surfaces, with appearances: what does it really mean? In particular, what did it mean to Andy Warhol? Images are nothing like objects. When things retreat into their images, the way they do on TV, they lose their solidity, their palpability, their presence. Images have a weightlessness that is both mysterious and soothing. They haunt us, like ghosts; they empty out space, the better to flicker interminably in the void. Images are premised upon a visibility so extreme that it relegates the world to a state of almost transparency. They resemble their objects so utterly, so perfectly, that the objects themselves become almost invisible. The most perfect resemblance, Maurice Blanchot says, is the one that has 'no name and no face'. An artist is some-body who wants to turn the whole world into images; but he usual-ly ends up making more objects instead. That is at least how Warhol regards the matter: '*I really believe in empty spaces,*' he says; 'although, as an artist, I make a lot of junk. ... I can't even empty my own spaces.'[1] It's a dilemma that assaults him day after day: 'I'm sure I'm going to look in the mirror and see nothing. People are always calling me a mirror and if a mirror looks into a mirror, what is there to see?'[2] Maybe that would even be the most satisfy-ing outcome. If only Andy could vanish into the mirror, into the camera, into the tape recorder. To be an empty image, and noth-

ing but an image, just like Marilyn or James Dean or Elvis. But try as Andy may, his body never entirely disappears. Instead, 'Day after day I look in the mirror and I still see something – a new pimple. If the pimple on my upper right cheek is gone, a new one turns up on my lower left cheek, on my jawline, near my ear, in the middle of my nose, under the hair on my eyebrows, right between my eyes. I think it's the same pimple, moving from place to place.'[3] This pimple, you might say, is Warhol's fleshly double, his abject objecthood, the thing that binds him to his body, or to himself. The thing that prevents him from turning into an image. 'Nudity', Warhol tells us, 'is a threat to my existence';[4] and the pimple is the point where he's exposed naked, for all the world to see. Your blemishes are the most intimate secrets you have; but they are also the first things that everyone else notices. That's why Warhol 'believe[s] in low lights and trick mirrors ... [and] in plastic surgery'.[5] You can never have too many skin creams and lotions and ointments.

No moral, aesthetic or metaphysical issue is more important for Warhol than the question of how to get rid of pimples. 'If someone asked me, "What's your problem?" ,' he tells us, 'I'd have to say, "Skin".'[6] And he's right, of course. Everything that matters is already out there, right on the surface. 'Don't think, but look!' as Wittgenstein said. Faced with the trauma of an acne outburst, or with the heartbreak of psoriasis, I must learn not to bother with searching out deep structures and root causes. For such disorders can only be treated topically and symptomatically: that is to say, only on the level of surfaces and effects. It's impossible to dig down to the origin; the best solutions for skin problems are always aesthetic or cosmetic ones. As my trusty old *Home Medical Guide* puts it: 'Since the cause of acne is frequently misunderstood, the "victim" may be accused of being responsible for his or her condition. Parents often blame their youngsters for eating too much junk food, eating too little, eating too much, not washing properly, not getting enough sleep, sleeping too much, being obsessed with the opposite sex, having no interest in the opposite sex, ad infinitum. The truth is, none of these things have anything to do with acne, and if there is any "blame" attached to the disorder, it may well belong to the parents' genes. No exact cause is known.'[7] Parents are all too likely to read acne as a sign of deviance: of not being properly heterosexual, most likely. But a careful, patient attention to images and surfaces undoes all such imputations of guilt. As Nietzsche says in a similar context, 'that no one is any longer made accountable ... *this alone is the great liberation* – this alone is the *innocence* of becoming restored.'[8] Warhol scrupulously abstains from pejorative judgments: 'It's so nice, whatever it is. I approve of what everybody does: it must be right because somebody said it was right. I wouldn't judge anybody.'[9] Instead, he dispenses expert advice on skin care: 'I dunk a Johnson and Johnson cotton ball into Johnson and Johnson rubbing alcohol and rub the cotton ball against the pimple.'[10] Or again: 'if you have a pimple, put on the pimple cream in a way that will make it really stand out'.[11] Or yet again: 'Haven't you heard about those ladies who take young guys to the theater and jerk them off so that they can put it all over their face? It sort of pulls it tighter and makes them younger for the evening.'[12] If one remedy doesn't work, then simply try another. In the end, Warhol says, 'I've never met a person I couldn't call a beauty. Each person has beauty at some point in their lifetime.'[13]

Warhol, too, shows us how to 'have done with the judgment of God'; but in a far gentler manner than Nietzsche or Artaud. I suppose that's why it's no big deal that he went to church every Sunday. For Warhol has none of the anxieties that plagued his great modernist forebears, none of their transgressive urges or buried ressentiment. Why worry, if nothing is true, and every-

thing is permitted? Lacan says somewhere that the real formula of atheism is not 'God is dead', but rather, 'God is unconscious'. If that is so, then Warhol – whatever his private observances – was undoubtedly the least pious of men. When everything's just an image, there's no Symbolic Order left to transgress. And that goes not only for God, but for all the other fetishes of modernist faith as well: sex, money and politics. They all come down to appearances, and nothing but appearances. Sometimes a penis is just a penis, is what Freud ought to have said. Think of it not as the Phallus, but as a convenient dispenser of facial cream. Castration is a matter merely of local and passing significance. The organ is nothing in itself; it's all a question of how you use it. And there are as many different uses as there are different male and female bodies. 'Everybody has a different idea of love,' Warhol writes. 'One girl I know said, "I knew he loved me when he didn't come in my mouth." '[14]

That's what Warhol's religion really comes down to. 'The Factory was a church,' Gary Indiana writes, 'the Church of the Unimaginable Penis, or something. ... The sanctity of the institution and its rituals is what's important, not personal salvation. Maintaining the eternal surface.'[15] Maintaining the image, you might say. Nothing is hidden in Andy's church, and nothing is transcendent: what you see is exactly what you get. Movie and media stars are the only objects of worship. Only Elvis or James Dean can tell me what it is to be a man. Or some other icon of the time: maybe even Fidel Castro. Castro was a hot media figure in the 60s, though his glamour has faded considerably since then. It's odd, the way his name always used to come up. At one point in Warhol's 1967 film *The Nude Restaurant*, Taylor Mead teasingly claims, in close-up straight to the camera, that 'I was in Fidel Castro's dictionary. I made it with the Big One, Big Number One of Cuba.' Viva responds by telling how, in pre-Revolutionary Cuba, a political prisoner was castrated by Batista's secret police for refusing to talk. At which Mead muses, in that offhand, campy manner of his: 'You would think Castro would be the castrator.' In fact, several years before this film was made the CIA had indeed plotted, if not to castrate Castro outright, at least to devirilise him by lacing his food with female sex hormones. They figured that his beard would fall out, and his voice become high-pitched and squeaky. Once Castro's macho image was ruined, they thought, he could easily be overthrown. An obsession with Fidel's sexuality seems to be present in other CIA projects of the time as well, such as the plan to kill him with an exploding cigar. This may well be one of those times when a cigar isn't just a cigar. Isn't the United States government's hysteria about the Castro regime – one that still persists today, even after thirty-six years – the result of envy and fear at the prospect of Fidel's 'Big One'? The CIA spooks never succeeded in putting any of their strange schemes into action; but the very existence of such plans testifies to the potency, as it were, of Fidel's media image. Just like a pimple that won't go away, his flashy and fleshly presence on the international scene in the early 60s was an affront to *norteamericano* manliness as then embodied by John F. Kennedy. After the Kennedy assassination, Lyndon Johnson more prudently (if no more successfully) decided to pick on Ho Chi Minh instead. After all, nobody would exactly say that old Uncle Ho had sex appeal.

Warhol, for his part, goes one better than JFK and the CIA when it comes to devirilising Castro. In his 1965 film *The Life of Juanita Castro*, not only does Fidel's estranged, anti-communist sister take centre stage, but Fidel, his brother Raul and Che Guevara are all played by women. This gender reversal testifies to the fluidity of postmodern bodies. It's not really a matter of deflating Castro's ego, or his cock, but of showing how his potency – how virility in general – is always

an affair of bluff and display, of pure pretence. That's just show business. In the world of Warhol's Factory, castrator and castrated, or Castro and castration, are able to exchange places with the utmost of ease. Warhol describes the idea of the film as 'fags on the sugar plantation';[16] he renders the Cuban Revolution as high camp. In Marxist terms, history is repeated a second time, as farce. Warhol's treatment not only outdoes the CIA, but trumps Hollywood as well: it is even more campy and over-the-top than Richard Fleischer's 1969 would-be blockbuster *Che!*, despite the latter's amazing casting of Omar Sharif as Guevara and Jack Palance as Fidel. *The Life of Juanita Castro* is ostensibly based on a *Life* magazine article in which Juanita denounced her brother as a tyrant. But it is actually inspired, Warhol claims, by reports that Raul Castro was a transvestite, and that Fidel himself had made 'attempts to become a Hollywood star', and had even appeared as an extra in an Esther Williams musical.[17] Was the Cuban revolutionary regime's notorious persecution of gay men a result of Castro's own sense of masculine panic, his need to bury a disreputable past? Warhol's film, you might say, presents a new Fidel, releasing his bitchy inner queen from the prison of Marxist–Leninist virility. And the romantic machismo of Third World revolution runs a poor second to the sexually more ambiguous allure of celluloid stardom.

The Life of Juanita Castro is a wonderfully *skewed* film, in all sorts of ways. The actors sit in rows, facing the place of the camera, with Juanita front centre and Fidel and Che on either side of her. Except that the supposed camera to which the actors always direct themselves is not the one that actually shoots the film. We see the stage instead from an oblique angle, well off to the right. The result is that, for instance, when Juanita or Fidel 'steps up to the camera' for a monologue and a close-up, she actually moves out of frame. The show must go on, but it isn't really being addressed to us: for we are way too off-centre to engage it. This formal absurdity is only heightened by how the script is presented to us. Ronald Tavel, Warhol's screenwriter, sits on stage along with the rest of the cast. He reads aloud from his script, telling the actors what to do and say. 'Fidel, smoke your cigar for a while with great satisfaction.' 'Juanita, say to Fidel, "You never really cared about the poor peasants."' 'Fidel, turn to Juanita and yell, "Puta! Gusana!"' The actor then repeats the line or follows the instruction, usually with over-emphatic gestures and intonations, but trying – with more or less success – to keep a straight face during the process. Marie Menken, who plays Juanita, has an especially hard time. She seems fairly sloshed throughout the film, frequently mumbling or mispronouncing lines, totally garbling Spanish phrases, and querulously complaining that the words she's been told to recite don't make any sense. Sitting in a wicker chair, fanning herself and taking occasional swigs of beer, she displays all the mannerisms of a fallen *grande dame*. Overall, she exudes an air of amused indifference mingled with haughty disdain, as if to say, I can't believe I'm doing this. Menken's 'bad' performance is the most memorable thing about the film, but all the actors have their moments. At times, Tavel instructs the entire cast to laugh, or cry, or smile as if for a family portrait. The result is something like a well-orchestrated political rally: the same stereotypical actions and expressions are manifested at once by everybody present. The whole film, in effect, is being dictated as we watch; which is just right for a film about a dictator. Language, as Deleuze and Guattari put it, is a performance and not a structure: 'the transmission of the word as order-word, not the communication of a sign as information'.[18] *The Life of Juanita Castro* thus *performs* the Cuban Revolution as camp spectacle, rather than informing us of its accomplishments or failures. Which is why Warhol says, deadpan, that the political 'point' of the film is, 'it depends on how you want to look at it'.[19]

Nothing could be further from the old familiar practices of ideology-critique and the alienation-effect. We aren't deceived or stupefied by this spectacle; but it doesn't give us space for critical reflection either. This is a point that Warhol's critics have often misunderstood. We're usually asked to choose between two readings of Warhol's work: one that praises him for exposing the institutional structures of commodity capitalism and the art world, and one that condemns him for being in complicity with these same institutional structures. But aren't both of these readings beside the point? After all, 'if a mirror looks into a mirror, what is there to see?'[20] Of course Warhol is in complicity, and of course he is always calling attention to that complicity. But the real interest of his work lies elsewhere. It's too late: the political and art worlds are high camp already. You may hate 'the society of the spectacle' with a puritanical fervour, as the Castro regime so ostentatiously does, or as Guy Debord and the Situationists did. But if you care at all for pleasure, if the old corrupt Yankee-controlled Havana of nightclubs, casinos and whorehouses holds any allure for you whatsoever, then such purism and puritanism clearly won't do. You'll have to work around and within the spectacle, just as Andy did. Near the end of *Juanita Castro*, Fidel accuses Juanita of opposing his regime only for the sake of publicity, just in order to further her career as a singer and dancer. 'But I am a great singer, I am a great dancer,' Juanita scornfully replies.

Isn't that the point, right there in a nutshell? As Nietzsche said, even philosophers ought to learn how to dance. What good is virile self-control, or political and aesthetic discipline, compared to the pleasures of a good Cuban cigar and (with a nod to Che) of an Argentinian tango? Warhol recounts asking Emile de Antonio, in the late 50s, why he was having trouble finding acceptance in the art world. 'You're too swish,' de Antonio replied, 'you play up the swish – it's like an armor with you.' And, Warhol adds, 'It was all too true. ... I certainly wasn't a butch kind of guy by nature, but I must admit, I went out of my way to play up the other extreme.'[21] Come the 60s, this strategy finally paid off. I distrust any account of Warhol, no matter how celebratory, that doesn't take his swishiness into account. If nothing else, Warhol says, he 'always had a lot of fun with [the 'swish' thing] – just watching the expressions on people's faces'.[22] Of course, this sort of campy aestheticism has been a common strategy of survival for gay men for quite a long time: at least since the invention of hetero- and homosexuality in the later 19th century. Oscar Wilde, Jean Genet and Michel Foucault all urge us to transform ourselves into works of art. If Warhol is 'the last dandy',[23] as Stephen Koch calls him, it's because he pushes this posture further than anyone else. Warhol is the first to understand that the whole postmodern world is in drag, and not just certain special individuals. In Marxist terms, the actual conditions of production have already outrun whatever we may think and say about them. Warhol is content merely to dramatise this fact. There's no place for us to look, except into the mirror. There's nothing left to do, except go to another party. There are no real men and no real women; it's all insinuation. 'I dreamed of scented rooms and endless permutations of identity: boys becoming girls, girls becoming boys who do boys like they're girls,'[24] as Grant Morrison writes in his recent comic *The Invisibles*. Despite Warhol's massive post-mortem institutionalisation, his swishy aesthetic retains its provocative force today. It's a permanent reproach to the American cult of virility. It's scarcely possible to take seriously any more, after Warhol, all those tough, high-minded claims these days for an art of political critique on the one hand, and for an art that teaches virtue on the other.

And that's the difference between Warhol and the CIA. The CIA sought in all seriousness to *subvert* Castro: to castrate him literally or metaphorically, to subject him to the Law of the

Father, to render him accountable, in one way or another. Warhol, in contrast, frivolously seeks to *pervert* Castro: to dress him in drag, and perhaps to drag him into bed. That's what drives the gender play in *The Life of Juanita Castro*. Behind every great man stands a woman, popular wisdom says; and in this case, Fidel himself is also that woman. Mercedes Ospina plays a rather butch Fidel, swaggering and smirking her way through the part. But she isn't in drag; she makes no attempt to pass for a man. She's just there, in a dress and without a beard. For masculinity is an image and not an object: a superficial performance, rather than an attribute of bodies. It's Fidel's very womanliness that drives him to act so butch. The effect of Ospina's performance is that of an infinite hall of mirrors: a woman playing a man who is really a woman in the guise of a man. Tavel's script heightens the atmosphere of silly delirium. It gleefully mixes political clichés, bitchy reproaches and insults and moments of absurd overdramatisation. At one point, Fidel makes an excruciatingly long speech in bad Spanish (it consumes a full fifteen minutes of screen time), while the other actors all fall asleep and snore loudly. (Castro, of course, is as notorious for his long speeches as Warhol is for seemingly interminable films like *Sleep* and *Empire*.) The film also abounds in sly sexual innuendoes and in teasing flirtations between the various players: especially between those two big *maricones*, Raul and Che. It's much more fun to casually cruise a Party meeting than to work twelve hours straight in the hot sun cutting sugar cane. Politics is pervaded and perverted by desire: not by that big, fatal passion that consumes your very being, but by those silly little whims and compulsions that vex you from day to day. Marxism and masculinity must both be redefined. Fidel Castro is nothing but a capricious, bitchy diva, spoiled rotten by too much early success on the world-historical stage. His revolutionary virility is a grand production number; if he carries it off well enough, he hopes history will absolve him. Fidel is best understood, then, as a fabulous camp icon: a dialectical Bette Davis or a Commie Joan Crawford. And now, in the late 90s, when he's become passé, still holding the line for an obsolete vision of Leninist virtue, doesn't he bear a striking resemblance to Gloria Swanson in *Sunset Boulevard*?

It all comes down to images, and nothing but images. Warhol's art really *is* about fashion and style. It couldn't care less about what's beneath the surface. Nothing could be more 'corny',[25] Warhol says, than 'agonized, anguished art'[26] that seeks to uncover hidden depths. The critical spirit finds the world to be radically deficient. Images never satisfy it; it always wants something more. But Warhol just shrugs his shoulders and suggests that enough is enough. The world, for him, is not deficient but, if anything, overly full. The junk we collect, Warhol warns us, will fill up all our spaces. The junk Warhol himself collected still hasn't even been catalogued properly. You may remove a pimple today, but you'll discover a new one tomorrow. There's too much out there already; why get excited about one organ more or less? The virile fear of castration is utterly foreign to Warhol. Straight men tend to get all touchy and anxious about their potency. But the straight man is only there to feed the comedian his lines. It's the latter who gets the laughter, and the money, and the applause. That's why Warhol prefers style over substance, swish over machismo, images over things. Why ever bother to dig beneath the surface? You can always make selections and corrections on the skin itself. You can add additional layers, covering acne with make-up, or treating it with sperm or with benzoyl peroxide. 'When I did my self-portrait,' Warhol tells us, 'I left all the pimples out because you always should. Pimples are a temporary condition and they don't have anything to do with what you really look like. Always omit the blemishes – they're not part of the good picture you want.'[27]

Notes

1. Andy Warhol, *The Philosophy of Andy Warhol: From A to B and Back Again* (New York: Harcourt Brace Jovanovich, 1975), pp. 143–4.
2. Ibid., p. 7.
3. Ibid., p. 8.
4. Ibid., p. 11.
5. Ibid., p. 63.
6. Ibid., p. 8.
7. The College of Physicians and Surgeons of Columbia University, *Complete Home Medical Guide* (New York: Crown Publishers, 1985), p. 627.
8. Friedrich Wilhelm Nietzsche, *Twilight of the Idols*, trans. R. J. Hollingdale (Baltimore: Penguin Books, 1968), p. 54.
9. Gretchen Berg, 'Nothing to Lose', in Michael O'Pray (ed.), *Andy Warhol: Film Factory* (London: BFI Publishing, 1989), p. 60.
10. Warhol, *The Philosophy of Andy Warhol*, p. 8.
11. Ibid., p. 65.
12. Ibid., p. 11.
13. Ibid., p. 61.
14. Ibid., p. 49.
15. Gary Indiana, 'I'll Be Your Mirror', in O'Pray (ed.), *Andy Warhol: Film Factory*, p. 184.
16. Andy Warhol and Pat Hackett, *POPism: The Warhol '60s* (New York: Harper & Row, 1980), p. 113.
17. Ibid., pp. 113–14.
18. Gilles Deleuze and Felix Guattari, *A Thousand Plateaus: Capitalism and Schizophrenia*, trans. Brian Massumi (Minneapolis: University of Minnesota Press, 1987), p. 77.
19. Berg, 'Nothing to Lose', p. 57.
20. Warhol, *The Philosophy of Andy Warhol*, p. 7.
21. Warhol and Hackett, *POPism*, pp. 11–12.
22. Ibid., pp. 12–13.
23. Stephen Koch, *Stargazer* (New York: Marion Boyars, 1973), p. 23.
24. Grant Morrison, *The Invisibles*, no. 8 (New York City: DC Comics, April 1995), p. 23.
25. Warhol and Hackett, *POPism*, p. 15.
26. Ibid., p. 13.
27. Warhol, *The Philosophy of Andy Warhol*, p. 62.

Albino humour

Ralph Rugoff

Andy Warhol once wrote that if he went to 'a lady of the night', as he delicately phrased it, he would probably pay her to tell him jokes. His idea of passionate sex talk went something like this: 'How am I doing?' 'Fine, that was very funny', or 'Wow. You were really funny tonight.'[1] Elsewhere he declared that 'If a person isn't generally considered beautiful, they can still be a success if they have a few jokes in their pockets. And a lot of pockets.'[2]

Andy wasn't generally considered beautiful, but he knew pockets, and he knew how to pocket things he could use. There are many who still feel that he pulled the ultimate joke on the art world, that he was a sly prankster who fooled collectors and critics alike into believing his trashy shtick was high art. And it was part of his particular teasing brand of humour that he did nothing to discourage this idea. Instead, with deadpan demeanour, he went out of his way to encourage it: in 1966, he placed an ad in the *Village Voice*, proclaiming his willingness to endorse 'any of the following: clothing, AC-DC, cigarettes, small tapes, sound equipment, Rock 'n' Roll records, anything, film and film equipment, Food, Helium, WHIPS, Money.'[3]

In the aftermath of such gestures, his much-talked about indiffer-

ence looks more like a condition of a seamless albino humour that created uncertainty about his every move, so that even when he insisted he had nothing to hide, we were sure he was hiding something.

In general, Warhol served his humour on the rocks. And as with a lot of good jokes that don't have punch lines, you probably had to be there to get the full impact, because Warhol's wit typically played off a specific context. As a visual comedian, he was a counter-puncher. Tired of encountering speed freaks who had stayed up nine days in a row, he figured 'Maybe it was time to do a movie about somebody who sleeps all night.'[4] When George McGovern asked him to do a poster for his presidential campaign, Warhol responded by doing portraits of Nixon. Invited by Phillip Johnson to decorate the façade of the New York State Pavilion at the 1964 World's Fair, Warhol proposed that state government be represented by the *Thirteen Most Wanted Men*. When his proposal was turned down by Johnson and the state sponsors, he covered the grid with aluminium paint, hiding his fugitive wit under a monochrome façade, as if to suggest that abstraction, far from being neutral, has always been in the business of covering up.

In the early days of Andy's art career, the target of his aggressive and contrary wit was often the status of art itself. Beginning with 1948's *The Broad Gave Me My Face, But I Can Pick My Own Nose*, Warhol's wit was traditionally iconoclastic and de-idealising. The underlying edge of aggression in this picture – its affront to the idea of what constitutes a proper subject for art – persists in many works from the 50s and early 60s, though in a chillier form. A work like *Telephone* (1961), Warhol's image of an outdated upright phone, quietly implied that painting was an obsolete medium in the age of electronic communication. More than painting, however, what was truly outdated was the idea of the artist as a heroic figure. With *Superman* (1960), Warhol humorously invoked the muscularity and hot air associated with Abstract Expressionism, which is here vanquished by a man in tights who goes 'Puff'. Of course, a creampuff, or in British slang, a poof, could be a term for a male homosexual, and from one angle, Warhol's painting wittily depicts the Pop artist as gay superhero, ushering in the real triumph of American painting over the European-biased New York School and its burning angst. And in works like *Ten Lizzes* (1963), where the actress's hair conjures the brooding and irregular masses of Franz Kline, Warhol showed that Abstract Expressionist motifs could be found in some not-so-lofty places.

Dance Diagram (1962), which was originally exhibited on a horizontal platform, seemed to specifically lampoon the Jackson Pollock two-step and Harold Rosenberg's famous description of the canvas as an arena in which the artist left not a picture, but evidence of an encounter. By using illustrations for outmoded dances like the tango and foxtrot, Warhol invited the viewer to dance on the grave of the art rituals Rosenberg championed, and to view his action-hero painter as just another campy persona. In a society swamped with mass media imagery, there was no room on the dance floor for transcendent aspirations. Calling to mind the chalk-marked outline of a body, these painted footprints also exuded a vaguely forensic air; a type of hero had died and no one could fill his larger-than-life shoes.

Much has been written about Pop as a stylistic rebellion against Abstract Expressionism's emphasis on introspection, personal feeling and existential, individualistic gesture – what could be called the Lee Strasberg school of 'method' painting – but Warhol dished out jokes at the expense of all kinds of art movements. The *Do It Yourself* paintings, also from 1962, played off

the idea of 'participatory aesthetics', preached earlier by the likes of John Cage and Allan Kaprow, and around this same time by the Fluxus group. Drolly literalising Duchamp's idea that the viewer completes the work of art, these paintings hinted that our popular culture was already participatory, far more so than art in fact – as no collector would actually finish colouring in Warhol's pictures.

For Warhol's de-sublimating wit, any art rhetoric that seemed inflated or idealistic was a ripe target. If minimalists sought to transform the cube, and the principle of seriality, into a reductivist aesthetic, banal yet also sombre and sublime, Warhol's *Brillo Boxes* (1964) again suggested one could find a parallel in the market-place, while calling attention to the gallery's status as a commercial arena. In a similar spirit, he sent up the industrial macho of much minimalist sculpture with his own weightless *Silver Clouds* (1966). Or he could take on the conceptual rhetoric about dematerialising the art object: on one level, *Cow Wallpaper* (1966) seems like a dig at the grave seriousness of Sol Lewitt's attempts to disrupt the frame of painting, and at the same time it brings Yves Klein's *Le Vide* – his 1958 exhibition of an empty gallery – down to earth. In fact, the idea for the wallpaper imagery was supposedly prompted by Ivan Karp's suggestion that earthy pictures – or more precisely, landscape painting – were a perpetual audience-pleaser. Andy's satiric response was to re-present the bucolic in Elsie-the-Cow-type packaging.

Rather than a stylistic rebellion, Warhol's Pop sprang from a realisation that there was little difference between Harold Rosenberg's 'tradition of the new' and the 'permanent revolution' of American business culture trumpeted by Henry Luce. In the late 50s and early 60s, a professionalised art world had become part of the larger culture industry. Looking back in 1968, Duchamp had bewailed this process of professionalisation. 'With commercialization has come the integration of the artist into society for the first time in a hundred years,' he complained. 'Today the artist is integrated, and so he has to be paid, and so he has to keep producing for the market.'[5] Compelled by commercial forces, the artist could no longer wait for inspiration to strike, but had to produce like a machine.

One way an artist could humorously respond to such a situation was to start up his own factory. As a commercial artist, Warhol had gained favour for the 'artiness' and handmade look of his drawing; with his Factory, he applied the same contrary strategy to the fine art world. Each market, after all, had its specific consumer audience and required a different kind of product differentiation. Again, Warhol's wit here is mainly de-idealising: art is no longer positioned as something that exists apart from consumer culture, but is merely another assembly-line product, demanding no special genius. Anyone could make it, as Warhol insisted with his repeated declarations that his assistants did most of the work. Perhaps the most poignant joke of Warhol's Factory, however, was the way deliberately inadequate quality control ensured the appearance of 'artistic' idiosyncrasies in its silk-screened products – the smudges and uneven surface application. Rather than the unique sensibility of the artist, 'individuality' was now synonymous with 'flawed'.

At its most sublime, humour extols the world's absurdities; as Freud argued, it finds a way to turn trauma into a source of pleasure. Pop did something similar. According to Andy, Pop was primarily a way of liking things – in particular, it was a way of finding pleasure in the absurdities of twentieth-century capitalism, and its culture of advertising and packaging.

What could be more absurd, after all, than an assembly-line commodity that comes to stand for home-cooking and motherly love, only rendered virgin and immaculate? Warhol's Campbell's Soup cans drolly showed us the Virgin Mary of our times. For his first show, in 1962 at the Ferus Gallery, he hung thirty-two paintings of these cans – a number determined not by aesthetic necessity, but by the number of Campbell's Soup flavours – and wrapped them around the gallery on a narrow white shelf, discreetly evoking a supermarket-type display. Warhol did know the difference, though, between a soup can and a Rothko. When asked by a New York dealer, he replied: 'Mr Rothko signs his name on the back of his product, and Campbell's does it on the front.'[6] But as Andy slyly hinted, both were signature products.

In using one repeated image for an entire show, Warhol insisted that pictorial vocabulary was not as important as packaging – the strategy by which an image is presented and addressed to its intended consumers. The idea that there is no inherent meaning in pictorial forms – an attitude which distinguishes Andy's low modernism from its high counterpart – was only part of the issue here. Warhol's wit was not only aimed at art, but also at the culture at large. As Robert Smithson noted around this time, 'only commodities could afford illusionistic values like purity and idealism; soap, for instance, is 99.44 percent pure, beer has more spirit, and dog food is ideal.'[7] Perhaps the best joke of all was to turn the language of packaging back on itself, to reveal the entropic abyss yawning beneath the 'aesthetics of plenty', to borrow Laurence Alloway's phrase. You didn't need an existential vocabulary to do this, you could use any commercial product. *Torn Campbell's Soup Can* (1962) was Warhol's pessimistic ode to a Grecian urn and arguably among the first of his disaster series.

Warhol was fatally fascinated by glamour, but he also took his wry revenge on it. While a single Elvis might look engaging, *Elvis Eleven Times* starts to look like a mass-manufactured item. In works such as this, Warhol coolly parodied the paradoxical mechanism of publicity: the more glamorous an image, the more it is replicated, and consequently the more common it becomes. But in *Elvis Eleven Times*, Warhol's sloppy silk-screening procedures ensure that each Elvis is actually slightly different. Do these arbitrary changes affect their content? I think they inevitably do. In the 30s, marketing psychologist Louis Cheskin created a classic experiment which demonstrated that the look of a package had an enormous impact on how consumers described the actual taste of the beer or crackers they sampled. It was a phenomenon he called 'sensation transference'.[8] By the 50s, this was already a commonplace of marketing research, and *Elvis Eleven Times*, like many other Warhol silk screens, explores the strange way that altered packaging redefines our perception of the 'content' we consume, to the point where our icons, rather than seeming predictable and stable, appear fickle and almost comically unsecured.

With its relentless de-idealising project, Warholian wit leads to a certain melancholy. An image economy which obliviously equates Mao and Marilyn may be comic from one perspective, but from another, it can seem like an indication of indifference, and an inability to make crucial distinctions. Warhol's art indifferently embodied that indifference and linked it specifically to the mass media's endless replication of images. 'When you see a gruesome picture over and over again,' he observed, 'it doesn't really have any effect.'[9] Especially when it's tinted in decorator colours, as with works like *Five Deaths on Red* or *Pink Electric Chair*.

'The world is a comedy to those who think, and a tragedy to those who feel,'[10] declared Horace Walpole. Warhol was plainly not in the feeling camp, and neither, he claimed, was the general populace. 'During the 60s, people forgot what emotions were supposed to be. And I don't think they've ever remembered,'[11] he famously remarked, adding that 'once you see emotions from a certain angle you can never think of them as real again.'[12]

By seeing emotions not as inherently meaningful, but as conventional and arbitrary responses, one can view even the grimmest tragedy from a comic perspective. In *The Philosophy*, Warhol writes of being on the Bowery after someone had committed suicide by jumping from the window of a dosshouse: 'A bum staggered over and said, "Did you see the comedy across the street?"' He concludes: 'I'm not saying you should be happy when a person dies, but just that it's curious to see cases that prove you don't *have* to be sad about it, depending on what you think it means, and what you think about what you think it means.'[13]

What then was Warhol's response to the news photo of a man leaping to his death which he replicated in *Suicide*? Remember these words: 'A person can cry or laugh. Always when you're crying you could be laughing, you have the choice.'[14] (This kind of traumatised humour has now found its way into religion. In Toronto, a new charismatic church exists whose service consists of a preacher listing a litany of horrors, deaths and disasters from the news; instead of talking in tongues, the congregation responds with hysterical laughter.)

One of the things Warhol liked about humour was that it was economical. Puns, like drag queens, have to do twice the work, while parody and satire, especially when understated, give you a two-for-one bargain: you get art, and you get something that makes a joke out of it. Warhol, who always liked a bargain, milked humour from his camp aesthetic of 'leftovers', his economical use of discarded images and people. 'If you can take [a leftover] and make it good or at least interesting,' he wrote, 'then you're not wasting as much as you would otherwise. ... It's also the funniest operating procedure because ... leftovers are inherently funny.'[15]

Leftovers are 'inherently funny' especially when they are exhibited in defiance of conventional classifications. The joke they then make comes at the expense of aesthetic hierarchies and the pretence of good taste and connoisseurship. Such was the case when Warhol curated a wry exhibition of leftovers, titled 'Raid the Icebox', in 1971 at the museum of the Rhode Island School of Design. As befits a self-proclaimed snacker, Andy was indifferent to the meat and potatoes in the museum's vaults, and instead chose to exhibit its collection in storage-drag. Among other items he selected were bundles of old magazines still tied in string, old hat boxes with the hats still in them, Windsor chairs that had been saved only for spare parts and a partially cleaned anonymous portrait. For a final touch, he had a tree, still tied up in a ball, dropped off at the museum's front door. As the museum director wrote in the show's catalogue: '... there were exasperating moments when we felt that Andy Warhol was exhibiting "storage" rather than works of art.'[16]

Warhol's leftover principle was probably most conspicuous in his film-making. 'I use the leftovers of show business, [people] turned down at auditions all over town. ... [People] whose talents are hard to define and almost impossible to market.'[17] In a society fuelled by calculated images of success, part of the humour of using these 'leftovers' was that failure could be con-

fused as the last refuge of authenticity. No matter what a bad performer tries to do, it never comes off, and therefore, concluded Warhol, 'it can't be phoney'.[18] There was another satisfaction as well: there is a sublimity in utter wrongness, a kind of purity, which caricatures the very idea of perfection. 'If you can't get someone who's perfectly right, it's more satisfying to get someone who's perfectly wrong,' Warhol maintained. 'Then you know you've really got something.'[19] (Warhol's leftover strategy was noted by Hollywood in the 1967 movie *The Producers*, in which a deliberately dreadful theatrical production becomes an unintentional hit. As a direct homage to Warhol, Dick Shawn, who plays the ultra-mod singer LSD, first appears on stage wearing a Campbell's Soup can around his neck.)

Warhol's cultivation of superstars parodied the Hollywood star system and suggested that charisma is not in-born, but an effect generated by publicity machines, a mere factory product in other words. His camera work, however, seemed to mimic a different area of film-making, and sets up yet another kind of humour. In *Chelsea Girls*, with its deliberately bad cinematography, sloppy zooming and scratched-up prints, Warhol ended up caricaturing the look of documentary movies; indeed, his sound films were shot with a newsreel camera, and presented viewers with unadulterated reality, with all its flaws and imperfections intact. And with performers rarely following the script, the line between documentary and fiction was often blurred, if not whited out completely, in such films.

Ultimately, this approach constitutes a more subversive humour than simply deflating or de-idealising: it aims instead to undermine the parameters of the real, to suspend the difference between the ersatz and the genuine. This kind of albino humour is a strategy also evident in the uncertainty Warhol promoted regarding the authorship of his Factory art. He confused critics and collectors alike, neither of whom could be sure if the piece they were examining was created by an authenticated artist or by unknown assistants.

Albino humour was also evident in Warhol's use of a tape recorder; once he began recording his conversations, Warhol observed that:

> Nothing was ever a problem again, because a problem just meant a good tape, and when a problem transforms itself into a good tape it's not a problem anymore. ... Everybody knew that and performed for the tape. You couldn't tell which problems were real and which problems were exaggerated for the tape. Better yet, the people telling you the problems couldn't decide any more if they were really having the problems or if they were just performing.[20]

This kind of delirious confusion of the ersatz and genuine – which typifies Warhol's albino humour – perhaps makes its first appearance in Warhol's own indeterminate image, which he began carefully packaging in his early twenties. At the age of 23 or 24, he decided to go grey so nobody would know how old he was: 'I would gain a lot by going gray,' he wrote. '(1) I would have old problems, which were easier to take than young problems, (2) everyone would be impressed by how young I looked, and (3) ... I could occasionally lapse into eccentricity or senility and no one would think anything of it. ... When you've got gray hair, every move you make seems "young" and "spry".'[21] Later, when he began wearing his silver wig and declared he wanted to be a machine, Warhol confused other kinds of distinctions – such as the line between cyborg and human.

At every step, Warhol's humour aimed to instil a state of uncertainty about his intentions. Nothing about him, not even his assassination, seemed wholly on the level. Sandwiched between the murders of Martin Luther King and Robert Kennedy, the attempt on his life, in retrospect, almost seems like another Warholian parody of a fashion trend – his would-be assassin, Valerie Solanas, was a leftover, after all, and so predictably botched the job. And Warhol himself never hesitated to turn even this trauma into a source of humour. Fashion conscious as ever, he commented afterwards that the surgery had left him looking 'like an Yves Saint Laurent dress – I had a lot of stitches.'[22]

His work ethic soon took over, however, as he sought a way to put his leftover flesh to work. In his *Philosophy*, a B tells him: 'I think you produced *Frankenstein* just so you could put your scars in the ad.'[23] And in the wake of his shooting, his earlier forensic images – of Marilyn, and other deaths and disasters – ended up taking on renewed poignancy. As a bumper sticker of the day declared, Warhol had found a new way to get back on the critical list.

In his second life, when he decided to seek immortality as a corporation (no one could assassinate a company, after all), he reiterated many of his earlier comedic tactics. He offered to paint portraits of the rich and famous, but also of their dogs, as if either constituted a reasonable subject. He religiously attended openings and parties, but again was comically indiscriminate; as Halston quipped, 'he'd go to the opening of a drawer.'[24]

The de-idealising tendency of his art also returns. In 1978, when Neo-Expressionism was coming into bloom, he caricatured its neo-heroic posturing with his Oxidation paintings, made by confusing a penis for a paint brush. In 1985, at New York's Area nightclub, a place where people go to be seen, he created his *Invisible Sculpture*. Perhaps the terminal point of his wit, though, is the 1984 untitled Rorschach series, which poked fun at the critical over-interpretation of his work, as well as responses inspired by his own hybrid persona. 'Instead of "going out to dinner", [people at New York restaurants are] "going out to atmosphere",'[25] Warhol had once observed, and in this work, he likewise provided an art atmosphere; viewers could supply the meaning they desired.

Today people still see the Andy they like. For some, it's the artist who fraternised with the Shah and the Reagans, for others it's the guy who made *Haircut* and *Tub Girls*. But despite his humour, some critics still find it necessary to raise the question of whether Warhol was a 'serious' artist, as if we couldn't take him seriously if he wasn't. Contemplating Warhol's *Ten Portraits of Jews of the Twentieth Century*, Robert Hughes asks: 'What other "serious" artist would contemplate doing [such] a series?'[26]

But one might just as well ask what other 'serious' artist would appear on *The Love Boat*, as Warhol did for the show's 200th anniversary episode in 1986. Certainly, there's a broad comedy in the mere appearance on this show of our most famous asexual cyborg, the loveless wonder of our times, who once proclaimed that 'The symptom of love is when some of the chemicals inside you go bad.'[27] But the episode makes another point as well: Warhol's appeal as the best-known American artist after Norman Rockwell trespasses the usual audience demarcations – his work, if not his personal appearance, appeals across class lines, and is admired by fans of *The Love Boat* as well as MoMA's board members. In the end, as Warhol's humour had argued all along, the distinction 'serious artist' is, if not a contradiction in terms, not a very useful notion.

In *POPism*, Warhol describes Eric Emerson as someone who was fascinating because 'you absolutely couldn't tell if he was a genius or a retard'.[28] It's a description that aptly sums up his own aesthetic strategy. Essentially, Warholian humour leads us to view belief of any kind – including belief in 'serious artists' – as suspect. It wryly insinuates that our relationship to representation is theological, based on faith, not rationality – which is why buying is more American than thinking. If you think too much, you might end up buying into beliefs you can't return for store credit. Andy's humour, on the other hand, counsels against a metaphysics that pits the true against the false, the genuine against the counterfeit. If surface is an illusion, it tells us, then so is depth. Consequently, we have a choice – we can either laugh or cry, we can either believe or disbelieve. Or we can try to exist in a state of perpetual window-shopping.

Catholic to the end, Warhol believed in salvation. Everything, in fact, should be saved, nothing should be left out – that way nothing had to be judged. He even envisioned the need for a 'smell museum' 'so certain smells wouldn't get lost forever'.[29] In these endeavours, the underlying goal of his humour was to disavow all possibility of loss, especially the trauma of rejection. In a culture sustained by grandiose expectations, Andy's ideal talk show was to be called *Nothing Special*.[30]

Since nothing is left out in the Andy Warhol School of Comedy Writing, anything can be turned into a joke. Even one's own death. Warhol's 1987 memorial service at St Patrick's Cathedral was held, appropriately enough, on April Fool's Day. He had said that when he died, he didn't want to be a leftover, but he felt that to simply disappear would be avoiding his obligation to work. As a compromise, he could imagine being reincarnated as a big ring on Pauline de Rothschild's – or Liz Taylor's – finger.[31] But basically, he wanted to go anonymously, to dissolve in a wake of albino wit. 'I'd like my tombstone to just say "figment",'[32] he quipped.

This figment's comedic legacy lives on. Besides the humorously traumatised figure of Garth, its most visible descendant is the new Las Vegas, where the ersatz and the genuine play off each other in a non-stop comedy of bad manners. Ultimately, the fatal triumph of Warhol's humour is that it has become as American as Campbell's, theme parks, gambling and *The Love Boat*.

Notes

1. Andy Warhol, *The Philosophy of Andy Warhol: From A to B and Back Again* (New York: Harcourt Brace Jovanovich, 1975), p. 49.
2. Ibid., p. 67.
3. Kynaston McShine (ed.), *Andy Warhol: A Retrospective* (New York: Museum of Modern Art, 1989), p. 411.
4. Warhol, *The Philosophy of Andy Warhol*, p. 95.
5. Pierre Cabanne, *Dialogues with Marcel Duchamp*, trans. Ron Padgett (New York: The Viking Press, 1971), p. 65.
6. Conversation with Dave Hickey.
7. Robert Smithson, 'Entropy and the New Monuments', in Nancy Holt (ed.), *The Writings of Robert Smithson* (New York: New York University Press, 1979), p. 11.
8. For more on Cheskin's work, see Thomas Hine, *The Total Package* (New York: Little, Brown, 1995).
9. Gene Swenson, 'What is Pop Art? Answers from 8 Painters, Part I', *Art News* 62 (November 1963), p. 60.
10. Horace Walpole, cited in Donald Kuspit's 'Tart Wit, Wise Humor', *Artforum* (January 1991), p. 94.
11. Warhol, *The Philosophy of Andy Warhol*, p. 27.
12. Ibid.

13. Ibid., p. 112.

14. Ibid.

15. Ibid., p. 93.

16. Andy Warhol, *Raid the Icebox* (Providence: Rhode Island School of Design, 1969), p. 15.

17. Warhol, *The Philosophy of Andy Warhol*, p. 92.

18. Ibid., p. 82.

19. Ibid., p. 83.

20. Ibid., pp. 26–7.

21. Ibid., pp. 98–9.

22. Quoted in footage from Chuck Workman's documentary, *Superstar.*

23. Warhol, *The Philosophy of Andy Warhol*, p. 11.

24. Quoted in footage from Chuck Workman's documentary, *Superstar.*

25. Warhol, *The Philosophy of Andy Warhol*, p. 159.

26. Robert Hughes, 'The Rise of Andy Warhol', in Brian Willis (ed.), *Art after Modernism* (New York: The New Museum of Contemporary Art, 1984).

27. Warhol, *The Philosophy of Andy Warhol*, p. 47.

28. Andy Warhol and Pat Hackett, *POPism: The Warhol '60s* (New York: Harper & Row, 1980), p. 212.

29. Warhol, *The Philosophy of Andy Warhol*, p. 151.

30. Ibid., p. 147.

31. Read by Nicholas Love at Warhol's memorial service (1 April 1987).

32. Paul Taylor, 'Andy Warhol: The Last Interview', *Flash Art* (International Edition; April 1987), p. 44.

Warhol's camp

Matthew Tinkcom

Upon its opening in the spring of 1994, the Andy Warhol Museum was heralded by a Pittsburgh gay newspaper as the 'largest museum in the world devoted to a gay artist'.[1] This statement was at odds with the Museum's own publicity, which described Warhol as 'the most influential artist of the second half of the 20th century' whose importance lay in the fact that 'the power of his work comes from its concentration on fundamental human themes – the beauty and glamour of youth and fame, the passing of time, and the presence of death.'[2] This contest between local gay activism and international art discourses reveals a significant fissure between what each wanted to claim in the name (or in the disappearance) of sexuality and artistic production, but it was not clear what was to be gained by either affirming or denying Warhol's status as a gay man. Once Warhol had been claimed as a gay artist, the question arose of how that was to be witnessed in his production. The question, from the point of fine-art production, became how to situate Warhol within a longer tradition of art in the 20th century, namely the avant-garde.

This moment introduces the problem of what might seem a nagging insistence upon avant-garde artistic production by gays as in some way being inflected by their sexuality, and I will address the

work of Andy Warhol in terms of the gay camp aesthetic in order to wonder how the idea of the avant-garde has neglected, at least in many of its critical descriptions, the vital importance of dissident sexualities in the historical project of ascertaining the 'avant-garde'. Avant-garde production can be understood as a radical response to the reorganisation of life under capitalist political economies, and has frequently been allied with leftist politics in order to interrogate and demystify the reshaping of everyday life under capital. A significant feature of the avant-garde has been its attention to the redefinition of sexualities within the industrial metropolis. Yet, as we well know, it has frequently been marked by a preoccupation with the powerful heterosexual tropes of desire; we need look only at Leger's *Ballet mécanique*, Salvador Dali's depictions of the female form, or more recently, the exercises of Jeff Koons to remember this. The effect has often been to equate the politics of the avant-garde legacy with *only* a radical heterosexuality, leaving open the question of whether gay, lesbian and other dissident sexualities might play a significant role in the avant-garde opposition to bourgeois culture.

In light of this, the task of underscoring Warhol's homosexuality as a vital force for the critical dimensions of his work is difficult to take up, particularly when we recall that the artist never depicted his work as interested in interrogating the dynamics of contemporary life from a leftist or Marxist interest. By this, I mean that critical and historical accounts of the avant-garde are bereft of any way of seeing how gay sexualities and sensibilities might inform the works of artists like Warhol. Ironically, despite the occlusion of gay themes and styles from idealisations of avant-garde practices, Warhol's artistic output was informed by his appreciation of gay responses to industrialisation, and this appearance of a gay sensibility within the avant-garde itself turns upon an important relation between gay subcultures and commodity culture, namely that of camp ironic practices. That is, what is most avant-garde about Warhol's work may also be what's most camp about it.

Recently, there have been many attempts to analyse and to theorise camp, but allow me here to offer my own definition. Camp is the alibi for gay-inflected labour to be caught in the chain of value-coding within capitalist political economies. By terming camp an 'alibi', I want to retain the notion that somehow a crime is being perpetrated, a crime upon value which involves gays passing off their labour as *not* differentiable so that they might enjoy the rewards of their work without being offered for nomination as participating in dissident sexual practices. At the same time, the trace of gay labour, which resides upon the commodity-form in its camp valences, also figures in this alibi because this trace allows for some consumers to wonder at the commodity's production ('did a gay have some hand in its making?') and, simultaneously, for others not to have to engage in any such speculation. By definition, an alibi (indeed, its Latin root) maintains the claim to having been elsewhere while the crime was being perpetrated; this does not mean that one did not participate in it, but that, as a suspect, one has the claim to being somewhere else, doing something besides being a criminal. This sense of camp's alibi preserves the tension of gay work as being produced under conditions where it is frequently a hazard to risk being named as gay, either by self-proclamation or through the act of being 'outed' by others.

Where camp's motives differ from those of the avant-garde might best be outlined in terms of the conditions under which each stance has arisen. Peter Bürger reminds us that the avant-garde is most powerfully understood as a set of institutions, ones that promulgate the notion that art is autonomous from the workings of capital in contemporary life. By autonomous, Bürger means

that the avant-garde can claim to investigate our ways of looking and hearing only by accepting that, in some measure, avant-garde production is irrelevant to more dominant economies of representation; taking his cue from Theodor Adorno, Bürger sets the avant-garde against popular culture. Yet, Bürger suggests that the apparent autonomy of the avant-garde is an illusion, one based upon the idea that, sanctioned from the noise of popular culture, the avant-garde artist can more fully perceive the operations of mystification which inhere to bourgeois cultural production. Reciting Adorno's claim that 'it is impossible to conceive of the autonomy of art without covering up work',[3] Bürger then suggests that 'like the public realm, the autonomy of art is a category of bourgeois society that both reveals and obscures an actual historical development'.[4] It is my claim that an actual historical development which idealisations of the avant-garde obscure, at least in the case of Warhol, is a gay camp sensibility as it had a measurable influence upon him. The 'covering up' of work, which Adorno describes and which bolsters avant-garde claims to autonomy, becomes more apparent for us in a discussion of Warhol when we consider Warhol's artistic training, not within the realm of fine-art production, but within the gay demimonde of New York fashion retailing and advertising during the 50s. For, in terms of that setting we might perceive the artist's talents to navigate the treacherous waters of a homophobic America and the conditions of its popular cultural production.

By raising the question of gay camp in the context of Warhol's subsequent work, particularly in cinema, I am suggesting that revisionings of his work in the name of the avant-garde have often cleaved gay camp apart from his output. And, by the way, there's every indication that Warhol understood the risks of articulating camp and homosexuality; witness the conversations with Emile de Antonio recorded in *POPism: The Warhol '60s*, where Warhol describes the animosity felt towards him by such Hemingway-esque straight-dude artists of the 50s as Pollock or de Kooning. (For a particularly fervent denunciation of gay tastes, see Vivian Gornick's pungent commentary in her *Village Voice* piece, 'It's a Gay Hand That Stokes the Campfire'.) But, ironically, it may be that the avant-garde disavowal of gay camp, which preserves the fictive autonomy about which Bürger warns us, occurs as much through the hostility of the avant-garde to popular culture as it does from any homophobia. Thus, if we should historicise Warhol in relation to the appearance of camp practices in post-war American commodity culture, it is not necessarily in order to preserve or apologise for the inadequacy of the idea of avant-garde production. That said, I would add that a specific feature of some avant-garde projects has been to pay attention to the proliferation of commodities and the social relations that they embody, a hallmark shared by camp. The question then becomes: what do avant-garde antagonisms and camp ironies share?

Let us remind ourselves of the avant-garde interest in the commodity form through Walter Benjamin. Benjamin sensed the power of capital's fresh energies to redefine consciousness when he described industrialism's 're-enchantment' of the social arena. For Benjamin, even to embark upon a critique of the social organisation of capital meant confronting the profusion of goods arrayed within the metropolis, where 'the commodities are suspended and shoved together in such boundless confusion, that [they appear] like images out of the most incoherent dreams.'[5] In order to confront the vibrant experiences to be had at the dawning of the age of consumerism, Benjamin's impulse was to consider the dream as a metaphor for the waking confusions which inhere to the experiences of commodity proliferation. These confusions (or, more helpfully, contradictions) account for the social formations and daily habits to which commodity-production gives form. As Susan Buck-Morss formulates this approach:

Here was a fundamental contradiction of capitalist-industrial culture. A mode of production that privileged private life and based its conception of the subject on the isolated individual had created brand new forms of social existence – urban spaces, architectural forms, mass-produced commodities, and infinitely reproduced 'individual' experiences – that engendered identities and conformities in people's lives, but not social solidarity, no new level of collective consciousness of the commonality and thus no way of waking up from the dream in which they were enveloped.[6]

We should note from Buck-Morss's reading of Benjamin that the subsumption of social consciousness within the realm of commodity-production is total and complete (as dreaming and waking become one in her analysis). While in general we might agree to the power of capital over those whose primary relation is that of wage-earner and consumer, it is not so immediately evident that the meanings to which the commodities give rise are always the same. Working from the notion that capital *engenders* its subjects, what of those subjects whose gendering works at cross-purposes to the total subsumption of their consciousness: what of the experiences and responses, for example, of some gays?

Benjamin sounds the call for us to pay attention to the proliferation of commodities, for in them we discover the reification of the historical development of capital. What Benjamin did not anticipate was that the circulation of commodities could take them into social settings that might redefine how and what those commodities mean. When we think of Benjamin gazing through the shop windows of the Paris arcades at the array of new goods, we might also remember that Warhol (and many of his contemporaries in New York, Rauschenberg and Johns among them) were originally window-dressers. The appearance of the Germanic critical eye on one side of the window may be met by its counterpart on the other, the camp gay artist organising the goods to be beheld in the spectacle of the window. Karl Marx, meet Oscar Wilde.

Most powerful among Benjamin's insights into the changing value of artistic production was his claim about the disappearance of aura from the artwork. For Benjamin, this occurred at the moment that the work no longer seemed singular and divinely remote and, of course, he was addressing the power of serial production to undermine a piece's sanctified status. Bürger powerfully reads Benjamin as having missed the strength of his own argument by insisting on periodisation; according to Bürger, the loss of aura is less helpfully debated in terms of a moment in which artistic aura might have faded (the appearance of non-sacral art, or the ascent of the bourgeoisie after the French Revolution), and more convincingly seen in terms of the processes of production and reception that were changed by industrial production. Bürger writes that

> the explanation of the change in the mode of reception by the change in reproduction techniques acquires a different place value. It can no longer lay claim to explaining a historical process, but at most to being a hypothesis for the possible *diffusion* of a mode of reception that the dadaists were the first to have intended.[7]

Bürger indicates that reproducibility and seriality do not necessarily beget habits of critique commensurate with these new features of cultural production. While, in Bürger's reading of Benjamin, industrial techniques spelled the death of aura, this did not necessarily entail radical new forms of viewing, especially of works reproduced serially (i.e. popular culture). Such new,

and critical, viewing practices would only appear when the avant-garde made demands of its audiences by upsetting and bewildering them. Yet, in camp we witness viewing practices (Bürger's 'diffusion of modes of reception') which do insist on reading both avant-garde art and popular culture for their limits and contradictions; the problem is that the gay marginality that gave rise to camp has never been understood as being in any way radical in the sense that a left-ist avant-garde might wish it. And it would seem that camp has had an upsetting and bewildering effect upon its critics; for this we might look at Stanley Kaufmann's repeated broadside attacks upon Tennessee Williams's plays during the 50s and 60s, where Williams's heroines become for Kaufmann an attack upon proper American femininity.

These problems within the avant-garde are important for situating Warhol's cinematic output, because Warhol's films did not necessarily depict the relation between artist and world, or critic and world, that the avant-garde tradition bequeathed to him. Responding to the overwhelming presence of Hollywood film in modern America, Warhol sought to use the materials of Hollywood in order to critique it. In particular, it was his great insight that film was like Duchamp's bottle-drier and snow-shovel; it circulated within the same domains of producer and consumer as virtually everything else made in industrial settings, and yet it did not restrict how its viewers could respond to it. (Nor for that matter did most commodities, as Duchamp's found objects sought to demonstrate.) As such, film could be both a powerful tool for demystifying everyday life and it could be a source of pleasure in the process. And, while this insight itself rested upon a contradiction: namely, that film in the 20th century has within the American set-ting been overwhelmed by Hollywood, to the exclusion of other kinds of film-making, Warhol's film-work breaks with a tradition, beginning with Horkheimer and Adorno, and continuing within the United States in the work of Clement Greenberg and Dwight MacDonald, in which popular culture was vilified as so much kitsch or 'ersatz high culture'.

Despite the saturating presence of Hollywood, which Warhol dreamed of in his Pittsburgh youth and, indeed, dreamed of all his life, his films demonstrated the dual bind of camp in that they were so alien to the very Hollywood product which they seemed to emulate. Warhol's cinema took its shape as a response to, but not a rejection of, the presence of Hollywood. Yet, how does camp function as a critique of the industries? Moe Meyer has recently claimed that camp 'is a suppressed and denied oppositional critique embodied in the signifying practices that processually constitute queer identities'.[8] Although I agree with Meyer's impulse to see camp as embodying an oppositional stance, I would suggest that camp is more productively seen in rela-tion to what it says about bourgeois representation (and its tendencies to exclude gays) than in whatever help it lends in the formation of identities. In fact, if camp were only instrumental in the formation of yet another identity (or as part of the trajectory whereby 'queer' replaces 'gay and lesbian' replaces 'homosexual') there would seem to be little to say about where those iden-tities are embedded in current social arrangements. It is more important to ascertain how camp critiques capitalist social organisation in its analysis of the work involved in producing representations that exclude same-sex desiring subjects, and how camp's energies are devoted to a constant reinsertion of gay tastes into the consumption and recirculation of 'straight' imagery. In order to ground this claim, I would focus upon one feature of Hollywood which Warhol's camp visions worked upon: namely glamour.

Warhol's films of the underground period sought to emulate the feel of Hollywood, not by emulating conventional narrative patterns, but by creating their own versions of glamour. In large measure, camp interest in Hollywood cinema is driven by spectacle and glamour, over and above narrative and identification. By spectacle, I mean that the cinematic image, be it the flickering light on the film screen or the 8x10 glossy of the movie star, is frequently arrested from its bond with the narrative and fixed in other sets of meanings. In this sense, the camp registers of Warhol's films accentuate the production of Hollywood and its related industries *as production by its spectators*, at least to the extent that they show how the media of popular culture can be manipulated to produce meanings probably unintended by the industries themselves.

The impulse by camp viewers to emphasise Hollywood's production of spectacle, *vis-à-vis* glamour, stems from the all-too-frequent perception of how gay life has been mostly excluded from Hollywood films, except for the occasional depiction of pathological homosexuality or a 'sympathetic' account of the miseries of gay life. (And, for an example of both those things, I would direct you to the blockbuster hit *Philadelphia*, whose own depiction of an opera queen embeds the gay man's attention to diva-glamour as a symptom of his own bathos-laden destruction.) Rather than ignore Hollywood because of its censorship of dissident sexualities, the camp underpinnings of Warhol's films take up Hollywood iconography at the moment in which it departs from narrative, in the form of the glamorous star icon.[9]

If not invented by the Hollywood studios, certainly the phenomenon of glamour in the 20th century must be one of Hollywood's most significant achievements. Loosely defined, we might say that glamour is the sense that an image achieves what could never be secured in our own everyday efforts; we are held in the thrall of the glamorous image because it depicts people and lives that are not our own. Not only is this because we are prohibited from imitating the glamorous image by virtue of our various physical shortcomings, but because we have little sense of the complicated efforts demanded in the enhancement of stars through make-up, costuming, lighting and film-stocks. Glamour, then, is profoundly a mystification. When we behold the image of a star, say in the voluptuous surfaces of a photograph by Hurrell or the renderings of Dietrich as captured by Von Sternberg, the glamorous image entreats us to defer to its power without recourse to understanding under what circumstances the image was made. We are subsequently prevented from an analysis of glamour because glamour is antithetical to labour; the failure of such an analysis to appear can be remarked upon in the primary metaphor of fans' responses to movie-stars. The fan is rendered helpless in the sight of the star's image.

Richard Dyer discusses the power of star-iconography in terms of 'charisma'. Dyer offers Max Weber's formulation of charisma, 'a certain quality of an individual personality by virtue of which he [*sic*] is set apart from ordinary men and treated as endowed with supernatural, superhuman or at least superficially exceptional qualities', and reads the power described in Weber's definition in terms of how stars are ideological embodiments of particular historical notions of femininity, beauty, morality and so on. Vital for my treatment of Warhol's films is Dyer's suggestion that, 'star charisma needs to be situated in the specificities of the ideological configurations to which it belongs', and that 'virtually all sociological theories of stars ignore the *specificities* of another aspect of the phenomenon – the audience.' He adds, 'I would point out the absolutely central importance of stars in gay ghetto culture' and that 'if these star–audience relationships are only an intensification of the conflicts and exclusions experienced by everyone, it is also sig-

nificant that, in any discussion of "subversive" star images, stars embodying adolescent, female and gay images play a crucial role.'[10] The ways that stars may embody gay images, though, has been notoriously complex to document, especially given the ways that many gays have *identified* with female stars (Garland, Taylor, Crawford, Davis and Monroe) while *desiring* male stars (Hudson, Clift, Dean and Brando).

As we know, Warhol was a fan all his life, beginning in Pittsburgh, where he filled in colouring books of stars while he was home from school, writing letters to Truman Capote during the 50s and taking photos of stars at the Factory and Studio 54 when he himself had become a star. These moments help to describe the link between gays and female stars as occurring through a perception on the part of the gay fan that glamour marks the achievement of becoming, through the expense of labour, something that one is not. For the female star, that 'something else' is perceived to be the star as in possession of an exceptional beauty that is further enhanced by clothing and make-up (which indeed would not exist without the clothing and make-up), while for the gay fan it comments upon the exclusion of many gays from cinematic/cultural depictions of seduction and heterosexual union. Sometimes, gay camp critique takes the form of drag, but it also appears through the intense devotion of the gay fan to one female star who embodies strength, vulnerability or humour and a defence against that exile from representation.

Even if the effect of glamour is that it seems to involve a complete lack of effort, that the star simply *is* glamorous, the achievement of glamour requires an immense expenditure of time, investment and effort on the part of the studio.[11] Indeed, we should take pains to remember that, apart from glamour's concealed labour, some versions of cinematic spectacle do encourage audiences to sit in awe at the expense of money and labour. For example, in the creation of immense sound-stages for historical epics or action-pics (such as De Mille's Roman Circuses or the *Die-Hard* films' exploding buildings), spectacle often demands our wonder at the magnitude of the project's undertaking. In contrast, glamour seldom seeks to portray equally enormous undertakings; audiences are seldom called upon to marvel at the fact that a star has been rendered even *more* beautiful. But it was this spectacle which Warhol sought to make even more spectacular. Remembering Warhol's comment that he wanted $1,000,000 from Hollywood to make a movie, I can only hazard that the final product might have looked like *Terminator II* with Rupaul playing the hero.

Warhol's films, then, depict glamour as a lever which refigures Hollywood through the gay camp spectator's reading. This involves reversing glamour, from being a form of concealed labour, to becoming a spectacle of its own conditions of production. For Warhol, this reversal would take the form of sustaining glamour by making remarkably marginalised figures into Factory stars. Warhol's work takes up the production of glamour in the everyday, in which non-stars produce themselves to be looked at.

Now, in a longer project I will explore this dynamic more fully through the course of Warhol's film-making career, but in the present context allow me to take up this motif of camp, labour and glamour in reference to one film only. In *Haircut* (a silent production from 1964), three men are seen; one carefully cuts another's hair, while the third packs a pipe with what appears to be marijuana and takes long, hypnosis-inducing drags from it.[12] With no edits save the reel changes, they go about the work of snipping and combing, all the while chatting casually and

ignoring the presence of the camera. As they groom themselves, they pose themselves within the frame, forming at moments abstracted compositions; even in a domesticated moment such as this, we see them taking pains to remember their appearances. The effect of *Haircut* is that it drives us back into the realm of the mundane, only to reveal the efforts required of us to appear within that quotidian life: even if we don't function as stars, star culture functions within us as we go about preparing ourselves for the world. At the film's conclusion, the figures fix their gazes directly upon the camera, seeming to respond to some unheard request from the director, and in this final tableau they display their handiwork. Finally, they begin to laugh, as if on cue, and we are left with this silent and ambiguous gesture that could be a mockery of us or an entreaty to share their pleasure. Particularly striking about this final segment is the serenely detached way in which they fix our gaze: these are expressions seemingly taken directly from the Hollywood icon. Cool and remote, like Harlow or Crawford, the stars of *Haircut* share with us the pleasures of being seen and *knowing* that one is being seen.

We can hardly ignore, though, in *Haircut* the fact that the action takes place in a rather squalid loft, and is lighted by a glaring lightbulb within the frame. Freddy Herko, one of the figures, is nude, and the clothing of the others displays the tattered flourishes of bohemian style, at the time signalled by their comparatively long hair. In this setting, it becomes apparent that we are nowhere near the glamour-mills of a Hollywood studio, and the film then presents us with the question of what impulse would drive the minute attentions given by these men to their appearance. I would hazard that, in part, the film serves to remind us of the immense difference between those whom Hollywood cinema understood itself as appealing to and, in this particular case, the inadvertent gay fans who model themselves upon it.

To conclude: I began this essay with the suggestion that Andy Warhol's films, as they have been subsumed to the avant-garde, operate in distinct tension to what the avant-garde is said to be capable of showing us. And perhaps it is not the case that what Warhol's cinematic visions depict is that different from the claims of avant-gardism as enumerated by its promoters and critics: if anything, we might all agree that a different sense of how we could look at the world might arise through inventive reuses of film in non-corporate settings of production. Yet Warhol sought to extend the capacities of film for a camp re-visioning of the world *through* his attentions to popular media in ways that make it difficult for us to understand the project of an avant-garde. The films strain avant-garde definitions in two respects: first, they honour the power of Hollywood film for the gay men who campily respond to it, and second, they indicate how much work is required in forging the camp response.

Given that Warhol departed from hands-on film-making after 1968, it is worth remembering these things for several reasons. For one thing, Warhol was commenting on processes of cultural production and dissemination that continue: Hollywood's place in the popular imagination is arguably stronger than ever and the dynamics which the underground film could imitate, mock, disavow and embrace are still central to our lives. Second, the processes of cultural appropriation work on both sides of production and critique: if Warhol used the icons and methods of Hollywood to explore the margins of its viewership, it was only a matter of time within the dynamics of mass-cultural production that his works would come to be imitated. Hollywood could (and did) reappropriate those very notions of the marginal for its own purposes, and one reads with a certain sadness the passages in *POPism* where the Factory members sense, upon

the release of John Schlesinger's *Midnight Cowboy*, an ill-judged euphoria over their future access to Hollywood, an access which never came for them. So much for that moment of capital's re-enchantment. Further, the fact of camp contestations over the functions of popular culture continue; the Oscar given in 1995 to *Priscilla, Queen of the Desert* for its splendid costuming signals camp's fascination with glamour as a now more central issue for popular cinema, while Bruce LaBruce's recent release *Super 8¹/₂* foregrounds Warhol's continuing importance for new visions of queer cinema. These lessons only affirm the importance of gay camp contributions to the avant-garde project *and* to popular forms, contributions which now, more than ever, continue to delight and challenge us.

Notes

1. *Planet Queer* (Pittsburgh), Spring 1994.
2. *The Andy Warhol Museum* (Pittsburgh: The Carnegie Museum of Art, Carnegie Institute, 1992); a promotional brochure distributed to schools and museums in advance of the museum's debut.
3. Theodor W. Adorno, *Asthetische Theorie*, ed. Gretel Adorno, R. Teidemann (Frankfurt: Suhrkamp, 1970), p. 9, cited in Peter Bürger, *Theory of the Avant-Garde*, trans. Michael Shaw (Minneapolis: University of Minnesota Press, 1984).
4. Bürger, *Theory of the Avant-Garde*, p. 36.
5. Walter Benjamin, quoted in Susan Buck-Morss, *The Dialectics of Seeing: Walter Benjamin and the Arcades Project* (Cambridge: MIT Press, 1990), p. 254. I am here relying upon Buck-Morss's reconstruction of Benjamin's unfinished *Passagen-Werk*, a monumental project in which Benjamin sought to account for the social organisation of the modern city that gave rise to the profusion of goods witnessed in the arcades of 20s Paris.
6. Buck-Morss, *The Dialectics of Seeing*, p. 261.
7. Bürger, *Theory of the Avant-Garde*, p. 29.
8. Moe Meyer (ed.), *The Politics and Poetics of Camp* (New York: Routledge, 1994), p. 1.
9. Camp fascination with glamour, as exploited in the work of Warhol, takes off from a perception of star imagery similar to that of Laura Mulvey in 'Visual Pleasure and Narrative Cinema'. Mulvey described the tendency of the female star to arrest, however temporarily, the narrative momentum of a Hollywood film, and her primary interest was to theorise the dynamics of patriarchal pleasure, i.e. how heterosexual male spectators were positioned to gaze upon the sight of the star. Interestingly, Mulvey's subsequent addendum to her essay addressed *female* (both heterosexual and lesbian) spectatorial pleasure, but did not provide an account of how the male homosexual might respond to the same image. See Laura Mulvey, 'Visual Pleasure and Narrative Cinema', *Screen* vol. 16 no. 3 (Autumn 1975) and 'Afterthoughts on "Visual Pleasure and Narrative Cinema" inspired by *Duel in the Sun*', *Framework* vol. 6 nos. 15–17 (1981).
10. Richard Dyer, 'Charisma', in Christine Gledhill (ed.) *Stars: Industry of Desire* (London: Routledge, 1991), p. 59.
11. The work demanded to achieve glamour, we should remember, is highly regimented and coordinated, and frequently in Hollywood, performed by women. While some of this labour is rendered glamorous in itself (as in accounts of Cecil Beaton's work, for example), more often it has taken the form of sweat-shop labour. See Elizabeth Nielsen, 'Handmaidens of the Glamour Culture: Costumers in the Hollywood Studio System', in Jane Gaines and Charlotte Herzog (eds), *Fabrications: Costume and the Female Body* (New York: Routledge, 1990), pp. 160–79.
12. Freddy Herko, one of the stars of *Haircut*, was an important figure for Warhol in his transition to the underground scene in New York; Herko brought many of the 'A-men' (amphetamine users) to the early Factory and put Warhol in touch with many of the figures who would populate the Factory. Warhol later wrote, 'The people I loved were the ones like Freddy, the leftovers of show business, turned down at auditions all over town. They couldn't do something more than once, but their one time was better than

anyone else's. They had star quality, but no star ego – they didn't know how to push themselves. They were too gifted to lead 'regular lives', but they were also too unsure of themselves to ever become real professionals.' Andy Warhol and Pat Hackett, *POPism: The Warhol '60s* (New York: Harper & Row, 1980), p. 56.

Death in America[1]

Hal Foster

In *The Philosophy of Andy Warhol* the great *idiot savant* of our time
chats about many of the big subjects – love, beauty, fame, work –
but when it comes to death this is all he has to say: 'I don't believe
in it because you're not around to know that it's happened. I can't
say anything about it because I'm not prepared for it.'[2] On first
reading, there is not much in this stony demurral (which has little
of the light wit of the rest of the book); yet listen again to these
phrases: 'not around to know . . . can't say anything . . . not pre-
pared'. There is a break in subjectivity here, a disorientation of
time and space. To me it suggests an experience of shock or trau-
ma, an encounter where one misses the real, where one is too
early or too late (precisely 'not around', 'not prepared'), but where
one is somehow marked by this very missed encounter.

I fix on this idiosyncratic passage because I think it encrypts a
relation to the real that suggests a new way into Warhol, especial-
ly into the 'Death in America' images from the early 60s, one that
may get us beyond the old opposition that constrains so many
approaches to the work: that the images are attached to referents,
to iconographic themes or to real things in the world, or, alterna-
tively, that the world is nothing but image, that all Pop images
represent are other images.[3] Most readings not only of Warhol but

117

of post-war art based in photography divide somewhere along this line: the image as refer------¹ or as simulacral. This is a reductive either/or that a notion of traumatic realism may ope productively.⁴

Traumatic Realism

It is no surprise that the simulacral reading of Warholian Pop is advanced by critics associ with poststructuralism, for whom Warhol is Pop and, more importantly, for whom the theo the simulacrum, crucial as it is to the poststructuralist critique of representation, sometim seems to depend on the example of Warhol as Pop. 'What Pop art wants', Roland Barthes in 'That Old Thing, Art', 'is to desymbolize the object,' that is, to release the image from meaning (metaphoric association or metonymic connection) into simulacral surface.⁵ In th process the author is also released: 'The Pop artist does not stand behind his work,' Barthe continues, 'and he himself has no depth: he is merely the surface of his pictures, no signifi intention, anywhere.'⁶ With variations this reading of Warholian Pop is performed by Mich Foucault, Gilles Deleuze, and Jean Baudrillard, for whom referential depth and subjective interiority are also victims of the sheer superficiality of Pop. In 'Pop: An Art of Consumption?', Baudrillard agrees that the object in Pop 'loses its symbolic meaning, its age-old anthropomorphic status'.⁷ But where Barthes and company see an avant-gardist disruption of representation, Baudrillard sees an 'end of subversion', a 'total integration' of the art work into the political economy of the commodity-sign.⁸

The referential view of Warholian Pop is advanced by critics and historians who tie the work to different themes: the worlds of fashion, celebrity, gay subculture, the Warhol Factory, and so on. Its most intelligent version is presented by Thomas Crow, who, in 'Saturday Disasters: Trace and Reference in Early Warhol', disputes the simulacral account of Warhol that the images are indiscriminate and the artist impassive. Underneath the glamorous surface of commodity fetishes and media stars Crow finds 'the reality of suffering and death'; the tragedies of Marilyn, Liz and Jackie in particular are said to prompt 'straightforward expressions of feeling'.⁹ Here Crow finds not only a referential object for Warhol but an empathetic subject in Warhol, and here he locates the criticality of Warhol – not in an attack on 'that old thing, art' (as Barthes would have it) through an embrace of the simulacral commodity-sign (as Baudrillard would have it), but rather in an exposé of 'complacent consumption' through 'the brutal fact' of accident and mortality.¹⁰ In this way Crow pushes Warhol beyond humanist sentiment to political engagement. 'He was attracted to the open sores in American political life,' Crow writes in a reading of the electric-chair images as agitprop against the death penalty and of the race-riot images as a testimonial for civil rights. 'Far from a pure play of the signifier liberated from reference', Warhol's art belongs to the popular American tradition of 'truth-telling'.¹¹

This reading of Warhol as empathetic, even *engagé*, is a projection (an essay could be written on the desire of leftist critics to make Warhol over into a contemporary Brecht). But it is no more a projection than the superficial, impassive Warhol, even though this projection was his own: 'If you want to know all about Andy Warhol, just look at the surface of my paintings and films and me, and there I am. There's nothing behind it.'¹² Both camps make the Warhol they need, or get the Warhol they deserve; no doubt we all do. (What is it, by the way, that renders Warhol such a site for projection? He posed as a blank screen, to be sure, but Warhol was very aware of these projections, indeed very aware of identification as projection; it is one of his great sub-

jects.[13]) In any case neither projection is wrong; but they cannot both be right . . . or can they? Can we read the 'Death in America' images as referential and simulacral, connected and disconnected, affective and affectless, critical and complacent? I think we must, and I think we can if we read them in a third way, in terms of traumatic realism.

One way to develop this notion is through the famous motto of the Warholian persona: 'I want to be a machine.'[14] Usually this statement is taken to confirm the blankness of artist and art alike, but it may point less to a blank subject than to a shocked one, who takes on the nature of what shocks him as a mimetic defence against this shock: I am a machine too, I make (or consume) serial product-images too, I give as good (or as bad) as I get. 'Someone said my life has dominated me,' Warhol told Gene Swenson in the celebrated interview of 1963. 'I liked that idea.'[15] Here Warhol has just confessed to the same lunch every day for the past twenty years (what else but Campbell's soup?). In context, then, the two statements read as a preemptive embrace of the compulsion to repeat put into play by a society of serial production and consumption.[16] If you can't beat it, Warhol suggests, join it. More, if you enter it totally, you might expose it; that is, you might reveal its automatism, even its autism, through your own excessive example. Used strategically in Dada, this capitalist nihilism was performed ambiguously by Warhol, and many artists have played it out since.[17] (This is a performance, of course: there is a subject 'behind' this figure of nonsubjectivity who presents it as a figure. Otherwise the shocked subject is an oxymoron, for, strictly speaking, there is no subject in shock, let alone in trauma. And yet the fascination of Warhol is that one is never certain about this subject 'behind': is anybody home, inside the automaton?)

These notions of shocked subjectivity and compulsive repetition reposition the role of repetition in the Warhol persona and images. 'I like boring things' is another famous motto of this quasi-autistic persona. 'I like things to be exactly the same over and over again.'[18] In *POPism: The Warhol '60s* Warhol glossed this embrace of boredom, repetition, domination: 'I don't want it to be essentially the same – I want it to be exactly the same. Because the more you look at the same exact thing, the more the meaning goes away, and the better and emptier you feel.'[19] Here repetition is both a draining of significance and a defending against affect, and this strategy guided Warhol as early as the 1963 interview: 'When you see a gruesome picture over and over again, it doesn't really have any effect.'[20] Clearly this is one function of repetition: to repeat a traumatic event (in actions, in dreams, in images) in order to integrate it into a psychic economy, a symbolic order. But the Warhol repetitions are not restorative in this way; they are not about a mastery of trauma.[21] More than a patient release from the object in mourning, they suggest an obsessive fixation on the object in melancholy. Think of all the Marilyns alone, of all the cropping, colouring, and crimping of these images: as Warhol works over this image of love, the 'hallucinatory wish-psychosis' of a melancholic seems to be in play.[22] But this analysis is not right either. For one thing the repetitions not only reproduce traumatic effects; they produce them as well (at least they do in me). Somehow in these repetitions, then, several contradictory things occur at the same time: a warding away of traumatic significance and an opening out to it, a defending against traumatic affect and a producing of it.

Here I should make explicit the theoretical model I have implicated so far. In the early 60s Jacques Lacan was concerned to define the real in terms of trauma. Titled 'The Unconscious and Repetition', this seminar was roughly contemporaneous with the 'Death in America'

images (it ran in early 1964).[23] But unlike the theory of simulacra in Baudrillard and company, the theory of trauma in Lacan was not influenced by Pop. It was, however, informed by Surrealism, which has its deferred effect on Lacan here, an early associate of the Surrealists; and Pop is related to Surrealism as a traumatic realism (certainly my reading of Warhol is a Surrealist one). It is in this seminar that Lacan defines the traumatic as a missed encounter with the real. As missed, the real cannot be represented; it can only be repeated, indeed it must be repeated. '*Wiederholen*', Lacan writes in etymological reference to Freud on repetition, 'is not *Reproduzieren*'; repetition is not reproduction.[24] This can stand as an epitome of my argument too: repetition in Warhol is not reproduction in the sense of representation (of a referent) or simulation (of a pure image, a detached signifier). Rather, repetition serves to screen the real understood as traumatic. But this very need points to the real, and it is at this point that the real ruptures the screen of repetition. It is a rupture not in the world but in the subject; or rather it is a rupture between perception and consciousness of a subject touched by an image. In an allusion to Aristotle on accidental causality, Lacan calls this traumatic point the *tuché*; in *Camera Lucida* Barthes calls it the punctum.[25] 'It is this element which rises from the scene, shoots out of it like an arrow, and pierces me,' Barthes writes. 'It is what I add to the photograph and what is nonetheless already there.' 'It is acute yet muffled, it cries out in silence. Odd contradiction: a floating flash.'[26] (This confusion about the location of the rupture, *tuché*, or punctum is a confusion between subject and world, inside and outside. It is an aspect of trauma; indeed, it may be this confusion that is traumatic. 'Where Is Your Rupture?' Warhol asks in a 1960 painting of a newspaper advertisement of a nude female torso.)

In *Camera Lucida* Barthes is concerned with straight photographs, so he relates the punctum to details of content. This is rarely the case in Warhol. And yet there is a punctum for me (Barthes stipulates that it is a personal effect) in the indifference of the passerby in *White Burning Car III* (1963). This indifference to the crash victim impaled on the telephone pole is bad enough, but its repetition is galling, and this points to the general operation of the punctum in Warhol. It works less through content than through technique, especially through the 'floating flashes' of the silk-screen process, the slipping and streaking, blanching and blanking, repeating and colouring of the images. To take another instance, a punctum arises for me less from the slumped woman in the top image in *Ambulance Disaster* (1963) than from the obscene tear that effaces her head in the bottom image. Just as the punctum in Gerhard Richter lies less in details than in the pervasive blurring of the image, so the punctum in Warhol lies less in details than in this repetitive 'popping' of the image.[27]

These pops, such as the slipping of the register of the image and the washing of the whole in colour, serve as visual equivalents of our missed encounters with the real. 'What is repeated', Lacan writes, 'is always something that occurs . . . as if by chance.'[28] And so it is with these pops: they seem accidental, but they also appear repetitive, automatic, even technological (the relation between accident and technology, crucial to the discourse of shock, is another great subject of Warhol).[29] In this way Warhol elaborates on our optical unconscious, a term introduced by Walter Benjamin to describe the subliminal effects of modern technologies of the image. Benjamin developed this notion in the early 30s, in response to photography and film; Warhol updates it thirty years later, in response to the post-war society of the spectacle, of mass media and commodity-signs.[30] In these early images we see what it looks like to dream in the age of television, *Life* and *Time*; or rather, what it looks like to nightmare as shock victims who

prepare for disasters that have already come, for Warhol selects moments when this spectacle cracks (the JFK assassination, the Monroe suicide, racist attacks, car wrecks), but cracks only to expand.[31]

Content in Warhol is thus not trivial (Crow is absolutely right here). A white woman slumped from a wrecked ambulance, or a black man attacked by a police dog, is a shock. But, again, it is this first order of shock that the repetition of the image serves to screen, even if in doing so the repetition produces a second order of trauma, here at the level of technique where the punctum breaks through the screen and allows the real to poke through. The real, Lacan puns, is 'troumatic', and the tear in *Ambulance Disaster* is such a hole for me, though what loss is figured there I cannot say. Through these pokes or pops we seem almost to touch the real, which the repetition of the image at once distances and rushes toward us. Sometimes the colouring of the images has this strange double effect as well.[32]

In this way different kinds of repetition are put into play by Warhol: repetitions that fix on the traumatic real, that screen it, that produce it. And this multiplicity makes for the Warholian paradox not only of images that are both affective and affectless, but also of viewers that are neither integrated (which is the ideal of most modern aesthetics: the subject composed in contemplation) nor dissolved (which is the effect of much popular culture: the subject given over to the schizo intensities of the commodity-sign). 'I never fall apart,' Warhol remarks, 'because I never fall together.'[33] Such is the subject-effect of his work too, and it resonates in some art after Pop as well: some photorealism, some appropriation art, some object art today. In other words, there is a genealogy of traumatic realism, and it has surfaced strongly in the present.[34]

Mass Witnessing

Barthes was wrong to suggest that the punctum is only a private affair; it can have a public dimension as well. The breakdown of the distinction between private and public is traumatic too; again, understood as a breakdown of inside and outside, it is one way to understand trauma as such.[35] But this understanding is historical, which is to say that this traumatic breakdown is historical, and no one evokes its effects quite like Warhol. 'It's just like taking the outside and putting it on the inside,' he once said of Pop in general, 'or taking the inside and putting it on the outside.'[36] This is cryptic, but it does suggest a new relay between private fantasy and public reality as both an object and an operation in Pop. 'In the past we have always assumed that the external world around us has represented reality,' J. G. Ballard, the best complement of Warhol in fiction, writes in an introduction to his great Pop novel *Crash* (1973):

> and that the inner worlds of our minds, its dreams, hopes, ambitions, represented the realm of fantasy and the imagination. These roles, it seems to me, have been reversed. . . . Freud's classic distinction between the latent and manifest content of the dream, between the apparent and the real, now needs to be applied to the external world of so-called reality.[37]

The result of this confusion is a pathological public sphere, a strange new mass subjectivity, and it fascinated Warhol as it does Ballard.[38] I want to turn to this fascination because it does much to illuminate not only 'Death in America' but politics in America as well. To do so, however, a quick detour through political theory is necessary.

In his classic study *The King's Two Bodies* (1957) the historian Ernst Kantorowicz provides an anatomy of the body politic in the feudal order. On the one hand the king represents this body politic (as in the synecdoche 'I am England'), on the other hand he serves as its head; and in this corporal metaphor lies a measure of social hierarchy and political control. (A late imaging of this body politic appears as the famous frontispiece of Hobbes's *Leviathan* (1651).) However, with the bourgeois revolution, this image, this social imaginary, is threatened. As democracy decapitates the king, it 'disincorporates' the body politic as well, and the result is a crisis in political representation. How can this new inchoate mass be represented?[39] For the political theorist Claude Lefort totalitarianism is a belated response to this crisis: the figure of the supreme leader returns as an 'Egocrat' to re-embody 'the People-as-One'.[40] But this return of the sovereign figure has a correlative in spectacular societies of the West: the politician as celebrity, the celebrity as politician, who rules through a politics of identification-as-projection – a return that Jürgen Habermas has called a 'refeudalising' of the public sphere.[41] In a gloss both on Habermas on the public sphere and on Lefort on democratic disincorporation, the critic Michael Warner describes this reembodiment in these terms:

> Where printed public discourse formerly relied on a rhetoric of abstract disembodiment, visual media – including print – now display bodies for a range of purposes: admiration, identification, appropriation, scandal, and so forth. To be public in the West means to have an iconicity, and this is true equally of Muammar Qaddafi and Karen Carpenter.[42]

Again, Warhol was fascinated by this mass subject. 'I want everybody to think alike,' he said in 1963. 'Russia is doing it under government. It's happening here all by itself.'[43] Warhol was no situationist, but in his own blankly affirmative way he does register here a convergence between the 'concentrated' spectacle of the Soviet Union and the 'diffuse' spectacle of the United States, one that Debord foresaw in *The Society of the Spectacle* (1967) and confirmed in *Comments on the Society of the Spectacle* (1988). And with his Maos, made in 1972 at the point of the Nixon opening to China, Warhol does suggest a related convergence of spectacular orders.[44] In any case he was concerned to address the mass subject. 'I don't think art should be only for the select few,' Warhol commented in 1967. 'I think it should be for the mass of American people.'[45] But how does one go about such a representation in a society of consumer capitalism?

One way at least to evoke the mass subject is through its proxies, that is, through its objects of taste (thus the wallpaper kitsch of the flowers in 1964 and the folk logo of the cows in 1966) and/or its objects of consumption (thus the serial presentation of the Campbells and the Cokes, the Heinzes and the Brillos, from 1962 on).[46] But can one figure this subject? Does it have a body to figure? Or is it displaced in the fetishism of the commodity-sign, dissolved in the society of the spectacle? 'The mass subject cannot have a body,' Warner asserts, 'except the body it witnesses.'[47] If we grant this principle provisionally, it may suggest why Warhol evokes the mass subject through its figural projections – from celebrities and politicians like Marilyn and Mao to all the lurid cover-people of *Interview* magazine. It may also suggest why the world of Warhol was overrun by voyeurs and exhibitionists. For Warhol not only evoked the mass subject; he also incarnated it, and he incarnated it precisely in its guise as 'witness'. This witnessing is not neutral or impassive; it is an erotics that is both voyeuristic and exhibitionist, both sadistic and masochistic, and it is especially active in two areas, the Factory film-making and the Warholian cult of celebrity. Here again Ballard is the best complement of Warhol, for while Ballard tends

to explore the sadistic side of mass witnessing (his 'Plan for the Assassination of Jacqueline Kennedy' [1966] and 'Why I Want to Fuck Ronald Reagan' [1967] are classics of the genre), Warhol tends to slip into its masochistic side (as in his servility before the likes of Imelda Marcos and Nancy Reagan).[48]

However, Warhol did more than evoke the mass subject through its kitsch, commodities and celebrities. He also represented it in its very unrepresentability, that is, in its absence and anonymity, its disaster and death. Eventually this led him to the *Skulls* (1976), the most economical image of the mass subject, for, as his assistant Ronnie Cutrone once remarked, to paint a skull is to do 'the portrait of everybody in the world'.[49] Yet Warhol was drawn to death, the democratic leveller of famous mass object and anonymous mass subject alike, long before. Here is one more statement from the 1963 interview:

> I guess it was the big crash picture, the front page of a newspaper: 129 DIE. I was also painting the Marilyns. I realized that everything I was doing must have been Death. It was Christmas or Labor Day – a holiday – and every time you turned on the radio they said something like '4 million are going to die'. That started it.[50]

But started what exactly? Nine years later Warhol returned to this question:

> Actually you know it wasn't the idea of accidents and things like that. . . . I thought of all the people who worked on the pyramids and . . . I just always sort of wondered what happened to them . . . well it would be easier to do a painting of people who died in car crashes because sometimes you know, you never know who they are.[51]

This implies that his primary concern was not disaster and death but the mass subject, here in the guise of the anonymous victims of history, from the drones of the pyramids to the statistical DOAs at the hospitals.[52] Yet disaster and death were necessary to evoke this subject, for in a spectacular society the mass subject often appears as an effect of the mass media (the newspaper, the radio), or of a catastrophic failure of technology (the plane crash), or, more precisely, of both (the news of such a catastrophic failure). Along with icons of celebrity like the Marilyns or the Maos, reports of disastrous death like '129 Die' is a primary way that mass subjectivity is made.[53]

Now even as the mass subject may worship an idol only to gloat over his or her fall, so too it may mourn the dead in a disaster only to be warmed by the bonfire of these bodies. In 'The Storyteller' (1936) Benjamin suggests that this is one service performed by the novel – to stir anonymous readers with a singular death – and I want, through Warhol, to suggest that media news offers a contemporary version of this mass warming.[54] Here, again, in its guise as witness the mass subject reveals its sadomasochistic aspect, for this subject is often split in relation to a disaster: even as he or she may mourn the victims, even identify with them masochistically, he or she may also be thrilled, sadistically, that there are victims of whom he or she is not one. (There is a triumphalism of the survivor that the trauma of the witness does not cancel out.[55]) Paradoxically, perhaps, this sadomasochistic aspect helps the mass subject cohere as a collectivity. For the death of the old body politic did not only issue in the return of the total leader or the rise of the spectacular star; it also led to the birth of the psychic nation, that is, to a mass-mediated polis that is not only convoked around calamitous events (like the Rodney King

beating or the Oklahoma City bombing) but also addressed, polled and reported as a traumatic subject (the generations that share the JFK assassination, the Vietnam War, and so on).[56] Warhol was interested in this strange avatar of the mass subject; it is a shame he did not live to see the golden age of hysterical talk shows and lurid murder trials.

For the most part Warhol evoked the mass subject in two opposite ways: through iconic celebrity and abstract anonymity.[57] But he came closest to this subject through a compromise-representation somewhere between celebrity and anonymity, that is, through the figure of notoriety, the fame of fifteen minutes. For me his best representation of the mass subject is an implicit double-portrait: the most wanted man and the empty electric chair, the first a kind of modern icon, the second a kind of modern crucifix.[58] What more exact representation of the pathological public sphere than this twinning of iconic mass murderer and abstract state execution? That is, what more difficult image? When Warhol made his *Thirteen Most Wanted Men* for the 1964 World's Fair in New York, power-men like Robert Moses and Philip Johnson – who not only designed the society of the spectacle but also represented it as the fulfilment of the American dream of success and self-rule – could not tolerate it.[59] As is well known, Warhol was ordered to cover up the image (which he did with his signature silver paint), and Moses was not amused when Warhol offered to substitute a portrait of Moses.

In a sense the notoriety of the most wanted man is not so different from the notoriety of Warhol. For, again, he not only incarnated the mass subject as witness; he also instantiated the mass object as icon. This double status allowed Warhol to mediate between the two as well as he did; but it also suspended him between the iconicity of celebrity and the abstraction of anonymity. Perhaps it was this in-between position that made for his strange presence, at once very marked, even targeted (he was an easy celebrity to spot, a trait that advertisers came to exploit), and very white, even spectral (he was never quite there when he was just there on the street). Warhol emanated a flat uncanniness – as if he were his own double, his own stand-in.[60] As both witness and icon, voyeur and exhibitionist, he often seemed caught in a crossfire of gazes, which is to say that he too became an object of the sadomasochism of the mass subject. 'In the figures of Elvis, Liz, Michael, Oprah, Geraldo, Brando, and the like,' Warner writes, 'we witness and transact the bloating, slimming, wounding, and general humiliation of the public body. The bodies of these public figures are prostheses for our own mutant desirability.'[61] Even as he represented these figures, Warhol became one of them – a status that he both wanted desperately and refused quasi-autistically (no prosthesis of desirability he).

Perhaps, finally, it was this status as a star that set him up to be shot. For stars are products of our own light projected above us, and often we come to feel that they influence us (etymologically: flow into us) too much. As Warhol must have sensed, this star-production can pass beyond the sadomasochistic to the paranoid: the relation to the star becomes a problem of distance (the star is too far from us, or too close) that is a problem of control (the star has too little, or too much, over us). Sometimes this conflict is only ended with the fall of the star; once in a while the mass subject is driven to shoot the star down – to eject this ideal double from the blinded self. Such, it seems, was the case with Mark David Chapman *vis-à-vis* John Lennon in December 1980. Perhaps a similar imperative drove Valerie Solanas, a frustrated hanger-on of the Factory, to shoot Warhol in June 1968.

In lieu of a conclusion I will end where I began, with the *The Philosophy of Andy Warhol*. This final monologue touches on most of my concerns here: a traumatic notion of the real, a contemporary version of the optical unconscious, a historical confusion between private fantasy and public reality, a hysterical relay between mass subject and mass object, a forging of a psychic nation through mass-mediated disaster and death:

> Before I was shot, I always thought that I was more half-there than all-there – I always suspected that I was watching TV instead of living life. People sometimes say the way things happen in movies is unreal, but actually it's the way things happen to you in life that's unreal. The movies make emotions look so strong and real, whereas when things really do happen to you, it's like watching television – you don't feel anything.

> Right when I was being shot and ever since, I knew that I was watching television. The channels switch, but it's all television. When you're really involved with something, you're usually thinking about something else. When something's happening, you fantasize about other things. When I woke up somewhere – I didn't know it was at the hospital and that Bobby Kennedy had been shot the day after I was – I heard fantasy words about thousands of people being in St. Patrick's Cathedral praying and carrying on, and then I heard the word 'Kennedy' and that brought me back to the television world again because then I realized, well, here I was, in pain.[62]

Notes

1. I would like to thank participants in the Visual Culture Colloquium at Cornell University, in particular Susan Buck-Morss, Geoff Waite and especially Mark Seltzer. I dedicate this text to the memory of Bill Readings, a true critical theorist who possessed a terrific *joie de vivre*.
2. Andy Warhol, *The Philosophy of Andy Warhol: From A to B and Back Again* (New York: Harcourt Brace Jovanovich, 1975), p. 123.
3. 'Death in America' was the title of a projected show in Paris of 'the electric-chair pictures and the dogs in Birmingham and car wrecks and some suicide pictures'. (Gene Swenson, 'What Is Pop Art? Answers from 8 Painters, Part I', *Art News* 62 [November 1963], p. 26.)
4. My way to this notion has come through the art work of Sarah Pierce. I think it opens onto other realisms not only after the war (photorealist and appropriation art in particular) but before as well (Surrealism in particular) – a genealogy that I sketch in 'Reality Bites', in Virginia Rutledge (ed.), *Hidden in Plain Sight: Illusion and the Real in Recent Art* (Los Angeles: Los Angeles County Museum of Art, 1996). I am also interested in this notion as one way to think beyond the stalemated oppositions of new art history – semiotic versus social-historical, text versus context – as well as of cultural criticism – signifier versus referent, constructivist subject versus naturalist body.
5. Roland Barthes, 'That Old Thing, Art', in Paul Taylor (ed.), *Post-Pop* (Cambridge: MIT Press, 1989), p. 25.
6. Ibid., p. 26.
7. Jean Baudrillard, 'Pop – An Art of Consumption?' in *Post-Pop*, p. 33. (This text is extracted from *La Société de consommation: ses mythes, ses structures* [Paris: Gallimard, 1970], pp. 174–85.)
8. Ibid., p. 35. Neither position is wrong, I will argue throughout this text; rather, the two must be thought somehow together.
9. Thomas Crow, 'Saturday Disasters: Trace and Reference in Early Warhol', in Serge Guilbaut (ed.), *Reconstructing Modernism: Art in New York, Paris and Montreal, 1945–1964* (Cambridge, MA: MIT Press, 1990), pp. 313, 317. This is the second version; the first appeared in *Art in America*, May 1987.
10. Ibid., p. 322.

11. Ibid., p. 324. Again, his 'attraction' to these subjects may not be 'complacent', but it is not necessarily critical.

12. Gretchen Berg, 'Andy: My True Story', *Los Angeles Free Press*, 17 March 1963, p. 3. Warhol continues: 'I see everything that way, the surface of things, a kind of mental Braille, I just pass my hands over the surface of things. . . . There was no profound reason for doing a death series, no victims of their time; there was no reason for doing it at all, just a surface reason.' Of course, this very insistence could be read as a denial, that is, as a signal that there may be a 'profound reason'. This shuttling between surface and depth may be unstoppable in Pop; indeed, it may be characteristic of (its) traumatic realism.

13. This is not to say that there are no qualitative differences between projections, or between fascinated projections and motivated interpretations.

14. Swenson, 'What Is Pop Art?', p. 26.

15. Ibid.

16. I hesitate between 'product' and 'image' and 'make' and 'consume' because, historically, Warhol seems to occupy a liminal position between the orders of production and consumption; at least the two operations appear blurred in his work. This liminal position might also bear on my hesitation between 'shock', a discourse that develops around accidents in industrial production, and 'trauma', a discourse in which shock is rethought in the register not only of psychic causality but also of imaginary fantasy – and so, perhaps, a discourse that is more pertinent to a consumerist subject.

17. Indeed, artists like Jeff Koons have run it right into the ground. For this capitalist nihilism in Dada see my 'Armor Fou', *October* no. 56, Spring 1991, and in Warhol see Benjamin Buchloh, 'The Andy Warhol Line', in Gary Garrels (ed.), *The Work of Andy Warhol* (Seattle: Bay Press, 1989). In Dada, in much reactionary representation of the 20s, and again in contemporary art, this nihilism assumes an infantilist aspect, as if 'acting out' were the same as 'performing'.

18. Undated statement by Warhol, as read by Nicholas Love at the memorial mass for Andy Warhol, St Patrick's Cathedral, New York, 1 April 1987, and as cited in, Kynaston McShine (ed.), *Andy Warhol: A Retrospective* (New York: Museum of Modern Art, 1989), p. 457.

19. Andy Warhol and Pat Hackett, *POPism: The Warhol '60s* (New York: Harcourt Brace Jovanovich, 1980), p. 50.

20. Swenson, 'What Is Pop Art?', p. 60. That is, it still has an effect, but not really. I mean my use of 'affect' not to reinstate a referential experience but, on the contrary, to suggest an experience that cannot be located precisely.

21. But this is the role of art history in relation to Warhol (among many others): to find a referent, to develop an iconography, in order to integrate the work. In some ways Warhol defies this process, as did Rauschenberg before him; in other ways they both play right into it.

22. Sigmund Freud, 'Mourning and Melancholia' (1917), in Philip Rieff (ed.), *General Psychological Theory* (New York: Collier Books, 1963), p. 166. Crow ('Saturday Disasters') is especially good on the Warhol memorial to Marilyn, but he reads it in terms of mourning more than of melancholia.

23. See Jacques Lacan, *The Four Fundamental Concepts of Psychoanalysis*, trans. Alan Sheridan (New York: W. W. Norton, 1978), pp. 17–64. The seminar that follows, 'Of the Gaze as Objet Petit a', has received more attention, but this seminar has as much relevance to contemporary art (in any case the two must be read together). For a provocative application of the seminar on the real to contemporary writing (including Ballard), see Susan Stewart, 'Coda: Reverse Trompe L'Oeil/The Eruption of the Real', in *Crimes of Writing* (New York: Oxford University Press, 1991), pp. 273–90.

24. Lacan, *Four Fundamental Concepts*, p. 50.

25. 'I am trying here to grasp how the *tuché* is represented in visual apprehension,' Lacan states. 'I shall show that it is at the level that I call the stain that the tychic point in the scopic function is found' (ibid., p. 77). This tychic point, then, is not in the world but in the subject, but in the subject as an effect, a shadow or a 'stain' cast by the gaze of the world. Lacan argued that this gaze *'qua objet a* may come to symbolize this central lack expressed in the phenomenon of castration' (ibid., p. 77). In other words, the gaze queries us about our rupture.

26. Roland Barthes, *Camera Lucida*, trans. Richard Howard (New York: Hill and Wang, 1981), pp. 26, 53, 55. For an account of this connection between Barthes and Lacan, see Margaret Iversen, 'What Is a Photograph?', *Art History* vol. 17 no. 3, September 1994, pp. 450–64.

27. Yet another instance of this popping is the blanking of the image (which often occurs in the diptychs, for example in the black panel opposite the panel of the crashes in *Five Deaths Seventeen Times in Black and White* [1963]). This blanking works as a kind of correlative of a black-out or a blank-down in shock. (For the point about the blur in Richter I am indebted to the art and music critic Julian Meyers.)

28. Lacan, *Four Fundamental Concepts*, p. 54.

29. For that matter, it is a great subject of modernism from Baudelaire to Surrealism and beyond. See, of course, Walter Benjamin, 'On Some Motifs in Baudelaire' (1939), in *Illuminations*, trans. Harry Zohn (New York: Schocken Books, 1969). Also see Wolfgang Schivelbusch, *The Railway Journey* (Berkeley: University of California Press, 1986).

30. In fact the notion is not much developed by Benjamin. See the passing references in 'A Short History of Photography' (1931), in Alan Trachtenberg (ed.), *Classic Essays on Photography* (New Haven: Leete's Island Books, 1980), and 'The Work of Art in the Age of Mechanical Reproduction' (1936), in *Illuminations*.

31. These shocks may exist in the world, but they occur in the subject. Certainly they develop as traumas only in the subject. And to develop in this way, to be registered as a trauma, requires that the first event, the shock, be recoded by a later event (this is what Freud meant by the deferred [*nachträglich*] action at work in trauma: it takes two traumas to make a trauma). This distinction is important for my reading of Warhol especially in the next section, for what is first a calamity, like the JFK assassination, or a disaster, like the Challenger explosion, only becomes a trauma later, *après-coup*; and the mass subjectivities effected by shock and trauma are different.

32. In 'Information, Crisis, Catastrophe', Mary Anne Doane argues that television coverage serves to block the shock of catastrophic events, only to produce this effect when its coverage fails (in Patricia Mellencamp (ed.), *Logics of Television* [Bloomington: Indiana University Press, 1990]). As suggested, the Warhol washing of the image in colour often screens and reveals the traumatic real in a similar way. These washes might then recall the hysterical red that Marnie sees in the eponymous film by Hitchcock (1964). But this red is too coded, almost safely symbolic, even iconographic. The Warhol colours are more acrid, arbitrary, effective.

33. Warhol, *The Philosophy of Andy Warhol*, p. 81. In 'Andy Warhol's One-Dimensional Art: 1956–1966', Benjamin Buchloh argues that 'consumers . . . can celebrate in Warhol's work their proper status of having been erased as subjects' (*Andy Warhol: A Retrospective*, p. 57). This is the other extreme of the position argued by Crow that Warhol exposes 'complacent consumption'. Again, rather than choose between the two, they must be thought somehow together.

34. I discuss this genealogy in *The Return of the Real* (Cambridge, MA: MIT Press, 1996).

35. I repeat this point because with artists like Warhol and Richter the punctum is not strictly private or public. This is especially the case with the Richter suite of paintings titled *18 October 1977* (1988) concerning the deaths in the Baader-Meinhof group. The painting of the little record player kept by Andreas Baader holds a special charge for me. This is not a private affair, and yet I cannot explain it through any public studium – its use in prison, its status as an outmoded leisure-commodity, whatever. I am aware of the psychologist tendency of this section of my text, in particular the slippage of trauma from a psychoanalytic definition to a sociological application, but I think my subject requires it.

36. Berg, 'Andy: My True Story', p. 3.

37. This introduction appears in the French translation of *Crash* (Paris: Calmann-Levy, 1974); it was published in the original English in *Foundation* no. 9, November 1975, and in *Re/Search* nos 8/9 (1984; J. G. Ballard issue), p. 98. In this regard Warhol and Ballard point to an important concern in recent psychoanalytical art and criticism (e.g. the work of Slavoj Žižek): the role of fantasy in the social imaginary and the body politic.

38. Mark Seltzer develops the notion of a pathological public sphere in 'Serial Killers II', *Critical Inquiry*, Fall 1995.

39. This is a primary question for many modernists, mainly socialists, across a range of practices (e.g. Sergei Eisenstein, El Lissitzky, John Heartfield, Diego Rivera), but Warhol addresses it too, from his own perspective. In *Crowd* (1963), for example, the mass appears as a truncated blur of a newspaper photo or a television image barely seen or remembered. In crowd theory of the 19th century, most of which is quite reactionary (e.g. Gustave Le Bon), the problem is posed explicitly in terms of control: how to restrain the mass in representation. (I am grateful to Susan Buck-Morss for her attention to this neglected part of the modernist project.)

40. Claude Lefort, 'The Image of the Body and Totalitarianism', in John B. Thompson (ed.), *The Political Forms of Modern Society* (Cambridge: MIT Press, 1986), pp. 298–9. For the image of the body in Italian fascism see Jeffrey Schnapp, *Staging Fascism* (Palo Alto: Stanford University Press, 1995).

41. Jürgen Habermas, *The Structural Transformation of the Public Sphere*, trans. Thomas Burger (Cambridge: MIT Press, 1989), p. 201. First published in 1964, this landmark text is also roughly contemporaneous with the 'Death in America' images.

42. Michael Warner, 'The Mass Public and the Mass Subject', in Bruce Robbins (ed.), *The Phantom Public Sphere* (Minneapolis: University of Minnesota Press, 1993), p. 242. My line of argument here is indebted to Warner, who also discusses Ballard.

43. Swenson, 'What Is Pop Art?', p. 26.

44. For an extraordinary meditation on different mass subjectivities from Chairman Mao to Doctor Moon, from the novel to terrorism in the news, see Don DeLillo, *Mao II* (New York: Viking, 1991).

45. Berg, 'Andy: My True Story', p. 3. He also preferred the term 'commonist' to 'Pop'.

46. The *Philosophy of Andy Warhol* includes an ode to Coke that celebrates the absurd democracy of consumerism at issue here: 'What's great about this country is that America started the tradition where the richest consumers buy essentially the same things as the poorest. You can be watching TV and see Coca-Cola, and you can know that the President drinks Coke, Liz Taylor drinks Coke, and just think, you can drink Coke, too. A Coke is a Coke and no amount of money can get you a better Coke than the one the bum on the corner is drinking. All the Cokes are the same and all the Cokes are good. Liz Taylor knows it, the President knows it, the bum knows it, and you know it' (pp. 100–1). In this ad for democracy there is only one Real Thing, and We are indeed the World.

47. Warner, 'The Mass Public', p. 250.

48. This is where the principle 'the mass subject cannot have a body except the body it witnesses' might be qualified. For the mass does 'have' a body (as with the phallus, having and being a body are not the same): it has a body in the sense that it may be convoked not only through a body (e.g. a celebrity) but as a body (e.g. a collective shocked or traumatised by the same event). It also retains its bodies in the usual sense (mass subjects as 'organisms' rather than as 'spectators' in the terms of my Ballard epigraph). These individual bodies of desires, fears and fantasies allow mass subjects to customise mass objects in personal and/or group ways (e.g. gay, Catholic, working-class); in the case of Warhol to camp or to clone images of Elvis, Troy, Warren, Marlon and other most wanted men in terms of gay desire (on this point see Richard Meyer, 'Warhol's Clones', *The Yale Journal of Criticism* vol. 7 no. 1 [1994]). To use a notion like 'mass subject', then, is not necessarily to massify the subject, to disallow personal and/or group appropriations. In fact the Factory was a virtual factory of such reinventions. For another analysis of some of these problems, see Christopher Phillips, 'Desiring Machines', in Gary Garrels (ed.), *Public Information: Desire, Disaster, Document* (San Francisco: MOMA, 1995). (The two Ballard texts are collected in *The Atrocity Exhibition* [London: Jonathan Cape, 1969].)

49. Ronnie Cutrone quoted in Trevor Fairbrother, 'Skulls', in Gary Garrels (ed.), *The Work of Andy Warhol*, p. 96. This is the best text I know on the theme of death in Warhol.

50. Swenson, 'What Is Pop Art?', p. 60. It is at this point that Warhol remarks, 'But when you see a gruesome picture over and over again, it doesn't really have any effect.' And yet this particular image from 1962 is not repeated, and with the blackened wing become a deathly scythe Warhol heightens its grim fatality.

51. David Bailey, *Andy Warhol: Transcript* (London, 1972), quoted by Buchloh in 'Andy Warhol's One-Dimensional Art', p. 53. Here, perhaps, there is a point of contact, however inadvertent, with Brecht; see, for example, his poem 'The Worker Reads History'.

52. Warhol captures the catastrophic version of contemporary death, in which 'death is no longer the culminating experience of a life rich in continuity and meaning but, instead, pure discontinuity, disruption – pure chance or accident, the result of being in the wrong place at the wrong time' (Doane, 'Information, Crisis, Catastrophe', p. 233).

53. 'Disaster is popular, as it were,' Warner writes, 'because it is a way of making mass subjectivity available, and it tells us something about the desirability of that mass subject' ('The Mass Public', p. 248). What are the different effects of the different mediations (newspaper, radio, network television, satellite and cable news, Internet) of modern disaster? For example, what is the difference in subject-effect between readings of the *Titanic* sinking and viewings of the Challenger exploding? Is the first as given over to compulsive repetitions, to the *jouissance* of the death drive, as the second?

54. 'What draws the reader to the novel', Benjamin writes, 'is the hope of warming his shivering life with a death he reads about' (*Illuminations*, p. 101).

55. This point may bear on the guilty implication that a mass subject may feel in relation to a disaster – that he or she has somehow participated in it, even indirectly caused it, as a spectator. Sometimes a disaster prompts a confusion of cause and effect, let alone of public and private, that is difficult to register except as a reversal, in which the subject – paranoically and pathetically – feels that he or she has dictated the event, or at least colluded in its fixing. Consider the superstitions of sports fans, who gyrate in front of televisions so that a catch be made, a putt sunk, or who turn off the game lest the hero fail, the team lose. (I am indebted to Christopher Pye for this example of reversal.)

56. Again, the difference is this: a shock may be instantaneous; a trauma takes time to produce (see note 31). This convoking of a mass subject through shock may be easier to register at the level of the city. To be a witness in New York in the 80s, for example, was to lurch from one fatal event to another (from Lisa Steinberg to Jennifer Levin, say, from Howard Beach to Bensonhurst), events usually marked by extreme violations of difference – generational, sexual and/or ethnic. These events wired New Yorkers, shocked them into a collectivity of (dis)identification, which is a role that New York long played for the rest of the psychic nation. This part has now passed in part to Los Angeles, the city that, outside of Hollywood Babylon, was long imagined to be free of such events. The term 'psychic nation' may be too slippery to define, let alone to locate. The 'psychification' of the nation is an old tendency in cultural criticism, from the 'nervous' 1880s to the 'narcissistic' 1970s and the 'schizophrenic' 1980s. I do not intend an analogy, much less an equivalence, between psyche and nation. Rather I see the presumed commutability of the two as another symptom of a breakdown between private and public (which is also difficult to define, let alone to locate). There is also the question of the technological mediation of the psychic nation: again, how does this kind of collectivity change with different media? And when does it exceed the national as a matter of course? This question may point to a difference between the early 60s and the mid-90s. In an almost sociological way Warhol could use certain images to represent 'death in America' for a show in Paris, with the assumption that these images would not be known there, and that American types of death were somehow distinctive. Today images of the carnage of the Oklahoma City bombing (or, for that matter, of the Sarajevo shelling) are broadcast internationally: the nation is hardly a boundary of the psychic collectivity effected by disaster and death. Indeed, not long after the early 60s 'death in America' might just as well signal death in Vietnam. Perhaps it was then, with the television reportage of the war, that the national boundary was definitively transgressed. In any case it is significant that Warhol tended to steer clear of these war images and indeed of television images.

57. These are opposite but not opposed, for most celebrities are so constructed in the social as to appear characterless if not anonymous.

58. Traces of churchly art are everywhere in Warhol: the gold relics of the shoe ads, the shrines to Marilyn and others, the *vanitas* skulls, the patron portraits, and so on. (I am indebted to Peter Wollen for the association of electric chair and crucifix.)

59. Even though these criminals fulfil this dream too, equal (if opposite) to any other top ten (or thirteen) list: the richest, the best dressed, and so on. On this point see Sidra Stich, 'The American Dream/The American Dilemma', in *Made in USA: An Americanization in Modern Art – The 50s and 60s* (Berkeley: University of California Press, 1987), p. 177.

60. Barthes: 'Pop art rediscovers the theme of the Double . . . but [it] is harmless – has lost all maleficent or moral power . . . the Double is a Copy, not a Shadow: beside, not behind: a flat, insignificant, hence irreligious Double' ('That Old Thing, Art', p. 24). Perhaps any encounter with a celebrity produces a degree of this flat uncanniness.

61. Warner, 'The Mass Public', p. 250.

62. This statement appears on p. 91 of *The Philosophy*. It also touches on a few related concerns that I have not much developed here: the dialectic of media and technology as both shock and shield for the subject, the complication in trauma of causality and temporality, the irreducibility of the body in pain. As for the first point, also see this statement in *The Philosophy*: 'The acquisition of my tape recorder really finished whatever emotional life I might have had, but I was glad to see it go. . . . During the 60s, I think, people forgot what emotions were supposed to be. And I don't think they've ever remembered. I think that once you see emotions from a certain angle you can never think of them as real again. That's what more or less has happened to me' (pp. 26–7).

Swimming underground: the Warhol years

Mary Woronov

The Ascension of Saint Ann

My nights were spent with Ondine and our good friends, the
Moles, and these nights always began the same way – with drugs.
This time we were crammed in a tiny apartment which none of us
owned. One by one we began to disappear quietly into the bath-
room for purposes of chemical alteration. I definitely wanted to
shorten the hem on my brain, maybe make a jumpsuit out of the
whole thing. Ondine, master seamstress that he was, leaned into
the mirror before me and shot up right in his eyeball. I almost
puked into the sink.

Murmurs fluttered, the word was passed, 'Shot up in his eye', and
we all took it as an omen that a particularly intense high was
ahead of us – all except Andy. He was oblivious, buzzing along on
his own little yellow pills. He liked to be next to things, feel the
energy, but he didn't want to know what was really going on, and
we were very discreet. Yes, to the normal eye it looked as if every-
body simply had an extreme bowel disease, but to us a bathroom
became a temple of porcelain and tile, the inner sanctum of bodily
functions where only the initiated were allowed, where the dealer
held communion, and ritual held sway.

The door of whatever bathroom we happened to be using was always guarded by some kind of animal-type human, usually a psychopath of the lowest order. The only thing left rattling around in his brain was the pure urge to open your chest and shit on your lungs. Milling around the door and under his control, empty ghosts huddled like shrunken heads. We called them the grey people; unfortunates who had lost their souls to get high. All they wanted was to be the one closest to the door, but one twitch from the animal and they scattered along the ground like wingless birds, scuttling into the corners of the room where they tried to look like furniture so no one would throw them out. We had no sympathy for them. To regain their human form all they had to do was leave, the one thing they could not do. Instead they hovered, searching our eyes for the flicker of recognition that would turn them from ghosts into people again

Before I was ushered into the bathroom, I was surprised to see Ann among the grey people, a new little ghost crouched up against the wall like a folding chair. She had not lasted long. When I first met her she was George's girlfriend, but now Silver George in his silver-painted cowboy boots was screamingly gay, and Ann didn't know how to gracefully go back to Alabama. Instead she became a drainage ditch into which George poured his frustrations, and George was very frustrated. The abuse was terrible. None of us liked to watch it, so George, always accommodating, usually made her wait in the street. She was such a sad little dish of water; now her eyes followed me vacantly, asking me to tell her what to do, who she was. It gave me the creeps. I'm sure that's how she drove George way past rage.

Meanwhile, George was on crib duty, meaning he sat with Andy pretending none of this was going on. They were playing Andy's favourite game, 'Let's be eleven-year-old girls at a pajama party' – two demented men swinging their legs over the edge of the bed, giggling and murmuring over private jokes, and colouring little drawings with a brand-new pen and pencil set. Actually, this was not so peculiar; we all had these pen and pencil sets and a trip book to go with them, standard paraphernalia for any speed freak against the paranoia that plagued us. Aware that the rap of a speed freak had been known to completely dissolve even the polish off silverware, we confined these rants to our books. Some people thought of their trip books as art – they weren't. They were reams of useless energy, complete with dizzying diagrams of intricate nothing – except when Andy Warhol happened to be doing the drawing.

That night Andy was drawing noses, before and after nose jobs. When he asked me if I liked it, I didn't answer. Why bother? I knew that the stupid drawing would appear in its silk-screen mode later, worth a fortune. My nose would get out of joint when I thought of my own angry black and white drawings. Why were they so unloved? Because Mom left me alone in Macy's department store? It was only for thirty minutes. Who knows, maybe it wasn't long enough; maybe it should have been three hours in order to form the correct aberrant psyche for a really famous artist. Maybe Macy's was really this big oven and she took me out too soon, and that was why I was only a half-baked artist. When I started thinking like this, I knew I was getting really high and I shouldn't be alone, which is why I was standing in this bathroom watching Ondine shoot up in his eye.

By the time we came out of the john, things had changed. Someone had put on *Tosca*, the Te Deum where Scarpia sings his dream of evil to a Catholic Mass. Even a rock 'n' roll head like myself could sense the oncoming doom. Warhol had left, and in his place sat Rotten Rita, the

very king of fear, the altar of evil. Already he had changed George from an eleven-year-old girl to a huge reptile hissing venomously at Ann. Eyes averted, hands around the leg of a table, she crouched on the ground before the cobra swaying above her. 'Leave. Do you hear?' His face slid around in cold coils. 'Get out, you stupid bitch! Get out while you can still walk.'

Actually, I was thinking of leaving myself. Normally I didn't get high with Rita around. I'd take my shit and go somewhere else, somewhere less tense. He was too scary for me, but Ondine had only to look at me, and I chose to stay.

Rotten Rita was known to have the worst speed in New York City. It could kill you. Rita himself was in the process of killing his own father. Every week they had coffee together, which Rita laced with megadoses of speed that often left the old man mumbling ninety miles an hour to a lightbulb for the rest of the day. Of course, Rita insisted he only did it to test each new batch of stuff. He was pleased to announce that this week his Dad had tossed himself out the second-storey window and broken both his legs, and this was the stuff that did it – all of which called for much tasting and sampling on our parts and another magnanimous promise by Rita that the score which finally put his old man in Bellevue would be free. More celebrating, tasting and testing, festivity which was cut to shreds by a hideous whine.

'You promised me a shot.' No one looked at anyone. No one spoke. 'You promised me a shot!' Quickly everyone moved away, leaving Ann's exposed mouth opening and shutting on the floor. It was unheard of for a ghost to speak. 'Where's my shot?'

Only Rita moved towards Ann, smiling cordially. 'Oh, did I promise you that? Thank you for reminding me.' He pulled out a giant horse syringe. I had never seen anything so big – the needle itself must have been nine feet long. 'You're right, I have your shot right here. Shall we?' His other hand pointed to the bathroom.

Even I knew Ann would be crazy to go in there with Rita. As the door shut, I was going to say don't, but my voice had disappeared. Anyway, you couldn't say no to Rita. I can't explain it. Rita was the most important person I had ever met in my life, and I still don't know why. Maybe it was chemical, but if you were high and Rita and the President were in the same room, Rita would be more important. That was Rita's charm: he was extremely impressive for no real rea-son. This was peculiar because Rita looked like a seven-foot cross between a truck driver and an insurance salesman, big biceps and tiny bifocals. He never acted gay and never raised his voice. The mild-mannered glasses framed a pair of screaming eyes that hinted at the horror living inside his head.

Most people used only one word to describe Rita, and that word was evil. He was the dealer, and a lousy dealer at that. Trying to cop from Rita was a nightmare. His apartment was a bare room with several glaring sunlamps and one black chair which he would sit in, telling you to make yourself comfortable. In the dead of winter people would be sweating in there. If you didn't have sunglasses it was hard to stay, but he would start insisting that before you scored you might like to watch his lover, Birdie, sit on a Coke bottle.

Of course, I never saw Birdie or this particular Coke-bottle-sitting activity, but the fact that it

was preparing itself in the next room put a definite edge on things. I didn't even know if there was a Birdie, but I did know that after an hour of this I would begin to seriously doubt my endurance. By the time I did leave I was so relieved to get out of there, I eagerly overpaid Rita and let him snort all my speed. Like I said, he was evil and his speed killed.

'She's dead. I said she's dead, you fucking moron. Don't you know what dead means? Well, it's right there, go refresh your memory.' It was Rene R., who looked like a perpetually insulted egret and who spoke to the world as if it were stupid. What was he screaming about? 'She's overdosed. I walk into the bathroom and there she is, lying there ... just lying there ...' Rita's voice serenely cut Rene off. 'Shoot her up with milk.'

What did that mean? There was no reply to that. And then I figured it out. Shit, it was Ann in there. Oh, my God. How long was Rita in there with her, an hour? It seemed like only two seconds had passed, but it could have been the next day. The windows were sealed against lethal daylight; even the crack under the front door was gently covered by a towel. Although the apartment building had a doorman, we still worried about someone sneaking in and spying on us.

Did he say dead? There was someone among us who was dead? My head flooded with curiosity and I waded across the room to look. Orion glided out of the bathroom past me, looking very Egyptian and slightly bored. 'It's only Ann,' she sighed, her wake shimmering like the sun on the Nile. I went in and was amazed to see Ann not on the floor in a pool of blood, but in the bathtub fully dressed and half floating in dull green water.

Ondine sat on the toilet, as white as marble, white as fog on a black ocean, but not as white as the milk he was pouring into a syringe. 'Ondine,' I smiled cautiously, 'I'm a doctor's daughter and I've never heard of milk curing anything.' His eyes looked at me and then back at the needle again. 'If you're a doctor's daughter,' he whispered, 'what are you doing here?' He was right; I wasn't a doctor's daughter. Carefully turning Ann's arm so that her vein rolled into place, I held it while he shot her up with milk. Ondine's voice was comforting, 'If you shoot them up with milk it prevents them from turning blue.' Anything sounded fine to me at this point. I guess we didn't notice her head slide under the marbled water while we were giving her the hammer, so even if the milk could have saved her, we had drowned her in the process. Now she had to be dead. She looked dead, separated from us by a quiet slab of jade water. Ondine pulled her out by her ears and she slid right back down again.

That night, little soundless Ann rose from ghost to goddess. What else does one do with a corpse? She became sacred, our sacrifice to Ananke for the necessity of dying in the first place. We laid Ann in state on the coffee table – more celebrating, tasting and testing. The feeling was becoming festive, euphoric. Ondine was eloquent. 'Ah, death, how good of you to come. You want a hat? No, no, we want to see your face.' Ondine gestured grandly to us all. 'Yes, by all means invite her to dinner: I doubt if you'll be able to stand it for more than five minutes. Now I have to strangle myself. Ugh, I am suffering from celestial rust. And you, you're all planetary detainees. Perhaps being born is your sin, and dying will be your greatest accomplishment.'

'Yeah, fuck Heaven and Hell.'

'Who said that?'

Nobody moved or spoke. Some people smiled, their ears flattening back against their skulls like dogs.

'Show me the face of the imbecile who said that. My darling, language was invented to conceal thought, but since you don't have any thoughts, just shut up. Since they put that clock inside your head, you poor monster, you got stuck, didn't you, between ignorant bliss and immortality; in other words, the animals shun you and God teases you. Heaven and Hell – you're a pathetic slave to a table setting of foolish opposites. Good and Evil, how boring; up and down, ugh. What about nowhere, what about nothing, what about the end? Well, there she sits, out of the closet at last, no longer a mystery, poor thing. I give you death.'

And with that, the entire room shot up. Ondine was right, we had captured death. She was lying on the coffee table. We knew where she was. We could see her. You have no idea what a relief this was, because if your neighbour is dead, then you must be alive. More celebrating, tasting, testing, and chatting with the corpse. It was religious.

'So your father is a doctor, Mary?'

Rita put his hand on my shoulder and smiled down at me, exposing a square hole where his front tooth was missing. I'd never noticed it before, but that hole was the entrance to the other side. I knew it, the decay, the blackness beyond. ... It was a little black door death had used to sneak in here. How clever.

'So, your father is a doctor, Mary?'

My knees buckled under the desire to tell Rita, 'No. He's my stepfather. I wasn't born with a father, I'm not really connected with men. I was a box baby, a preemie. I was born so early I had long black prenatal hair everywhere and a spinal tumour that looked like a tail. Yeah, it was gruesome. I looked like a monkey. Every time the nurses rolled me in, my grandmother screamed at them to take me back, you know, like I was some kind of mistake. I think it kind of set the tone for the rest of my life.'

That was another thing about Rita, you always told him everything, usually in the form of a confession. There would be days when the only thing anyone at the Factory said to you was 'I don't believe what I just told Rita'. No one was above this humbling performance where you dragged your soul kicking and screaming into the light while Rita watched with the expression of a housewife seeing her toilet backing up and wondering if this could be the day when, due to a plumbing mistake, every shit she had got rid of was about to reappear. I don't know why Rita was the executioner, or why we needed Rita's particular brand of punishment; guilt at being so high, or just more Catholic shit? Rita didn't punish, he was the means by which you punished yourself. I don't know if he planned it or even liked it. Yet it was addictive, people waiting in line to attract his attention, eager for the high of being petrified by the horror of themselves.

Now Rita, in the buff except for a towel turbaned around his head, was at the piano singing

Tosca, something I was told he did when he felt upset. I was transfixed. I had never seen a 250-pound naked fag become Maria Callas before. He knew every word, and he was dead serious, until the Duchess made the mistake of mentioning the police. We tried to silence her, but it was too late. The walls began to crack under the unbearable emptiness that the outside held for us, paranoia lapped at the sealed windows, the door shuddered like a dog and the towel beneath it went black with water. All I could think of was my parents finding out – I was an accessory to murder – I was finished – I'd have to get a job and support myself – shit, I'd go to jail! Rita stopped playing the piano and stood before us.

'It's all right, I have a solution. Everyone will be immortal for five minutes. That's all we can afford for the moment. Life is not a bargain basement.' What was he talking about? 'But now we have to get rid of the body.' He said it like the voice at the airport, 'The white zone is for loading and unloading only.' Get rid of the proof, of course, but how? We all started running in peculiar patterns, 'Drag her into someone else's apartment.' 'Oh no, who's got a key?' 'What if they're home?' If we took her down the stairs, someone might be coming up the stairs and discover us. If we used the elevator, the door would open and people might be there. My whole family might be in that elevator, just waiting to pour out on me.

Rita was right, it was the law; if someone overdosed, you dragged them into the street. It had just happened to Eric, and they had left him with his bicycle on the sidewalk and told everyone he had been hit by a truck.

'Post her. Put her down the mail chute.'

Ondine, how brilliant. More celebrating, taste, taste, test, test. Bring stamps. Address her forehead. Return address, Mount Olympus. Ronnie Vile, who normally only drew subway maps of nonexistent cities, drew an incredible diagram of Ann's postal journey, of how this 120-pound girl could fit into a three-inch mail slot and be deposited eight storeys down into the mailbox in the lobby. But there were some who didn't want to give her up, wanted to keep her. They insisted her death released life into the system, into us, and we would die without her. Wonton, who was an ex-construction worker, wanted to seal her up in the wall or at least flatten her out under the rug. He said when he worked on the Verrazano Bridge they had sealed two dead hookers up in it for good luck. We had an argument, but it was settled; we let Wonton and the others keep her clothes. So now Ann was nude for her Valkyrian posting.

'Open the front door and drag her into the hall. Open the front door!'

Everyone stopped – open the front door? We all shrank to the walls – we never opened the door. With the dignity, but alas, not the costume, of a high priestess, Rita walked to the door and opened it. The silence burned the fur we stuffed into our ears. We cringed. Then, still very naked, with a well-draped towel about his head, he stepped into the hall … slowly … like a spaceman … leaving the ship … without his space suit. We all watched intently to see if he would survive or shrivel up in the alien air. A couple of feet into the hallway he turned, smiled and waved us on. Picking up Ann in sci-fi silence we descended into the hallway, Rita in the lead. The pattern on the wall grew into dense foliage out of which foreign eyes watched us, the carpet felt spongier with every step down the murky corridor, when a foot suddenly kicked me in the

mouth. I dropped Ann's leg, screaming, 'She's alive!' Smash, she hit the carpet and sat up just as the elevator doors opened, revealing two 911 guys and Silver George, now renamed the Squealer. All of us shrieked and fled like roaches back to the apartment, barricading the door. No one came after us. Why should they? We were mentally ill.

Later Ondine told me Rita had given Ann heroin to shut her up. I asked him, 'Didn't you think she was dead?' and he laughed. 'No,' he said, 'grey people don't die. They're like rubber. You can't kill them. If you could, there wouldn't be any.' How simple, and here I was worried about being an accomplice to murder.

These games were played constantly on thinner and thinner ice until we believed we could walk on water, while the people on shore shook their fur hats and fluffy mittens as they watched us stand naked in the snow, chatting and tasting and testing. But I wasn't playing a game with Ondine; I meant everything we said. And I never looked down and saw the warm ocean licking the ice beneath my feet.

The True Cross

Do not imagine that I scampered around those velvet sewers completely unscathed. You cannot play with shit all night and come out looking like a boarding school virgin. No, no, no, you have some shit in your hair and a little on your shoe, and soon you're talking shit. Every time you open your mouth it just falls out. If you hung with the Mole people, somewhere, somehow, either their drugs, one of their thoughts, or just one of their little hairs got into your skin and burrowed deeper and deeper, quietly driving you insane. It was the law, and nobody escaped, not even Andy.

The Mole people knew this law. They didn't jump out and attack you, they just smiled and waited. Nobody got to leave the playground, nobody. At first you think you're just visiting, you're not one of them, then suddenly one sunless day everyone crowds into your room dragging something, something large and dark, and you know it's meant for you, and they say, 'Hi. Here it is. Your cross.' Then they nail it on your back, and that's it; all you can do is drag it around. You tell them you didn't order this, it doesn't look good. It can't be yours, but it doesn't matter. Your friends accept your cross, and, to your horror, even appear to like it. They begin to identify you by it. Then the final insult, they invite your cross to dinner without you. That's what happened to me.

The name of my cross was Vera Cruz. She was a fan. I can never tell you how much I loathed, despised and prayed to God for this thing's death. Looking back, I realise it was my extraordinary hatred that brought her to the attention and later enjoyment of my perverse friends, but try as I might, I could not stop hating her. It was like trying to ignore a 135-pound tumour, and that was how close she wanted to be to me – me, who groaned at the thought of the hug, and even considered the handshake a mild form of social torture. She wanted to be inside my very skull, a voracious boll weevil in my precious cotton brain. Nothing was close enough. If I put my hand out, she tried to lick it. If I talked to her, she wanted to fuck me. She was a bottomless pit, ugly too – short with a little turd-shaped body one could only imagine floating dead in a porcelain bowl.

Long before you ever saw her, you heard her greedy, needy, sucking sound, caused by a perpetual case of neurotic asthma, followed by the breatholator pump, a grotesque little apparatus which she carried with her at all times. I still smile at the thought of her panicked gulps for the air that eluded only her, while I breathed effortlessly and deeply. To my delight, I found I could induce these hysterical attacks by focusing all my attention on her. Like a happy dog, she would get overexcited and have an attack – start to die right in front of me, emitting short desperate gasps which I wanted to gather together in one big fat death rattle, but she was always saved by a few sucks on the breatholator. Asthma was not her only physical problem. She did not have a vagina. Apparently God just forgot to give her one, a deformity that made her instantly famous in my crowd.

What did I do that the demons of the sewers should send this harpy without a hole after me, to shred my brain with her stupid beak and rip out my liver with her dopey claws? I don't know. Punishment for letting Violet strut her stuff on stage for a bunch of leather queens in the play called *Vinyl* that we put on at the Café Chino? It was a take-off of the torture scene in *A Clockwork Orange*. We called it camp, but actually it was naively pornographic, which was fine by me because everyone knew I was too high to have real sex. I told my mom it was a legitimate play by Ron Tavel; in reality it was a big hit with the S&M crowd, who would go wild as Violet and I tortured Gerard, and why not? Violet had gotten quite theatrical but was still authentic enough to attract a lot of very strange admirers. Gerard was lucky, he only got the whip. I got the cross.

She was waiting for me after the third performance, and I knew right then and there I was fucked. First, she showed me a shirt I thought I had lost, which she had stolen from the dressing room, but that wasn't all – what really unnerved me was a wadded-up voodoo-like ball of hair that she insisted she had plucked from my hairbrush. She wanted to go home with me. She wanted to suck on my mother's tits. I took the most severe action I could – I asked Stanley to get rid of her. Stanley was a machine fag that guarded the Café Chino; you never messed with him unless you wanted your entrails rearranged. He threw her out, but the way he suggested I spend the night at the club rather than go home scared me. I watched his eyes. He was telling me this was serious, not just another dyke joke.

The next night the keys to a new Jaguar were delivered to me. I threw them in the gutter as fast as possible and left the car glowing in the street. But too late, the black mark had been delivered. She drove me nuts from then on. During the performance of *Conquest of the Universe* I played the conqueror both on and off the stage, which was how these experimental plays were directed by Vaccaro, our homicidal genius of a director. I say homicidal because whenever a cast member was late he would close his eyes and say, 'I killed them', something we always disregarded until he held up a performance by trying to strangle Patsy in the wings. Every night he hissed in my ear, 'Do anything you like to them, I want fear in their eyes.' I was all-powerful, except for this troll I could not get rid of. Like the hump on a hunchback, Vera mocked me at all times.

Ondine played the Red Queen of Mars, but even he could not help. On stage he would whisper to me, 'My darling, I hate to be the one to break the news, but your faithful boil is waiting for you in the dressing room; I would be careful if I was you.' Jabbing my fists into my eyes I would scream in pain to the audience, like a tortured animal, but Vera did not let go. She followed me

everywhere, or would be waiting for me when I got there. She continually followed me to Jane's apartment and even to my parents', which I considered sacred ground and where I struggled with her in the elevator until it was evident even to our eighty-year-old doorman that she was enjoying it. For that matter so was the doorman; when I planted my foot on her chest and propelled her out of the elevator, I distinctly saw the old guy smile and slap his fists. If she couldn't see me, she would call my parents thirty or forty times a day. She got to know all of my friends and told them graphic sex stories about us. I couldn't stop her. I wanted to kill her.

Usually Vera Cooze (as my friends liked to call her – a subtle reminder that she was not sitting on both holes) never followed me into the subway. Either finding out from the friends I had just left or guessing where I was going next, she would arrive ahead of me in one of her stolen cars. But this time she couldn't know where I was going because I didn't know myself. This time it was different. I'd just fucking had it, that's all. I was standing alone in the IRT subway station at 14th Street. I decided when I came down the subway steps and saw the platform empty, and, at three a.m., likely to remain that way, that if she followed me down, I would kill her. The decision was made, and now all I had to do was wait. Soon I heard her wheezing, and saw her feet start tentatively down the stairs, but I didn't move – she had to come all the way to me. She was wheezing badly. She was excited, she knew something was up, she couldn't believe how close I was letting her get to me. Maybe three feet from me she stopped and tried to talk, but I didn't answer, I was getting off on the adrenaline squirting into my veins, just like before going on stage or after getting really high. I was going to like this. If she came closer, if she tried to touch me, I was going to do it. She reached out, and it was so simple, even graceful. I grabbed her arm, and, swinging her off balance, I shoved her off the platform and onto the tracks. Next, the train came and smashed her skull into her asshole.

Correction. Next, the train was supposed to come, but it obviously missed its goddamn cue. I really felt kind of light-headed. The subway station was weirdly quiet except for this dry scraping and gulping sound. It was Vera, having an attack and trying to climb up at the same time, but she was too short to reach the platform, and too out of breath to scream for help. Disgusted with the bad timing of the train, there was nothing for me to do but watch. I don't know, I was kind of proud of not giving in to the rescue urge, and a tiny drop of satisfaction came when I saw Vera's eyes understand that I was not going to help her out; but mostly it was boring.

Things picked up when we both heard the train coming. First, I watched her run by me to the nearest end of the platform where there were stairs, but as the train got louder, she freaked out because she was going towards the sound of the train, so she started running the other way, and I got to watch her run by me again. This was too stupid; I felt like a spectator at some bizarre sport. What was I supposed to do, cheer? 'Come on train, flatten the bitch!' Shit, my voice was so loud, I was afraid I'd scare the train away, but no, it came all right – to the wrong side of the platform. I couldn't believe it, it was the express. I also couldn't believe that people were getting out of the train to witness my first attempt at murder, but they just headed for the stairs, totally oblivious to Vera sucking and stumbling over her breath pump on the other track. Even if they did see her, they couldn't have cared less at that time of night. New Yorkers were so cool.

I could see the lights of the local lumbering along. It seemed to be moving slower than Vera. Fuck it, I jumped onto the express, and heard those steel doors smash shut, but this time with pleasure.

One last prayer: 'Fucking crush her, man, just fucking crush her!' Actually, it feels good to have finally told this. I never told anyone, and now I'm telling everyone. I don't care. I'd do it again.

I didn't look in the papers for news of Vera's death. I didn't have to. Instead I went to Max's, straight to the back room, the dreaded back room, where I was immediately greeted, 'Mary, Mary, come over here. Sit with us.' It was Andy's table. They were actually throwing someone out of the booth to make room for me. I pranced over, sat down, and painfully realised why everyone was smiling at me. Vera was tucked under Andy's wing like a pet viper. This was going to be really ugly. I could see by her smile she had told no one about what had happened in the subway, nor was she going to. She had enjoyed being that close to me and was ready to repeat it with a knife, or a gun, or standing on the sill of an open window.

Was she capable of resurrection? Did the incident in the subway not happen at all? I began to doubt my very sanity, as she pulled out a vial of yellow liquid. Andy couldn't contain himself. 'Oh Mary, Vera's been telling us that this is your piss. You've been letting her collect it for some time now. Why didn't you tell us? Gerard, why didn't she tell us?'

Gerard: That's disgusting, Andy. I don't know.

Morrissey: Vera's going to be in our next movie. We're going to have her collecting everyone's piss. That should be entertaining.

Andy: Yes, maybe you should do a sex scene with her, Mary.

Vera: A love scene.

Morrissey: No, no, Vera, that's too ugly. Nobody wants to see that.

Andy: No, we can do that. Oh, where are you going? Don't you want to do that? Where is she going, Gerard?

I knew what they wanted. They wanted me to throw a scene, to beg, to fight with Vera. Well, forget it. I left. She had won, so let her gloat in the back room, take my place at the royal court of screaming assholes. I banished myself. I slid back, back into the shadows where old queens apologise in runny make-up, and toothless speed freaks mumble incoherently. Shit, I slid so far I practically fell off the map. People I normally wouldn't talk to, I was getting high with now. It was limbo, full of ghosts and exiles like myself. It was OK, quieter, no spotlights, no splashes, just water, running, running full force towards an ugly drain. Ondine found me sitting by this stream, licking my wound. It wouldn't heal. Even here at the bottom, I hated Vera.

Ondine said he had come to get me. I was having trouble focusing ... I couldn't even sit up, but I tried to follow his voice. After all, he was the Pope, our shaman (my legs buckled), the alchemist. Maybe he could cure me, absolve me, help me, or just turn me to stone.

Ondine's voice stuttered over words like water laughs over rocks, and at first he sounded very far away. 'No, you cannot stay here. It's too dangerous. Of course, it's one of my favourite places,

but – here, take these. I got them from the Turtle, they're divine. Now, you must come back with me. I miss you. Jack Smith wants me to do this movie, and you must do it with me. Fuck Andy and his pet vermin of the month, besides, I have news. Vera's gone. Yes, my dear! To a hospital in Arizona. Her lungs collapsed, isn't that divine? I knew you would be pleased. No, I didn't do it, but I know who did. I took you know who to her house, you know how she loves to torture people. He started playing with her breatholator, kicking it across the floor, while Vera was lying there making fish noises, you know, those disgusting sucking sounds, when all of a sudden her face looked like it just went under water, and her lung popped. I was horrified, but then I thought, how wonderful.' His brown eyes smiled into mine, 'Didn't you think I would avenge you, my dear? She was too undignified to live.' I stood up like Lazarus, not because Vera was gone, but because Ondine said he missed me.

I did Jack Smith's movie with Ondine – well, I think I did it. We waited in an old warehouse on Hudson Street for hours. There were bundles of rags and old clothes around, mountains of them, but I don't remember seeing a camera. Much later we discovered another couple waiting also. They were cooking over a makeshift fire and they said they had been there for at least a month. When we finally left I could not tell if we had shot a movie or not, but I was definitely missing a couple of days. Anyway, I was so pleased to be working again that I hardly had time to be upset by Vera's return, but I was told that she had come back with a man-made vagina. Apparently when they were uncollapsing her lung in Arizona, she paid them to slap in a new cunt while they were at it. To prove the reconstruction of her vaginal area was a success, she invited first John Cale and then Louie Waldron to fuck her, which they both did. Later, I spoke to Mr. Waldron about this appalling incident.

'Louie, how could you fuck her? She was so disgusting, so ugly, so not human. It wasn't like you were hard up. How could you do it? How could anyone?'

'Look, Mary, I know you hate her, and believe me, I don't like her either. I mean she isn't that bad-looking, but she's off. Hey, it was an adventure, I had to feel what it was like to fuck a man-made ... ah ... well, the latest thing in ... You know, if it was any different.'

'So, how was it?'

'You really want to know? Well, she didn't have any lubrication, so she filled it with a whole tube of Pepsodent toothpaste. She liked the way it felt, and we fucked. I couldn't really feel —'

'I don't want to hear any more.'

'You know, she had a gun with her the whole time we were fucking. She said it was for you, to shoot you in the cunt. And then she made me promise not to tell you, that's why I never mentioned it before now.'

'Thanks, Louie, you're a real pal.'

We both laugh, Mr. Waldron and I, because we are survivors. Louie put his hand on my back where the cross used to be nailed and it was smooth – not a mark on it.

Like rockets and television II

Lynne Tillman

I wrote the text for a book of photographs by Stephen Shore, *The Velvet Years: Andy Warhol and the Factory, 1965–1967.*[1] In the summer of 1993 when the Velvet Underground reformed (for a minute), some of Stephen's photographs of the Velvets appeared in an English magazine; an editor from an English publishing house, Pavilion Books, wanted him to do a book and asked whether he knew a writer? Two weeks before – Stephen and I were both teaching in an MFA programme – I told Stephen that the last time I'd seen him was in 1967 at a party in his parents' apartment; Warhol was there. I think I remember seeing him. Then I described to Stephen what his parents' apartment looked like and how and where he was standing. Stephen didn't remember me. He didn't know my writing. But I had remembered what he and things looked like then, had a picture in my mind, like a photograph, and that impressed him, he said. He asked me to be the writer.

I started interviewing Stephen, whose memory, he claimed, wasn't great. We looked at his pictures together and talked; we had five sessions. Then I decided to interview other people associated with the Factory, some of whom I knew. I researched Warhol's films and the art he made then and earlier, I looked up dates and when works first appeared and where – details I hate doing – read what

was written about Warhol and his work at the time, captioned all the pictures – more details I hate, and then wrote an essay about Warhol and the Factory.

I realised I was doing history, involved, to some extent, in the growing Warhol corpus, his body of work, his body and other bodies, and his corpse – after an important artist's death, various institutions and people begin to close in, to gather information, to buy work, to sell it, to memorialise, capitalise, to assert influence, to shape interpretation, etc. Oddly enough, sometimes the people closest to the artist are not the best interpreters. I'm reminded of the temporary fate of Chaucer, whose pupil John Lydgate was, for about one to two hundred years after Chaucer's death, considered a greater poet. Lydgate is thought to have hurt the reputation of Chaucer's poetry because he dropped the pronunciation of the final 'e' from Chaucer's lines.

Allowed 30,000 words, including captions, for 200 photographs, I decided to give most of the words to Stephen and the people who'd been part of the Factory. My method involved meeting with them, if I could, and showing them xeroxes of 200 pictures. I asked questions, taped everything, tried to get them to identify others in the pictures, let the pictures function as *aides-mémoire*. Sometimes I talked to people over the phone; sometimes I mailed them xeroxes of pictures, then talked with them over the phone.

I decided to interview only those people in Stephen's photographs. That was a self-imposed limit. I met with Taylor Mead and then found out he wasn't in any of Stephen's photographs. Stephen was there the two years that Taylor was out of the picture. So I used a quote from Mead as one of the epigraphs to my introduction: 'Andy was difficult. I mean, it was great to be with him. He was cheap and impossible some days. I consider him a genius, I guess. Whatever that means.'[2]

I couldn't find Chuck Wein. I phoned everywhere, even a horse-breeding establishment where, I was told, he might still work. Brigid Berlin wouldn't talk to me. I got her on the phone. But she said, 'oh no'; then I discovered she'd been fired, or had left the Warhol Foundation, only days before. Lou Reed refused to be interviewed, his assistant said; I thought about using his lyrics, but knew that would become a nightmare. The Velvets had split up again, etc.

The photographs were the first frame. Through them I excluded or included possible speakers for the book. And I used the photographs as something to talk about.

The interview format was another frame. How did I frame my questions? Why did I ask what I asked? In interviews, in doing history through interviews, one relies on experience and memory, rather than on already written texts – after all, history is what is written, recorded – and even if they contest one another, written texts have the status of history. But in trying to get history, in trying to encourage a series of words, or images, to narrate two years, 1965 and 1967, of the Factory and to add them to the Warhol story, I became one of those choosing what gets written down. That felt ominous.

It's why I decided not to do an overview or to paraphrase but to present most of the material in the interviewees' words. Reading interview after interview is tedious, so I edited myself out and presented the interviews as stories and thoughts. I had to edit a lot; I couldn't use hundreds of pages of material. I had to select what I thought was most important, most compelling, for a

kind of record that was already incomplete, reduced or preselected. If several people agreed about something, for example, I might have only one of them say it in their section. Sometimes there was considerable overlap. Sometimes that seemed important to indicate.

At the very end, Stephen reduced the number of photographs; the layout was too crowded. The design changed, and even more words had to be cut. There's an alternative universe, another history or histories, that could be culled from what is edited out. It could be called 'the deleted'. Some of the deleted stories and thoughts that would have been in *The Velvet Years* are:

Danny Fields said, 'I can't believe we all had crushes on Lou.' But he was sexy. Dark, sullen. He was pleasant enough to me. We used to go to transvestite after-hours bars and stay up drinking coffee to 4, 8, 10 in the morning. He had stuff to say, the Delmore Schwarz background, he was well read in a certain kind of literature. I would talk to people about things. That's what I remember, substance. – Donald Lyons

Edie thought Andy would be her ticket to film stardom, that she'd be the focus forever of Andy and the Factory's interest. She'd be the permanent Pop girl. She didn't realise that the flux was very furious at the Factory; so Edie was there, then we came along, not wishing to be the Pop girl of '66, or anything else. We were there because Andy wanted to put a show together, wanted us to be the band. It didn't impinge on anything else, as far as we were concerned, he never asked us to assist in making silkscreens, he never asked us to give him ideas for his paintings. We just played music and were in the photographs. Edie got very upset, when all of a sudden Andy's interest seemed to turn to the show and us – what was her role going to be in the show? Nothing, in particular. She could dance if she liked. If you wanted to work the projectors, work the projectors. Edie wasn't happy with that. After we arrived, official, she more or less departed officially, and fell in with the Dylan camp disastrously. – Sterling Morrison

I never understood what all the excitement was about the silver toilet. It seemed to create such an incredible effect. I never quite got it. I think it was also because I'd been in a million lofts, so it all seemed a little bit old West Village stuff. The West Village was full of photographers. Every beautiful, long, leggy thing was invited up to someone's studio, to have some sort of photograph taken, so it felt a little bit like that. – Pat Hartley

The whole Factory, every evening, would go to some restaurant, some event. We'd go to the Ginger Man, where Edie had an account; she'd pick up the bill. Nothing to eat during the day except milkshakes, junk food, then we'd go out and, WOW, steaks, hamburgers, dessert. Everybody would order a dessert which nobody would eat, except Edie. She would eat everybody's dessert. Thin as a rail, but she would eat like a horse. Three, four desserts. I think Barbara Rubin said she learned how to lose weight from Edie, when they met in upstate New York, wherever this mental home was where they were incarcerated – I think that's how Barbara introduced Edie to Andy. They used to eat, and she would throw up. Bulimic, exactly. – John Cale

'SYNDROMES POP AT DELMONICO'S: Andy Warhol and His Gang Meet the Psychiatrist' – The New York Society for Clinical Psychiatry survived an invasion ... billed

as an evening's entertainment for the psychiatry society's 43rd annual dinner at Delmonico's Hotel ... 'I suppose you could call this gathering a spontaneous eruption of the id,' said Dr Alfred Lilienthal. 'Warhol's message is one of super-reality,' said another. 'Why are they exposing us to these nuts?' a third asked. 'But don't quote me.' ... The act really came into its own midway through the dinner when the Velvet Underground swung into action. ... Guests stream[ed] out. 'Put it down as decadent Dada,' said one. 'It was ridiculous, painful,' said Dr Harry Weinstock. 'It seemed like a whole prison ward had escaped.' – Grace Glueck, The New York Times, 14 January 1966. [This was to have been the sole exception to my rule about not including people who weren't in Stephen's photographs.]

Andy and I talked about movies. He liked Doris Day, superficial Hollywood movies, certain European avant-garde films. Jacques Demy. Extravagant Hollywood movies. He might have liked Vertigo, not because it was Hitchcock, but because it was a kind of lurid, insane display of personality, or image. – Donald Lyons

Last time I saw Danny Williams was when Lou had hepatitis, and I had to do the honors of the singing because we were booked into Poor Richard's in Chicago. I sang from the piano, and drew this review – 'Flowers of Evil are in Full Bloom at Poor Richard's.' I heard this thumping going on in the middle of the set. I looked up from the piano into the dark. Paul Morrissey was out there, where the projector was, with Danny. It was something that happened at every gig, like clockwork. Paul and Danny had their arms around each other's throats, and they were like leaning over the parapet and they were punching each other, about whoever could get to the extension cord first. That's what they were fighting over, the bloody extension cord. – John Cale

Edie left New Year's Eve, 1966. The Velvets, Edie, Andy and I were having dinner at the Ginger Man. Edie put the call in to Bob Dylan's office, because Grossman promised Edie a singing career – she could sing with Bob Dylan. What a hoax that was! So why does Edie want to hang out with us fags, when she can hang out with those straight guys? She didn't say that. This was the situation, her decision. Edie was very rich, but she had gone through two trust funds, and now she was on a very tight leash. She was on a $500 a month allowance, which was a lot in those days, but was tight for Edie. It appeared Andy was making money from his movies when in fact he wasn't – the movies were supported by the paintings. Edie wanted some of the money. She wanted to get paid for the movies she was in. She was right in a certain sense, but the point was she was incorrect in her perception. Andy was not making money off the movies, or else he might have given her money in those days. But then if he did that he would have to give money to everybody, and that would have spoiled the fun of making those movies. When she realised that Andy was not going to be forthcoming, she made the phone call. – Gerard Malanga

Andy didn't live with his mother, Andy's mother lived with him. She moved in on him. They were Old World. My family's like that too. Like I live near where my mother was born, right in this neighborhood [Poughkeepsie, NY]. The church I was baptized in was in this neighborhood. My mother still lives here. Linich is Prussian. And on one side my father is Prussian and Juncker, both Germanic. My mother is Italian, Naples and Sicily.

I'm the Central European. The Axis powers. See, I had trouble with that when I was a child. People used to call me Nazi when I was a kid. Like I was the actual enemy. I was born in 1940. I was the enemy kid. – Billy Name (Billy Linich)

I didn't represent one point of view, except in my introductory essay, where I wrote some of what I think about Warhol and his work. In doing the interviews, and of course my essay, I had to recognise and occasionally assert my biases. I made claims: Warhol as anarchic artist and film-maker, as scene-maker, as queer social critic, as irreverent and reverent, as a shopper, a scandal, a culture vulture, a dissonant, as a multifaceted, troubling voice, and more.

I functioned as an art critic and interpreted *Thirteen Most Wanted Men*:

In 1964, Philip Johnson, the architect, asked [Warhol] to decorate the New York State Pavilion for the World's Fair building which Johnson had designed. Warhol produced *The 13 Most Wanted Men*, meant to grace the outside of the building – thirteen criminals in profile and full face. Decoration for a state building. The image was rejected, as might have been expected and intended; then Warhol proposed a replacement – cover the building with images of Robert Moses, the World's Fair director. This sweetly perverse reversal of positions was also rejected. In the end Warhol painted over *The 13 Most Wanted* in his signature aluminum/silver paint. The wanted men obscured, made obscene, they were set against the state, or under it, as a palimpsest. They were the literal underworld of the state, a physical layer residing in the state.

It's an uncanny rebellion. Max Weber defined the state as that institution alone legitimated to kill. Some of *The Most Wanted Men* must have committed murder, a practice reserved for the state. So the preserve of art and the preserve of the state met on the surface of a building and had a silvered fate, were a turn of events, like that which the flip of a coin might produce, as flip as a coin flip, those changed positions or fates. *Most Wanted Men*'s other provocation is sexual, challenging the state with an outlawed, unspeakable love, homosexuality. Warhol, queer-American, gives new meaning to the phrase 'self-made man'. A self made into any man, bad, good, as random an end as the flip of that coin.

I presented Warhol as productive, contradictory, a man whose thinking and making continues to shape the present, whose work and life confounds most categories, most oppositions. Along with other leading figures of the 60s, there was an attempt made on his life. It failed, but it changed him and the Factory radically. In a curious way Warhol's place as a cultural leader, and the way the Factory was a parallel world to the larger world, is hinted at through the mimicry of the assassination attempt. It was that kind of time.

Another bias was to present the Factory people I talked with *not* as survivors – of Warhol, of the 60s, of the Factory. And to present the Factory not as a desperate place of no return, where everyone died and everyone else left hung on, or were losers, even beautiful ones. Life is led and goes on in all sorts of ways. I was interested in the living, and the living can be interviewed.

Experience is at once always already an interpretation and something that needs to be

interpreted.

An interview's results is evidence and reason why no characterisation or generalisation of Warhol and the Factory is true enough, accurate enough, or adequate, or entirely convincing. No interview result is untroubled by memory or subjectivity or desire or experience.

Paul Morrissey told me there were no parties at the Factory, maybe two, in all the time he worked with Andy; the existence of the parties was just media hype. Others told me that there were parties all the time. For some people, two's a crowd.

The edited interviews stand as fragments, bits and pieces, increments, meant to be incremental, meant to add to other texts. A silent interrogator is eliciting or urging responses. Among many questions, I was interested in how Catholic the Factory was and in Warhol's catholicism, in both senses. I wanted to know how class operated at the Factory, since class divisions are evident in his films, such as *Bike Boy*, as well as in his choice of objects to frame. In a country that pretends class isn't a problem, Warhol was class conscious. He had a class act.

People answered the questions or parts of them or not at all. Being the interviewer is as weird as being the interviewee. There's nothing neutral about either position. It's a set-up, asking questions, getting answers, an exchange with agendas, and both sides usually have one or several. Sometimes I lost myself in the answers and forgot why I had asked the question. I asked leading questions. Maybe all questions are leading – is one really disinterested in the answers? Especially when one is writing a history, and one has biases, implicit and explicit. And even the words that weren't my words became 'my material' to shape, from which to construct narratives, partial histories.

No one provided the total story, no one could, there isn't one, no one told me everything, although Gerard Malanga seemed as if he could. The total picture couldn't fit within one frame, each frame is a character, with all of that character's complexity. All the characters have different viewpoints, and each augments the others, or maybe detracts, but unlike the metaphorical or real jigsaw puzzle one hopes to finish, there are pieces missing. That's a given. And everyone would want a different finished puzzle anyway, a puzzle specific to each one of them, where each would be a little more central in and to the completed, but always incomplete, composition.

Doing the project I was doing, trying to get at what happened, what the Factory was like, how people saw the times and themselves and Warhol, I felt I was living Freud's dictum from *An Outline of Psychoanalysis* that 'in the end, reality will always remain unknowable'. It was incontrovertible.

In 'Like Rockets and Television' I posed the following question: 'Is the Factory, now that it's gone, just a place, a physical space, or a historical space, is it a mental space, or even a frame of mind?' What would be a Factory frame of mind? Does anyone still have it? Jonas Mekas commented, and I paraphrase, that while he thought Warhol's films were unique, he thought what Warhol had started would continue. There would be more Factories. But now he realises that

wasn't true. It was unique too. I wrote that:

> The Factory itself was a frame, including, excluding. It was a part of the sixties 'counter-culture', but counter to much of that too. Maybe Warhol's Factory was countercounter-culture, not as straight, more on the couch than on the bus or road.

What is the Factory now; what will we make of it, what purposes will it serve, how will it be interpreted, what will we make it be?

What are these photographs, now? They can't be taken at face value. They are art objects, visual objects. They are places or spaces, with history, holding history, about a historical moment, but how are pictures history? When is a photograph a historical document? What does it need to document? Do famous people in a photograph make it historical? Can any photograph, which is necessarily of the past, claim to be part of a history?

Pictures are apposite to, and analogues to, the problems of history. They need interpretation. They are not transparent. They don't control meaning, they don't limit meaning, they allow for meanings, they can be ambiguous, they ask to be decoded, they will be projected into and on to. They can be evidence – such as, Warhol is behind the camera; so he shot his films. Or: there was only one telephone in the Factory on 47th Street. But these 'pictorial facts' can be contested; the statement about the telephone is. By citing or writing about them, one engages in determining their meanings and their value. Photographs aren't conclusions or necessarily conclusive.

What was I showing to the people I interviewed?

Someone I know said that when he saw photographs of the Factory, when he was a teenager, they were like rock 'n' roll to him. They gave him the same kind of feeling.

The Chelsea Girls recently played at the Film Forum in New York. A friend who'd only read about the Factory and people like Nico and seen the pictures was amazed by it. *The Chelsea Girls* was very different from what he expected. Why was that? I asked. He hadn't expected that it would be sad.

As I worked, a little plagued, I asked myself: when one studies history, when one investigates memory and experience, when one studies other people's pasts, when one looks at photographs, what is one looking for? And, when doing something like this, how is one in the present? How is the past coterminous with the present, and how is it not? What is one's attachment to the past in the present? And why that past and not another? How is the present changed by the study of history, by one's absorption in even a recently past moment?

I thought of a Borges-like story in which a character, like me, becomes consumed with a year – let's say 1965. It is 1995 as I write; all I want to do is find out about 1965. It becomes more and more urgent to me. I want to know everything. Everything takes up more of my time than I have in 1995. Many more days of time, oddly enough, than there are in 1995, and in 1965, because to study as many facets as I can of 1965, I must necessarily live that earlier year in a

way that I don't live the present. I would want to know what was happening everywhere else and in the lives of others, whom I don't know, with the kind of intensity and attention I reserve for friends. That takes time and energy. I would be trying to encompass time in a way that one does not live time. Studying even one day in 1965 would take more time than twenty-four hours in 1995, maybe it'd take a year.

> I feel I'm very much part of my times, of my culture, as much a part of it as rockets and television – Andy Warhol[3]

Writing my book sometimes seemed anti-Warholian. Warhol was very much in his time, of it, in a present, his present, which became part of other peoples' lives, their present. He made the present as dense as history. He chose to make art and films from the present moment and instantly made the present into history. When you think about *a (a novel)*, Warhol taping and documenting twenty-four hours in the life of Ondine, you realise he's making history of and in the present tense. He's recording, preserving – preserving the present – archiving, and even extending present time, which he did again and again, with real-time films and serial images. Maybe Warhol's sense of time was Augustinian. Maybe my project wasn't completely anti-Warholian.

Of all the comments made about Warhol, one of the most intriguing was that he asked other people for ideas. Henry Geldzahler, Gordon Baldwin and others told me he asked people for ideas. Or they said he said, 'tell me what to do.' It seemed important but hard to figure out, another curious Warholian element. In 'Like Rockets and Television' I reported Gordon Baldwin saying: 'It's something people haven't noted very much.' How does one note or emphasise it? He wasn't interested in being the originator of the idea; he wasn't interested in the origin of the idea, where it came from or who it came from. It's easy to talk now in terms of appropriation – he appropriated images, he appropriated ideas – but how does one interpret 'tell me what to do.' What is its meaning? It can be used as evidence by those who think Warhol is 'unoriginal'. Stephen Shore thought he did it to include other people in his work, to keep people around. Psychoanalytically, one could think about symbiosis, about his relationship to his mother – maybe he's saying, 'tell me what to do, Mommy,' and keeping her with him. It may entail Oedipal issues, sadomasochism, and narcissism, too. It's also about a human exchange, with the idea as currency, as a kind of money, which also meant something to Warhol. He even made paintings of it.

Ultimately, 'tell me what to do' made me wonder what an idea was. The history of art, to name one history, is filled with notions about ideas: whose idea was it, who did it first, where did it start, who influenced whom, with ideas about ideas as forms. In the work of Warhol the status of the idea – its relevance, its origin and its originality – is in question. The difficulty about what an idea is is in the work, how something like an appropriated image functions apart from and as part of its origin. Someone who borrows ideas likes borrowed ideas.

I thought about it in three ways:

1. Warhol worked all the time, everyone said that, he never stopped making things, so for him maybe an idea is different from its execution, or maybe an idea doesn't exist until it's made;

maybe he objected to something's being 'just an idea'.

2. If you think of the frame, a social frame expanding and contracting, if you see Warhol inside a culture, a culture he feels part of, like rockets and television, then maybe the idea is an idea precisely because it circulates, is available, not because it's hard to find or that it should have to be found at all. What is an unrealised idea? Is it still an idea or only just an idea – useless? Would anyone have realised these ideas if Warhol hadn't? Was it in Warhol's mind to make every idea into work?

3. Hasn't Warhol himself become a borrowed idea? Hasn't he become an idea? I've borrowed him and his work to write about, to use for my own ends and to organise my 'own' borrowed ideas.

As for ends, ideas and borrowings: on Monday 24 April 1995, Billy Name and Callie Angell went to the filmset of *I Shot Andy Warhol*, a Valerie Solanas story, produced by Tom Kalin and directed by Mary Harrow. They wanted Billy Name to critique the set, a re-creation of the silver factory. They wanted to know if they got it right.

Notes
1. Lynne Tillman, 'Like Rockets and Television', *The Velvet Years: Andy Warhol and the Factory, 1965–1967* (London: Pavilion Books, 1995). Unless otherwise stated, quotations are from this source.
2. Joan Scott, 'The Evidence of Evidence', *Critical Inquiry* vol. 17 (Summer 1991), p. 797.
3. Gretchen Berg, 'Nothing to Lose', *Cahiers du Cinéma in English* no. 10 (May 1967).

An incomplete and idiosyncratic index of Warhol's worlds

Michael Eaton

A is for Andy and A is for Acne. A is for Aura, loss of, and Aura, as commodity.

Albino white out.
Alibi, see elsewhere.

A is a (a novel)
and A to B ...

B s are the others, always buzzing around,
and the Builders of the pyramids.

B is Brecht;
a Billy Budd routine.

C is for Clouds and also for Crowds.

Camp, see Alibi (q.v.), see Crime.

C is a Cup bearer, see Drug Pusher.
Curtis, Jackie;
Curtis, Ian.
C is for Carlyle (and how did he get here?).
C is for Cannibals (look no further) –
for Conspiracy
for Commonism (sic)
for Courtier and
for Court, see Royal Court of the Screaming Assholes,
see Factory (q.v.).

C is for the Council of Trent (?).
Church, see Factory (q.v.)
Church of Hysterical Disasters, see TV.
C is for Continuum.

D is for Drella and
D is for Death:
Death in America
Death at Work
Death and Democracy
Death and Disasters.

D is for Death – I don't believe in it … but Drella Dies.

Eternally Ephemeral, **E** is for Exposé –
Exposures, Expletive deleted.

E is for Electric Shock, see Silence.
E is for Electric Shock, see Cardio-vascular resurrection.

E is for Ego. I mean Egret.

F is for Fifteen minutes long past.

F is for Fashion –
for Faith
for Factory, see Desert of Destroyed Egos.

F is a man's best Friend, see Empty Chair.

F is for Funeral: mine or Bobby's?

G is for Green Disaster –
for Greene, Graham (and how did he get here? see Catholic
Church perhaps?)

Oh Gee!

H is for Hollywood –
Heinz soup
Heavenly rest.

There are no Hs.

I is for Instant Execution,
see Silk Screen
see Electric Chair
see Silence.

I is for Icon –
for Iconostasis: a channel between the people and their God, or a barrier
between the people and their priest? See Art.

The only **J** is the Judgment of God.

K is for Kiss
and Kiss of death.

L is for Life
and Life magazine, see 'amateur effort'
see underground films.

M is for Meet the psychiatrists –
(What is this: a spontaneous eruption of the Id? Who are these nuts?
What's happened? The whole ward has escaped!)

Multiples
Mourning
Melancholy
Masochism
Marcos, see icon
see fetish
see shoe.
Mannequins
Machines
Men on the Moon.

M is for Mass Subject – an oxymoron or a tautology?

M is for Money, see Romance
see Passion
see Honesty
see Truth
see Paint What You Really Love.

N is Nudity – a threat to existence.

Nothing Left Over
Nothing Special
Nothing Else
Now Here to Nowhere.

No Ns.

O is for Ondine
O is for Ondine, and
O is for Ondine.

O is for Object, do not see Actress
do not see Performance, see Only Object.

Performance Anxiety: Join It To Beat It
see Do It To Yourself Before They Do It To You.

P is for Philosopher (or should I say Photographer?)

Polaroid and
Paranoid and
Peacock Throne, see Pooch Portraits.

P is for Pop, see Faith (q.v.) and
P is for Pope, if you add an 'e'.

Phallus as Paintbrush
Phallus as face cream dispenser.

Q There may well be no Qs except Queer.

R is for Rhinoplasty, Before and After –
for Ready to wear
for Ready to hang
for Ready to fry, see Electric Chair, see Silence.

R is for Repetition, do not see Reproduction.
R is for Repetition, see Deification.

Reality (how did that get here?)
Religion (couldn't keep that out of here!)

Robotic
Ritual (compulsion, confirmation, or change of status?)

R is for Rage. But don't ever let on.

S is for Surveillance, see FBI, see CIA, see IRS
see Lonesome Cowboys.

Subversion of/or Status quo.

Screen, Silver
Screen, Blank

Soap, see Dove
Last Supper
Third Person of the Trinity

S is for Self-portrait, see Conspicuous Absence, see Camouflage.

Stars, see Edgar Morin or see Dollar Bills
don't see Stars see Superstars
don't see Stars see asterisks
see Sphinx but don't see riddle.

Silence
Scheming
Shopping
Signing
Sad
Scary
Swish
Satanic

Speed? See Rotten Rita (or Ganymede).

Sensation transfer
Snip the hair
Sniff the canvas

6.99 – the price of the Beast.

T urn on the camera, go make a phone call.
Tell me what to do.

Traumatic realism.

U is for Us
and Ultra Violet.

V is for Voice –
V is for Voices.

World's fair
World in drag
Where were you when – you first heard the Velvet Underground?

W is for Warhol, see Orwell (and how did he get here?)

X it from system.

Y not?

Because **Z** stands in for B and Back Again to A.

Index